DATE DUE

Creative
Vision

Digital & Traditional Methods for
Inspiring Innovative Photography

Academia
the environment of learning

AVA Publishing SA
Switzerland

An AVA Book
Published by AVA Publishing SA
Rue des Fontenailles 16
Case Postale
1000 Lausanne 6
Switzerland
Tel: +41 786 005 109
Email: enquiries@avabooks.ch

Distributed by Thames & Hudson (ex-North America)
181a High Holborn
London WC1V 7QX
United Kingdom
Tel: +44 20 7845 5000
Fax: +44 20 7845 5055
Email: sales@thameshudson.co.uk
www.thamesandhudson.com

Distributed by Sterling Publishing Co., Inc.
in the USA
387 Park Avenue South
New York, NY 10016-8810
Tel: +1 212 532 7160
Fax: +1 212 213 2495
www.sterlingpub.com

in Canada
Sterling Publishing
c/o Canadian Manda Group
One Atlantic Avenue, Suite 105
Toronto, Ontario M6K 3E7

English Language Support Office
AVA Publishing (UK) Ltd.
Tel: +44 1903 204 455
Email: enquiries@avabooks.co.uk

ISBN 2-88479-072-1

10 9 8 7 6 5 4 3 2 1

Designed by Them

Production and separations by AVA Book Production Pte. Ltd., Singapore
Tel: +65 6334 8173
Fax: +65 6334 0752
Email: production@avabooks.com.sg

Creative Vision

Jeremy Webb

Digital & Traditional Methods for Inspiring Innovative Photography

Contents

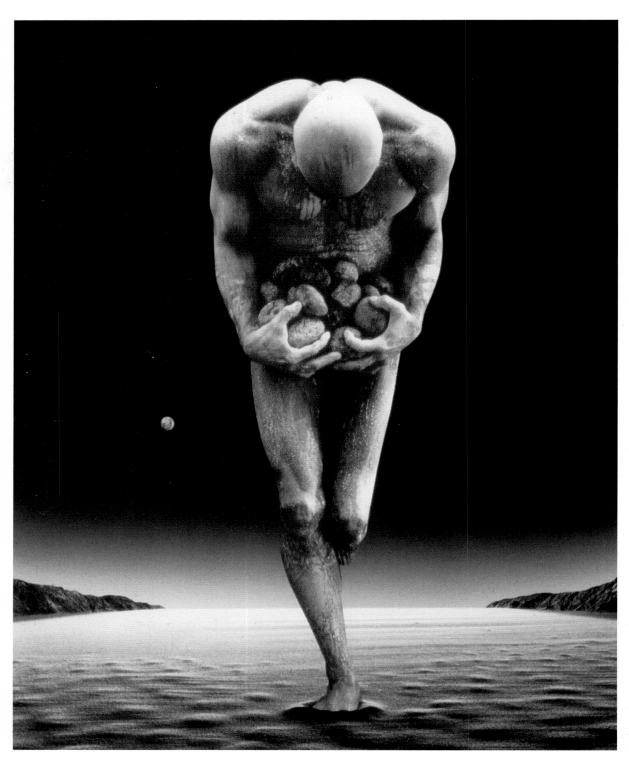

Doubt 43: Misha Gordin
Created using a multiple masking technique under one enlarger.

Introduction

Visual artists I suspect, find it much harder to separate their working lives from their personal lives. In my experience, we often create woolly, half-hearted boundaries separating working space from personal space. Of course everyone, from plumbers to professors, can find it hard to leave their work behind them, but dedicated and expressive artists and photographers find it harder because they are driven by a powerful force much greater than mere passion for the job, or putting food on the table.

That powerful force that drives a motivated, productive and fulfilled artist is their 'CV'. Creative vision is something that all artists and photographers strive to achieve. Without a desire to develop and use it, there's little point in going on. A willingness to nurture it can release the slumbering artist from an unfulfilled existence into a bright and vivid world, where an insightful and highly-creative working life exists.

We may be motivated, super-productive individuals most of the time, but sometimes we reach a stage when what we're doing just feels a bit tired, and what was once a satisfyingly creative working day now seems to have lost its spark. We know we have something to say, some meaningful communications to make, but we just can't put it into words, or rather pictures. Casting around for ideas or triggers to kick-start that battle against a sense of retreating creativity leads us to examine the work of other artists, and to explore other means of communicating artistically – with other processes and techniques, and by finding other voices, other channels, other languages.

This book is really an attempt to snuggle supportively between the pixel and the silver halide – between progressive digital image creation at one end of the sofa, and traditional photography at the other. They don't have to be separate. The emphasis here is on creativity, experimentation, risk-taking, and inspiration rather than technique, rules, or safe strolls down well-trodden paths. A basic level of understanding about the photographic medium is useful, as is an understanding of digital image editing.

I'm hopeful that some of the following images and exercises will encourage expressive photographic artists to explore a range of different disciplines as a means of adding to their creative armoury and realising their primary artistic goals. So we'll mix it up a bit, live a little dangerously, and shelve some of those habitual, entrenched attitudes. We could all shed a few pounds of that old art school baggage too, and allow ourselves to have some fun.

I hope that there will also be food for thought within these pages for other 2D artists, graphic designers, digital aficionados, and artists whose work incorporates the photographic medium as a significant aspect of their work. Thanks to the continuing fragmentation and reconfiguring of many previously exclusive art forms and the emergence of new ones, photography today seems to seep effortlessly into installation art, conceptual art, performance art, net-based art, and many other forms of self-expression as yet unlabelled. The blurring of these boundaries has to be welcomed in order for genuine changes to be made by contemporary practitioners, not just tentative ones.

I don't intend to present a cerebral workout in the style of "Creative Thinking" or "Using Creativity to Solve Problems". There are many fascinating books that deal with this area of mind-expanding and higher-level consciousness raising. Authors like Tony Buzan, Edward de Bono, and Michael Michalko have a lot to teach us in this area, but much of this field, however, concentrates on problem solving, left brain/right brain issues, and case histories of creative 'genius' such as Michelangelo, Einstein, and Leonardo da Vinci. We are all gifted individuals too and this book is directed squarely at the creative inside you.

I'll leave cultural history, critical theory, semiotic analysis, and other more specialist perspectives on the nature of photography to others. Not because I consider them unimportant or unnecessary, but because they deserve some standalone space within which to be absorbed. No matter how intellectually stimulating and informative they may be, their textual 'weight' could interfere with a necessary degree of playful 'unlearning' required for those with a thirst for creative adventure.

Creative vision is a process, a permanent state of openness and a willingness to challenge everything you've ever thought about yourself, and been taught about art in general. Creativity is driven by questions, not answers – by understanding, intuition and the subjective. Some of these questions might pop up as notes, queries or diagrams from my own notebooks and visual diaries, not because they're clever or deep, but simply because they may illustrate a simple point of interest, or present an idea with economy.

It's my sincere intention to avoid techno-babble at all costs. Partly for my own sanity and reluctance to engage with anything 'technical', but also because creativity itself is so often stifled by an over-reliance or misplaced trust in technical expertise. Technological knowledge for me has always been acquired on a strictly need-to-know basis, so if you feel intimidated or simply disconnected from the world of techno-speak, you're in good company here. I'm far more interested in how artists understand their own practice and motivations, find their own creative vision, and put their tools to the service of their ideas, not the other way round.

There's even a section in the book that requires no camera at all, and a few projects and assignments to locate and exercise those creative muscles for anyone who's up for it. A kind of aerobic creative workout.

Ultimately, any search for added value to an artist's practice begins with the artist themselves, and a revealing personal self-analysis is one of the first hurdles to negotiate in the next chapter. Moving on from the personal to the more practical, I'll provide a brief résumé of standard and well-known creative techniques before introducing some less widely-practiced techniques, along with some images from artists who use creative and playful experimentation as a major part of their practice.

In doing so, I hope to generate a rolling sequence of inspirations, and to offer up some ideas that can provide photographic artists with strategies and techniques to maximise that creative vision, adopt new modes of thinking, and inspire new and challenging works as the deserved and satisfying outcome of that process. Photographers are too often labelled or categorised, and too often they are instrumental in labelling themselves. By doing so, they wear one hat at all times. Wouldn't it be more fun to try on lots of different hats? Step outside our 'normal' selves and play a little.

How to get the most out of this book

Divided into ten chapters, this book sets out to investigate what creative vision is and how to harness it. Chapters cover mixing film with digital, cameraless photo-art, montage, distressing films and papers, specialist films and processing, abstract images and using light effectively, found objects and documentary projects, extending traditional genres and styles, and finally, innovative ways to present your work effectively. Each chapter ends with a summary, encapsulating what has been discussed and learned in the chapter. Each page is illustrated with stunning imagery to help explain what is being discussed in the text.

Chapter heading
These open each chapter and help the reader navigate through the book.

Introduction
Each chapter opens with some introductory text to lead the reader into the new subject area and provide easy understanding of what is to follow.

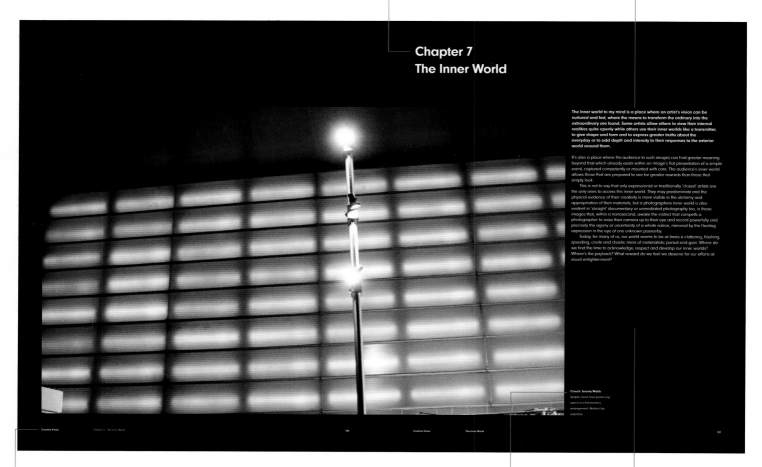

Chapter 7
The Inner World

The Inner world to my mind is a place where an artist's vision can be nurtured and fed, where the means to transform the ordinary into the extraordinary are found. Some artists allow others to view their internal realities quite openly while others use their inner worlds like a transmitter, to give shape and form and to express greater truths about the everyday or to add depth and intensity to their responses to the exterior world around them.

It's also a place where the audience to such images can find greater meaning beyond that which already exists within an image's flat presentation of a simple event, captured competently or mounted with care. The audience's inner world allows those that are prepared to see far greater rewards than those that simply look.

This is not to say that only expressionist or traditionally 'closed' artists are the only ones to access this inner world. They may predominate and the physical evidence of their creativity is more visible in the alchemy and appropriation of their materials, but a photographers inner world is also evident in 'straight' documentary or unmediated photography too, in those images that, within a nanosecond, awake the instinct that compels a photographer to raise their camera up to their eye and record powerfully and precisely the agony or uncertainty of a whole nation, mirrored by the floating expression in the eye of one unknown passer-by.

Today, for many of us, our world seems to be at times a clattering, flashing, speeding, crude and chaotic mess of materialistic pursuit and gain. Where do we find the time to acknowledge, respect and develop our inner worlds? Where's the payback? What reward do we feel we deserve for our efforts at visual enlightenment?

Crouch: Jeremy Webb
Simple, clean lines patterning space in a harmonious arrangement. Abstract by reduction.

Foot
Headings at the bottom of the page help with the navigation. In this instance, you can find out immediately which chapter you are in by looking at the bottom left-hand side of any page in the book.

Image caption
Every image featured in this book is accompanied by a caption that states the name of the image, the photographer's name and, in most cases, some explanatory text.

The text
Each chapter opens with some text to lead the reader into the new subject area and provide easy understanding of what is to follow.

Page heading
Each section within a chapter opens with a page heading to help navigation throughout the book.

Introduction
Each section within the chapters opens with some introductory text to establish what will be examined in the following page or pages.

The text
The text is broken down into easily digestible sections. Headings help the reader anticipate what he or she is about to read about.

Imagery
The book is full of beautiful and arresting images that can be appreciated on their own merit, but that also help to explain what is being discussed in the text alongside.

Image transfers

Image transfer techniques:

Magazine transfers
By coating a glossy magazine page with solvent (water to start with, if this doesn't work, move up to white spirit), it's possible to dissolve some printing ink before pressing the page firmly and evenly against a thick absorbent receiving paper, in whole (with a roller) or in part (by using a blunt tool to work on small areas). It's a bit hit-and-miss, but once you are on a roll it's possible to create some interesting backgrounds for over-printing, or building up intricate montages.

Newspaper transfers
The knack here lies in applying your solvent so that the newspaper is damp, not soaking wet. Trim the cutting to size then tape down along one edge so that progress can be checked without moving its position above the receiving paper. Use cotton wool to apply the solvent to the back of the newspaper by hand pressure only. If your newspaper cutting is taped into position, you can easily sneak a peek by lifting up an edge to check progress.

Black-and-white photocopier images
These can be transferred in a similar fashion, but which type of solvent to use will depend on a trial-and-error approach depending on the nature of ink used.

Laser copy and inkjet transfers
As above, inkjet prints can be transferred remarkably easily with very simple solvents, although many modern colour copier inks can be unpredictably stubborn or deliciously stable (depending on whether you're an artist or a copier ink manufacturer!).

Polaroid transfers
These are made by peeling the negative portion of a polaroid image away from its attached print immediately after exposure and pressing it against damp receiving paper with a roller. Timings for such transfers are critical, but the results can be dramatic.
Polaroid image transfers are by far the most well-known type of image transfer technique available, and further information on such techniques can be obtained from Polaroid, as well as a vast number of independent publications.

NB In all these processes, good health and safety practices should be observed. Always follow the safety precautions on solvents and work with plenty of ventilation and in situations where such work can be carried out safely.

Image transfers quite simply enable an artist to transfer one image on to another receiving surface; be it paper, cloth, or other absorbent material. It requires that the source image and the receiving surface are prepared in a certain way (according to the properties and characteristics of the materials involved), but as cameraless art it's a lot of fun when it works.

There exists an extensive range of techniques that require far more detail than can be accommodated now – for the purposes of this book, it is best simply to introduce the concept now and allow students to delve deeper if they wish to do so, using the resources in the appendix as a start. Incorporating a much-lamented element of craft into image creation, the techniques employed are briefly outlined here and can be applied to one's own imagery as well as other media in a variety of image transfer processes.
The appeal of such images for their creators is largely in the creation of a different, more muted atmosphere to the image, one where grain, colour changes and texture are all of greater visual significance than sharp detail or descriptive clarity. Such images often impart an aura of quiet calm and classical, timeless authority, or when used with multiple transfers on to a single surface, they build complex, richly-patterned abstracts.

'Ultimately, my hope is to amaze myself. The anticipation of discovering new possibilities becomes my greatest joy.'
Jerry Uelsmann

Image transfer tools and materials

Receiving surfaces such as printmaking paper, watercolour papers etc.	Cotton wool and brushes for detailed work.
Rollers for press-rolling source images on to their receiving surfaces.	Variety of solvents necessary for priming the source images, or receiving surfaces. These range from water, to white spirit, to acetone solvents, and clear gels.

Family Closet: Donna Fay Allen
'For me, creative vision is about seeing possibilities'

Quote
Quotes are littered throughout the book to add another level of knowledge and understanding for the reader, and in places, highlight an anecdote.

Getting started
Separate box-outs succinctly supply the information the reader needs to carry out a suggested technique themselves.

Image captions
Every image featured in this book is accompanied by a caption that states the name of the image, the photographer's name and, in most cases, some explanatory text.

Foot
Headings at the bottom of the page help with the navigation. In this instance, you can find out immediately which section within a chapter you are in by looking at the bottom right-hand side of any page in the book.

KODAK EPT 6037

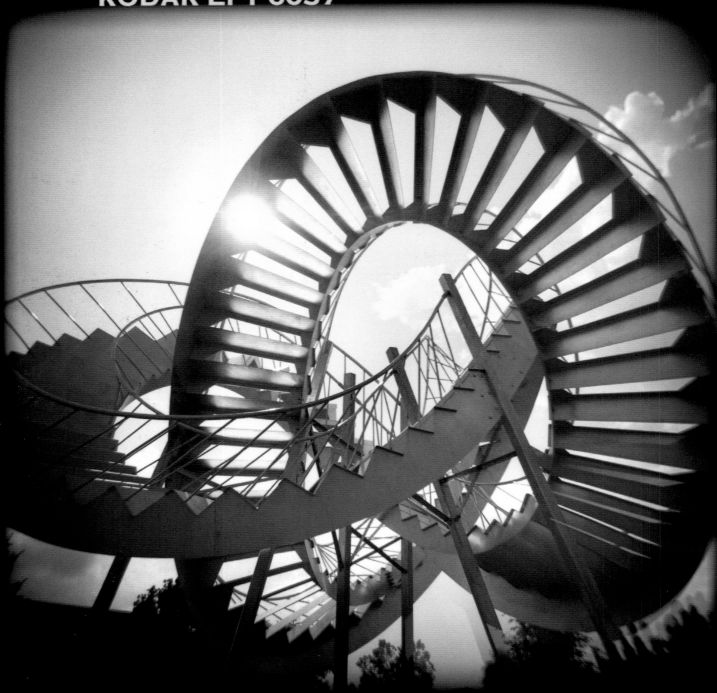

FPT▷1

FPT▷2

L'escalier tordu: Alain Gauvin

The Holga toy camera works well with simple, graphic shapes and this characteristic has given additional emphasis to the central area of the image by the vignetting in the corners. An 'unwanted' effect that happens frequently with toy cameras, as Alain Gauvin says: 'thanks to their many faults'. This image was taken using out-of-date tungsten-balanced film and then cross-processed.

Royal Crescent, Bath:

Justin Quinnell

'After a degree in photographic studies at Derby college, I did many types of photography, but didn't feel it was of much use. I discovered pinhole at a time when I was teaching in a less-than-affluent area of Bristol. Most kids couldn't afford cameras (but could afford cans of Coke), so I started with all of us making our own cameras out of Coke cans. It was then I realised the untapped potential of pinhole.'

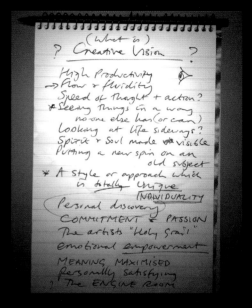

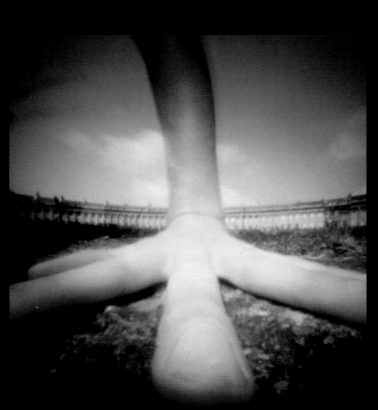

Is it a process? A way of doing things differently? An ability to drive forward, to constantly innovate and create challenging art? To break the rules? To produce work with passion, and to inspire passion in others?

Perhaps it's easier to define what it's not. It's not derivation or imitation, it's not being experimental for the sake of it, to show off, or to demonstrate technical or mechanical mastery. It's not slavishly following the fashions of the day or eagerly jumping on to arty bandwagons.

Creative vision is a process that requires you to question everything, and allows you to challenge every assumption, every unwritten rule. It lets you experiment freely in the knowledge that your experiments may provide the vehicle for bringing into being a sense of clarity, or it may fail but still be useful to your learning. It's about being relentlessly positive and maximising your imaginative power to drive your productive output. It also allows artists to dispense with their adult egos and adopt the curiosity and playfulness of a child.

Creative vision begins internally, with the personality, experiences, and nature of the artist. Eventually it seeps externally into the world, through the eyes and hands that hold the camera or capture the scene. Our task is to understand this journey, make rewarding choices along the way, and allow ourselves to wander without barriers or restrictions.

Like musicians who naturally have perfect pitch, some image-makers are lucky enough to be born with an equivalent visual gift, which allows them to make the transition from passively looking, to actively seeing, with ease. But we are not all Picassos or da Vincis, yet we can all learn the notes and scales of photography as a base upon which to acquire greater visual skill and awareness. As so many photographers will testify, technical knowledge of the camera and of the mechanics of photography only amount to less than 5% of the photographers' art. The other 95% is about developing the creative vision.

Who are you?

Before we head off into the great unknown, there's the small matter of ourselves to consider. We could start this journey blind-folded or take a little time out to consider who we are as a person, and conduct a brief SWOT analysis of our artistic practice and where we want to take it.

There's a whole industry out there that carves up populations into easily-digestible demographic segments in an effort to label a person's profile or type. Personally, I'm not big on navel-gazing or introspective self-analysis – in the end these simplistic categorisations become yet more labelling opportunities to stifle the poor artist, and pigeon-hole what they do or direct what they produce. But where in our hectic lives do we really find the time and a little courage to take an honest look at who we are and why we do what we do?

At the risk of adding to this plethora of personality appraisal techniques, it may be simpler and more relevant to ponder the following thoughts in a rational and open-minded attempt to examine one's personal attributes as a 'personality' and an image-maker; Are you a plate-thrower, or a sulker? Do you prefer chaos, or order? Are you an introvert, or extrovert? Do you nibble at your projects, or take them full-on and only stop when complete? Are you aware of an audience as you create your work, or do you work solely and exclusively for yourself? Do you generally distrust rules, or do you prefer to work within known and agreed boundaries? Do you buzz with ideas constantly, or does inspiration strike intermittently or haphazardly?

There's no score to reach, no tally of ticks in the Yes box or No box to identify you as type A or type B. The important thing to consider is that your self-awareness can influence your creative vision and deeply affect how you operate as an artist.

**Light Drawing Purple,
2004: Rob & Nick Carter**

Creative vision, for Rob Carter, is about 'passion and commitment, using light and experimenting constantly with what can be produced.'

**The Uncertainty Principle,
#7–3: Warren Padula**

'The camera, and photography overall, is the Devil's tool, and must be wrestled, subdued, and forced to give the result you want.'

The Creatrix below was created in an attempt to identify creative 'types' and serves as a useful tool with which to examine one's motivations and attributes.

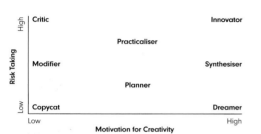

Source: S. J. Guastello, J. Shissler, J. Driscoll, T. Hyde, 'Are some cognitive styles more creatively productive than others?' from the Journal of Creative Behaviour, Vol 32, 1998

The Critic takes risks by expressing opinions, but has a low motivation for creativity. Good at analysing ideas and language skills, the critic will enjoy finding fault in others' work.

The Modifier will explore the edges of existing styles or genres, but will not add significantly to these fields or improve upon them.

The Copycat is most reluctant to take risks, often through self-consciousness or fear of being judged by others. The copycat will, as the term implies, simply duplicate what's already out there.

The Practicaliser is in a good position to take risks if he/she weighs carefully the evidence, and judges it right to do so. Practicalisers may well have some degree of originality, and often plenty of drive and commitment.

The Planner often finds it hard to get beyond the planning stage. Ideas are tried in pursuit of a goal, but often they are not taken any further, and procrastination sets in.

The Innovator is driven to try a multitude of exciting projects. As individuals, they are often driven by their own self-confidence. They can be spectacularly successful, and they can also fail miserably. The risks and the motivation are both high – a powerful combination.

The Synthesiser shares the same gentle tweaking approach to advancing other people's ideas, but may have a talent for fusing together ideas and concepts thought to be unconnected and finding new expression in this way.

The Dreamer can claim hundreds of new ideas every day, but these remain as ideas due to a disabling reluctance to take risks or stand out from the crowd.

Once you attempt a kind of personality audit of this kind, using tools like these, you can begin to address those working methods or habits/rituals that happen automatically, without being challenged or addressed. How many avoidance tactics do we go through before finally making a mark on that blank sheet of paper? These little rituals can become ingrained, invisible to the artist themselves, but all too apparent to close friends and family with a more objective standpoint. It takes a great deal of honesty to identify your faults in this way, many of which are not really faults at all – merely behaviours which one wishes to modify:

If you consider yourself shy and reluctant to photograph people, change this. What is the worst that can happen? The world won't end if you get a rejection.

If you wait for inspiration to strike, make a commitment to become more actively curious. Deliberately set aside time within which you will create something meaningful to and for yourself.

If you are reluctant to show your work, choose five people whose opinions you respect, then choose five whose opinions you don't! What do you find?

If you take too few risks, become bolder, experiment, do the unthinkable. Actively avoid routines, take different journeys.

If you are careful with film, and everything you shoot or design is staged and planned, become (at least for a fortnight) careless, carefree, and shoot on impulse.

If you are prone to complicate things, simplify, get to the heart of the issue. Similarly, if you reduce everything to attempt simplification, dig deeper, and uncover new levels, new layers, allow the branches of the tree to spread further, expand.

Early experiences

As children we absorb and negotiate the world using the visual sense and we are exposed to visual stimulations that can later feed into our work as artists. It may be helpful to revisit some of those experiences that now impact on our current lives.

As a personal exercise and a piece of fun, I've identified my own earliest, strongest visual experiences, which I've recalled and listed below. These are lifted, word for word from my own notebook:

I remember lying in my pram and looking into the sky to see an aeroplane streaking across the sky from one edge of my pram cover canopy to the other. I remember a sense of frustration once the aeroplane had passed.

I remember the impact of Ladybird Books' illustrator Frank Hampson and can recall many of those images in detail. They simultaneously repelled and intrigued me.

I remember drawing in an infant school classroom. I was attempting to draw a figure of a man with fingers on the end of his hands, not just stick arms. The teacher was laughing at my attempts. Why didn't she get it?

I remember a nature text book where the drawing of a caterpillar was just too terrifying to look at. I used to challenge myself to be brave enough to look at the picture again, but never could.

I remember looking on in horrid fascination at the stark black-and-white

'Perhaps the experiences recounted through my life have had a significant impact on my own personal work as a photographer to date.'

photographs in my mother's medical and nursing textbooks that featured facial disfigurements, skin rashes and malformed limbs. I remember feeling that these poor people deserved to have better pictures taken of them.

I remember the spine-tingling power and emotional impact I felt when I saw Robert Doisneau's 'The Higher Animals 1954'. The knowing expression of the tethered monkey and the stupid features of the gloating man standing next to the monkey left me with a powerful revelation that this kind of emotional punch could only be communicated through the photographic medium.

I remember using my eyes to blink and hold the after-image within my closed eyelids as a simple means of taking photographs off the television, sitting watching Royal Marine gymnasts performing acrobatics at the Royal Tattoo on the television.

I remember thinking how absurd a pelican looks, sitting on my Dad's knee watching the television.

I remember a world which grown-ups couldn't see – underneath the grand piano, where a series of ledges or unintended shelves supported my little figures and soldiers, and where I created miniature worlds to enjoy.

I remember a deep fascination with torchlight, underneath my den of deckchairs and blankets, a secret world where the light transformed everything into anything.

Given a superficial analysis of these memories, I might appear to have grown-up into a darkly-secretive, authority-hating, self-mutating psychopathic loner. Unless

Untitled: Jeremy Webb

Within each of us lies a struggle

to escape from the straightjacket

of conformity and return to more

primitive needs, a respect for

nature and to live more in tune

with the planet.

my wife and children report otherwise, I'm hopefully a relatively balanced and healthy human being, but perhaps the experiences recounted above have had a significant impact on my own personal work as a photographer to date, echoes of which may have (at least in part) given rise to:

— A willingness to present ambiguity and simplicity.
— An interest in the surreal.
— An interest in representations of the human body, erotic, imagined, absurd, imperfect, the body as communicator, as vessel, as conduit etc.
— An interest in what lies under the surface.
— An ongoing body of work using torchlight photography.
— An interest in exploring photographically what lies beyond the four edges of the photographic frame.

We are all composed of bits from our pasts, some of which resurface in later life. Recognising these strong triggers of today's current creativity creates a strengthening bond between past, present and future, and helps us to value what we do today as well as using this knowledge as a driving force towards future goals and as a means of respecting the source from which much of our current creativity stems.

What are you trying to say?

Kennedy Lake Tree: Siegfried Burgstaller
This image evokes a blissful calm conveyed not just by the subject matter, but by the simplicity and vision that lies behind this beautiful image. Of his work, Siegfried Burgstaller says: 'My mind tends to bounce around new ideas constantly – I think this is why photography suits me so well. I focus very intently on the task at hand, almost to the point of obsession...then move on when it's done. This works because you can photograph anything, there is a whole world out there waiting.'

The Night Cedric Buried Grandpa in the Garden (Western Gothic series): Patrick Loehr
'My goal is to express a unique visual impression of the world, not to record what the eye sees. Digital photography is simply the tool I use to paint.'

It goes without saying that photographers and digital image-makers have something to communicate. Rather than getting hung-up with arty terms, which can be self-limiting in themselves, it makes more sense to attempt to define our ambitions by identifying which of the following terms can suitably describe our stylistic approach:

What we might loosely term Interior/Closed approach characterised by:
— Highly personal approach
— Inner feelings and sentiments
— Self-examination
— Expressing an 'alternative' reality
— The subjective, expressive, or disguised
— Implying something universal from something specific

What we might loosely term Formalist or Self-reflexive characterised by:
— A primary interest in the media used in the production of photo images
— Creativity expressed in presentations of the image
— Innovative techniques of production
— The photograph as a whole, as an object
— Photographs about photography

What we might loosely term Exterior, or Open characterised by:
— Allowing viewer to engage unmediated by the image creator
— Information
— Detail and documentary
— Accuracy
— Neutrality
— Truth
— Objectivity
— A record or proof of something

Doubtless some would argue that this is a distressingly simplistic and incomplete analysis of photographic practice, but sometimes one needs to identify one's practice in relation to others in a world so obsessed with technique. An abiding interest in more so-called objective documentary does not preclude the photographer from exploring more expressive forms of communication. Neither, for that matter, should a highly artistic photographer be put off attempting to produce work with a more neutral, unmediated bias. Photographers need to explore all of these approaches in an open-minded effort to develop their creative vision. Let go of all that artistic conditioning and explore creativity.

'The creative person is both more primitive and more cultivated, more destructive, a lot madder and a lot saner, than the average person.' Frank Barron

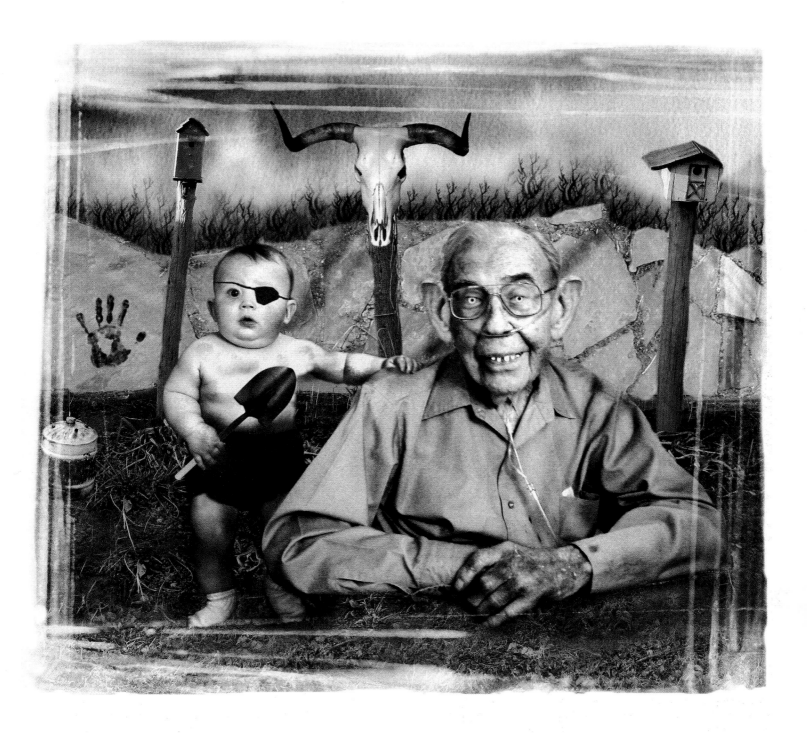

Some creative strategies

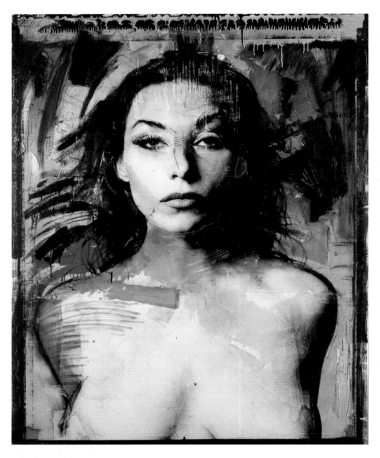

Eumenide 111: Floris Andrea

'The base of an Andreatype is a wooden panel. While being aware of the image that'll be on it, I will polychrome the panel with home-made paint; real pigments are used for this, plaster, pastel, etc. After drying and coating I put photographic emulsion on top of the layers. Drying again, in total darkness this time. From this moment I handle the panel just like normal photographic paper.'

Overturn expectations

Nothing remarkable here, just the creative photographer's ability to commemorate the everyday as the exceptional, or the exceptional as the mundane. Applying alternative contexts to iconic subjects in this way can stop your audience in their tracks, and allow them to consider your subjects in a completely new light. In the end, can we really ask for much more from photography?

Juxtapose opposites

The pastel with the pop art, the quiet with the loud, the clean with the dirty, images which place two opposing themes within four sides of the frame often leave an arresting feeling akin to a visual 'itch' that needs scratching.

Expose incongruity

Most of us from time to time (and some of us for most of the time), will consider the world to be a pretty mundane and predictable place. Incongruity is where the unexpected or uninvited appears in an unlikely or unsympathetic setting. Such moments always stick out and remind us what it is like to be alive and sentient in a world full of genuine surprises.

Simplify/complicate

Simplicity can smack us in the face and leave no room for misinterpretation, the opposite approach can impart a pleasing imprecision, a teasing ambiguity that may hold our attention longer than any immediate hit.

Mix your media

Resist the temptation to sneer at the idea that paint, crayon, acetate overlays, and other artistic materials might not be useful to your practice. The point is not to experiment for the sake of technique, but an open-minded approach to experimentation like this can reveal previously unarticulated ideas.

Reveal/hide

We live in an age of instant gratification. We're expected to have opinions on everything. We expect a return for our efforts. The activity of looking at photographs raises many of these issues. Photography can shout and scream at you, or it can purr softly in the corner where only the quiet child will notice it's there. Be bold not bolshy, or be enigmatic, not exposed.

AAF – Actively Avoid Fashion

Fashions come and go and every dog, as they say, has its day. Just because a gallery displays a transient vogue for huge, realist documentary photographs doesn't mean something new won't be required in the future. Don't be seduced by fashions. Explore the components of these genres to understand their appeal, then subvert them and appropriate their language in order to offer something fresh, not dish up the same.

Recycle everything

Those test strips or that scratched negative could provide you with something useful. A textured overlay, a non-specific background to scan in and use later, a chemical spill that holds a fascinating abstract in it yet to be discovered.

Mistakes present new opportunities

In other words, embrace failure as a positive experience. This one can be hard to swallow when a whole day's shoot is accidentally exposed. Less extreme

Floating Smile: Jeremy Webb

Sometimes I enjoy the challenge
of expressing a simple concept
with directness and economy.

disasters, however, can present us with alternative outcomes which could form the basis for further work.

Challenge every rule
Where do the rules come from? Who says this or that is so? The art world is full of rules. Some are very formal, such as the rules on composition laid down in rigid Victorian fashion by painters such as Henry Peach Robinson. While others trickle down informally from positions of cultural power, permeate educational institutions, and become stifling straightjackets that can directly and profoundly affect the course of an artist's practice.

'Notebook. No photographer should be without one!'

Ansel Adams

Use a notebook
Memory can't be relied upon when one is preoccupied with the business of creation. Films have different characteristics – which one suits your aims? You create a magnificent digital abstract: What were the stages you took in Photoshop now that the history palette is wiped clean? Jot down ideas as and when they occur.

Give yourself doodling time
Time to fiddle about absent-mindedly is a gift. Get used to the idea of experimenting without aims or outcomes in mind, purely for the fun of it.

Develop and trust your intuition – not technology
Intuition can only flourish once technology is mastered, or at least until the manual and functional operations of a camera are second nature to you. The formidable Albert Watson once remonstrated with Photography Monthly's Terry Hope in an interview: 'Look at this camera here. It's the same camera that's been sitting around here since 1978 – it's old, it's worn, it's held together with Gaffa tape...You should know everything there is to know about a camera until you can virtually use it in your sleep. That doesn't make you a teccy: it just means that you're fluent.' Today, I wonder if we're as fluent with our cameras as we are with our mobile phones?

Change your brainwaves
If you get stuck, take a break, have a shower, do some puzzles, allow your subconscious some time to marinate the issue before returning to it refreshed. Just don't sit there, head in hands, creating negativity.

The raw materials lie right under your nose
Or to put it another way, familiarity breeds contempt. Photographers are constantly looking for the bright, shiny, exotic, next best thing, but tend to ignore subjects closest to them: their lifestyles, interests, environments, which are often overlooked. Is a fish aware of the water within which it swims?

Let your interests and emotions drive your creativity
Music, literature, poetry etc. all celebrate the world of meaning, values, emotions and life. For the expressive artist, it helps to develop a kind of photo-sensitive synaesthesia – seeing sounds and smells, creating work in response to a piece of music, illustrating a short story, and so on.

Mission impossible —
What makes a 'good' photograph?

This is not my personal manifesto. This is an attempt to address this hugely subjective question by identifying some of those criteria used to judge whether an image is good or bad. I like to think of it as a basis for discussion:

There are many exceptions to these 'rules' and not all of them apply to all images. You may wish to delete some, you may wish to add others. It's an exercise that holds many benchmarks by which one's work can be measured, if only for the rather simple pleasure of reminding ourselves of the standards which our work is often judged by others, knowingly or otherwise.

— A good photograph should express the photographer's intention
— A good photograph should communicate something that words cannot
— A good photograph should engage the viewer
— A good photograph should generate sympathy or empathy
— A good photograph should communicate a general truth, say something new, or reaffirm some existing truth
— A good photograph is best seen not in isolation, but in the context of other images
— A good photograph should 'retain' itself, allowing other interpretations and meanings to unfold on further visits
— A good photograph demands a response from the viewer
— A good photograph should be well-composed and well-lit
— A good photograph has longevity, is a long distance runner, not just a sprinter
— A good photograph demonstrates care in its production and presentation

Perpignan, France, 2003:

Victoria J. Dean. 'My images feel like part of me. They communicate something to others that I would not be able to communicate in any other form. It is a necessity for me to create photographs, it is almost a spiritual thing that if I was not able to photograph, I would feel an emptiness.'

A quick résumé of film photography techniques

Before moving on to more adventurous pastures in the following chapters, it would be a good point here to list some of the better-known creative techniques employed by photographers of the analogue era. It's worth remembering that when we point the camera and shoot, we're already using our intuition and personal judgement to establish:

— Choice of camera, lens and film
— Choice of angle to subject
— Choice of distance to subject
— Choice of viewpoint to subject

Remember, these are all personal choices. As Ernst Haas once said, 'The best zoom lens is your legs.'

We then have to consider:

— Focusing
— Shutter speed and aperture combination (if we wish control over these)
— Composition – the spatial arrangement of forms within the viewfinder
— Framing of subject (what to include/exclude)

Before moving on to anything extra such as:

— Panning
— Zooming
— Deliberate blur
— Double exposure
— Flash – bounced, direct, filtered, slow sync etc.
— Filters

At the film processing stage we can:

— Use specialist developers
— Over/underdevelop
— Cross-process
— Deliberate reticulation of the film grain etc.

Before reaching the printing stage to:

— Select contrast grade
— Dodge/burn-in
— Create negative sandwich
— Crop
— Solarise
— Double expose
— Splash the developer on
— Pre-fix the paper
— Zoom in during exposure
— Use soft focus filter over enlarger lens
— Move paper during exposure
— Use textured glass/acetate to print through etc.

The list is inexhaustible, but it's interesting to compare how the list would shorten if applied to the production process of the digital image. Now that digital image editing can replace the later stages of this list, film processing and darkroom printing are superseded by digitising the image into pixels and doing further work in Photoshop. Filters are no longer required, toners and chemical baths can be a messy and expensive business, the darkroom can be replaced by the computer and printer. For some.

And yet, for so many photographers still, the world of silver-based image production remains special, the physical 'craft' of darkroom work and the thrill of seeing that blank piece of paper transform into an image in the red glow of a safelight never really leaves those whose first experiences of photography are linked forever to the darkroom.

'I think the best pictures are often on the edges of any situation, I don't find photographing the situation nearly as interesting as photographing the edges.'
William Albert Allard, 'The Photographic Essay'

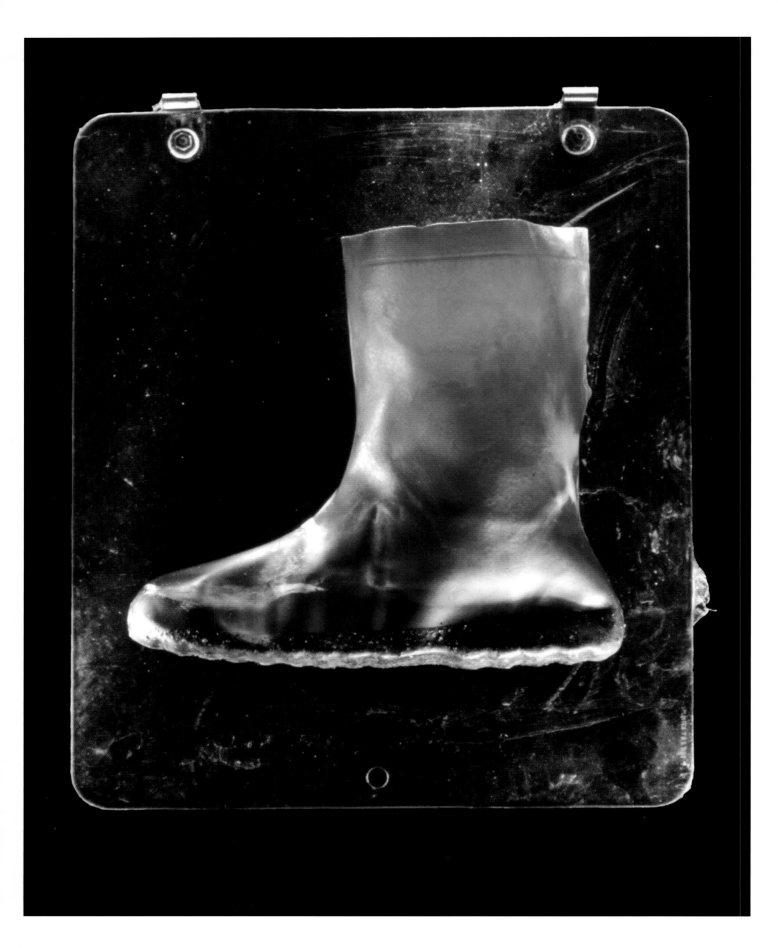

Summary

Green Garden Boot:
Jeremy Webb
One image from a series of
images that attempts to illuminate
ordinary found subjects from
garden sheds. The lighting was
supplied by a constantly moving
torch beam during a long, timed
exposure of 40 seconds.

**It comes as no surprise that the process of creative image-making is a
complex and highly-structured web of choices made and journeys denied or
taken. The list that opens this chapter contains within its words and
implications much of what could form the blueprint for a more creative
approach to image-making – no matter what level your knowledge, skill, or
motivation. The inner world is where it all begins.**

The outer world holds many temptations. Technology rears its fairly attractive
head throughout this book. So often it has an enabling power that can drive an
artist's practice into unexplored territory, or it snuffs out personal vision, or
becomes the scapegoat that reinforces an artist's own prejudice. There is
absolutely nothing inherently interesting in a piece of software on a shiny disc.
Only when the potential of what it can assist in achieving is realised, does it
become any use to anybody.

Amidst all the voices and influences that overwhelm or inspire artists to
greater things, the time to take stock and examine oneself honestly is an
opportunity that should be taken once in a while. The intonement for an artist to
'know thyself' couldn't be more apt.

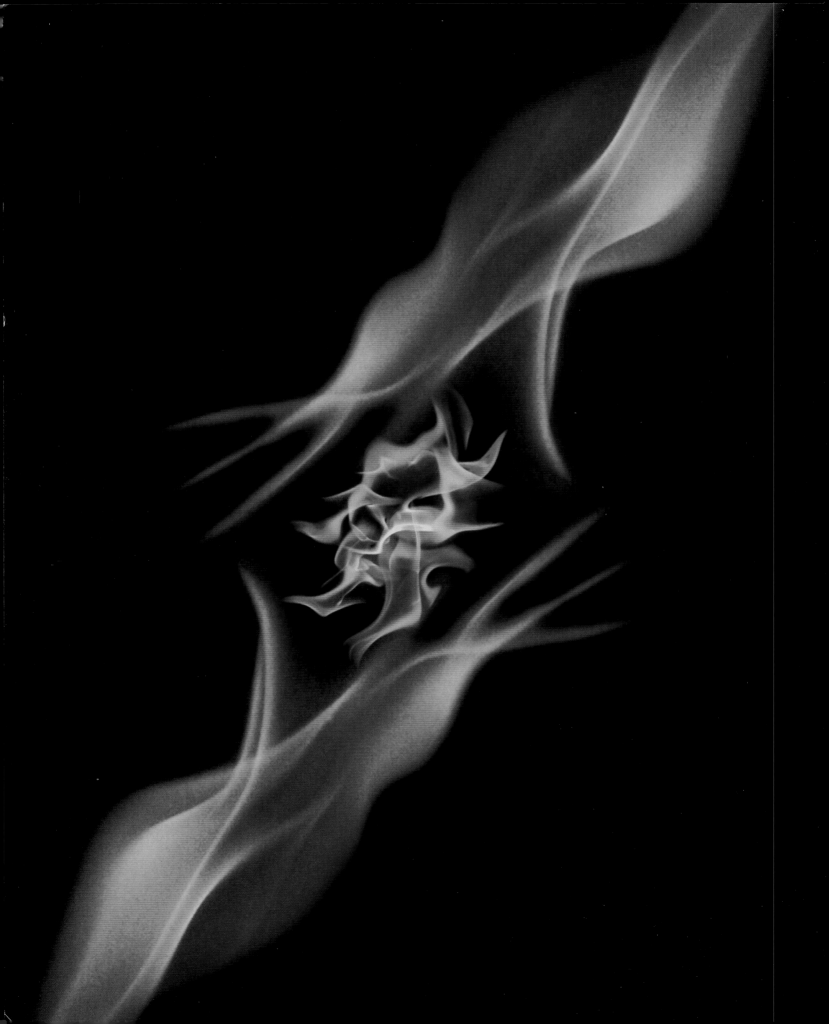

Chapter 2
Mixing Film with Digital

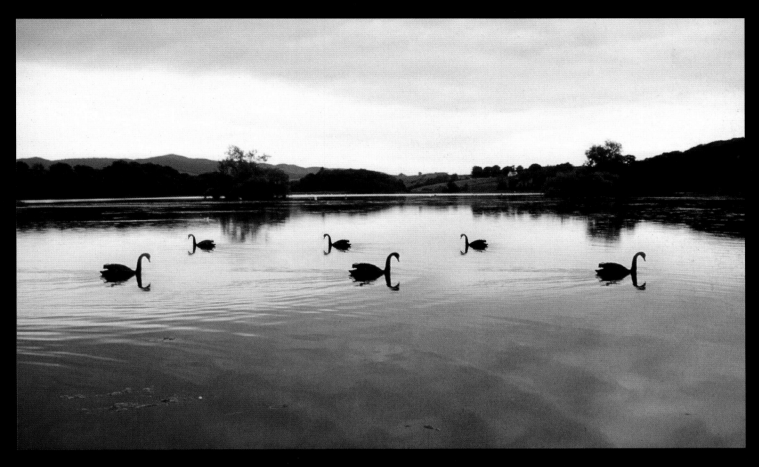

Untitled: Jeremy Webb

Originally a shot of a lone black swan, this image was an attempt to create something slightly less wholesome than the original image. Using a variety of flipping and copying techniques within Photoshop, the swan was transformed into strange beatle-like creatures that hint at something altogether more sinister.

Untitled: Jeremy Webb

The merging of the film and digital worlds, and the opportunities presented by such a young marriage are still at an early stage of growth. Before the digital realm became mainstream, photographers and image-makers went to great lengths to point out the differences between the two, rather than discuss any similarities or explore the idea that practitioners might even entertain the idea of utilising both, for a powerfully creative collision of two worlds.

Now, with traditional film photographers converting to digital by the score, it seems many photographers of the fine art persuasion have firmly stuck their heels into the either/or camp of their choice without exploring the shared trenches of the middle ground, which is being quietly and capably mined by artists who see the benefits of taking the best bits from both worlds.

Here there exists a potential supernova of fresh and highly-expressive art, which at last provides the means to transport an artist's creative vision. All it takes is the artist's creative drive, and an open-minded approach towards experimentation, to gain a deeper aesthetic understanding, and a richer, more fulfilling artistic life.

Adopting a fresh approach

'Creative exploration allows image-makers to gain courage from the experience of attempting untested and unknown paths.'

Embracing the unknown can be a scary prospect for some of us, but that's no reason to take the artistic equivalent of curling up in a comfortable chair and doing nothing for an entire weekend. Examining the familiar at a distance, or denying safe, habitual behaviour in favour of discovery will keep motivation high and indifference towards one's own practice down to a minimum. Creative exploration allows image-makers to gain courage from the experience of attempting untested and unknown paths.

The most powerful work emerging from this field – an individualistic, personal creativity delivered by materials and processes that are, above all else, put totally towards the service of transmitting a particular vision. It is not enough merely to play with new technology like new toys, or attempt to impress an audience with mastery over some new piece of kit.

The ideal starting points for artistic discovery in this arena can be found largely within the artist's own imagination and temperament. Some may take an exhausting route in the process; image capture on film, transfer to digital, output again to film, project on to textured surface, recapture on digital and so on, until their work acquires a multi-layered and intensely textural style. For others, there may be fewer steps in the process, which means that their experience of the film and digital collision is a less complex one; film capture, scan to digital, edit in digital, output to print.

Throughout this chapter we'll look at some well-known stages of the image capture and production process and throw in some lesser-known methods and materials. For the inquisitive artist keen to explore new means of expression, the following sections might throw up some interesting combinations or alternative routes in the creation of images, which treat the creative possibilities of film and digital in equal measure.

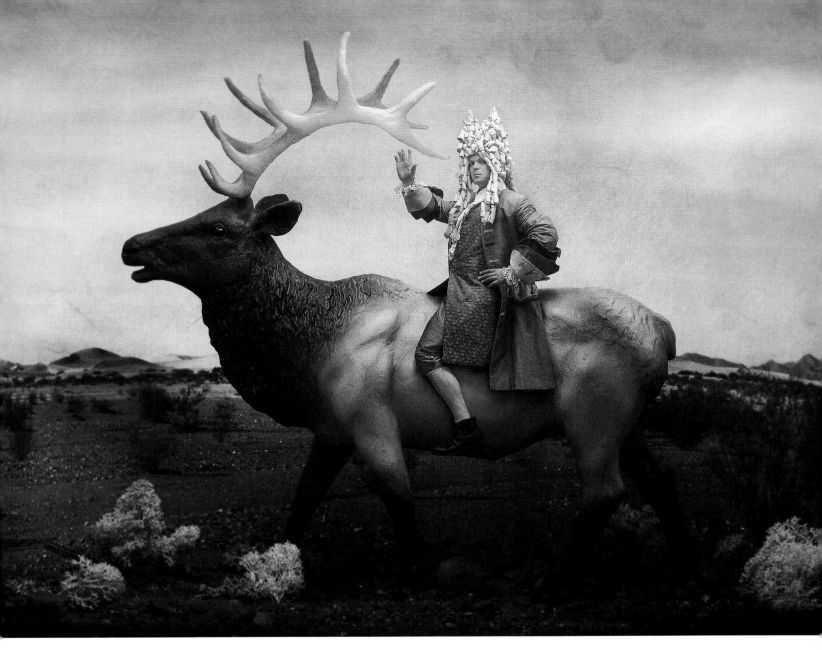

Untitled: Mark Holthusen

A wonderfully irreverent image, full of humour and a sense of the absurd. Mark Holthusen's images often feature clowns, conquistadores and plastic illusions, and project an atmosphere that can be both jarring and elegant.

Break the rules

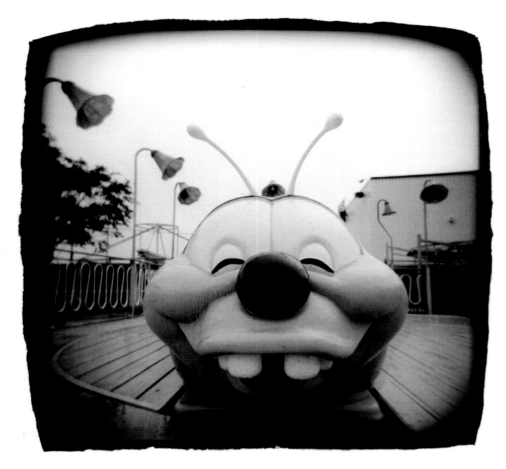

The practice of photography is riddled with rules at every turn and many of these rules are laid down in childhood, but still haunt us in our adult lives. For example, smile, don't look so glum. You can't take a proper portrait with a wide-angle lens, cheap cameras are a waste of money and so on.

Breaking these technical rules involves thinking around the edges of a piece of equipment. For example, cameras are assumed to be expensive investments with pin sharp optics and multiple functions to provide versatility and quality.

So buy disposables. They have limited functionality, poor optical quality, and have to be discarded once the film is ready for process. And yet, in the right hands, their limitations could actually assist an artist who specifically seeks to depict a subject in blurry, unsharp or indistinct fashion and whose journey towards that goal is hindered by the multiple shooting modes, autofocus capability, or other 'helpful' advances provided by most modern camera manufacturers. One student recently turned in a superb set of portraits taken with the stark flash of a disposable camera, faces distorted and bleached-out by their close proximity to the lens, but more vivid and memorable than many more earnest or traditional assignments I viewed that week. The garish flash effect was deliberately created by using a poor camera sloppily but, more importantly, this was known and exploited to the full by the student concerned.

Other rules of this nature literally beg photographers and artists to stick neon-coloured card into the desktop printer, or print out on to newspaper, or other such non-standard surfaces. It's really just extending the use of a piece of equipment in the same way that digitally-orientated photographers started to bypass the camera altogether and use the scanner to capture still life on the scanner bed.

Alternative lighting techniques

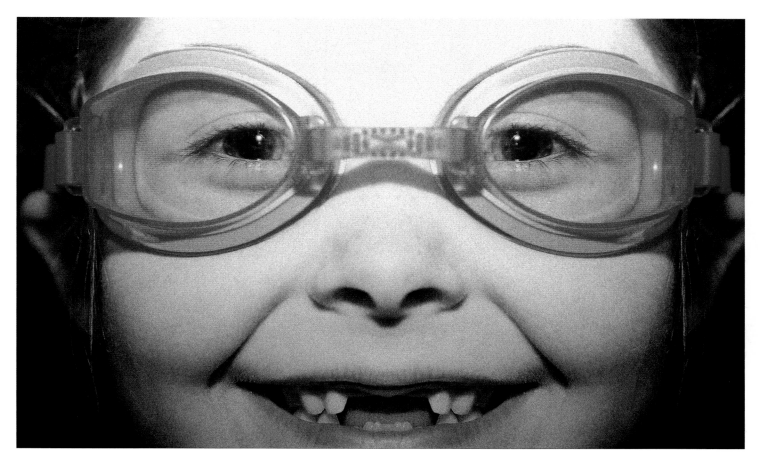

Photographers can be a conservative lot. Always sticking to their tried and tested flashguns, or their studio lights set just so, no matter what or who the subject is. The currency of photography, light itself – the very thing which makes photography possible – is freely available from a whole range of sources, which add their own special characteristics to a portfolio of lighting styles and sources (which every photographic artist should have).

A slide projector can create dramatic raking light across a textured surface, or used with coloured or textured slides and gels, project pattern or colour on to a subject. If used with ordinary daylight-balanced film, the light will be warm orange due to the colour temperature of the bulb, but used with tungsten-balanced film, a more neutral light will be recorded as witnessed by the eye.

Even the studio lightbox (normally static and used solely for the purpose of viewing slides) can be used as one of the softest lights available, from underneath, or to the side, provided that it can be supported securely. Like studio tungsten lights, its WYSIWYG (What You See Is What You Get) lighting style is highly predictive and immediate, making it easier to calculate correct exposure and see the result which this form of lighting provides. Although the quality of light is beautifully soft, it's usually used with the camera mounted on a tripod to prevent camera shake due to the low power of the light.

Car inspection lamps, BBQ lights etc. provide excellent opportunities for bright sources of light. Any colour cast is irrelevant if shooting in black and white, but as with the slide projector, these lights are best used with tungsten-balanced film or a cool blue filter to reduce the orange nature of the bulb's light. Naturally, colour casts can be corrected with care in Photoshop, but image editing of this sort requires skillful handling to retain as much of the original's pixel information as possible.

Cigarette lighters, torches; everything is up for grabs. All it takes is the motivation and imagination to try it out.

Experimental formats

'The world just does not fit conveniently into the format of a 35mm camera.' W. Eugene Smith

Who says a picture should be rectangular? That it should have four sides? That it should even have edges? The whole notion of framing our images within that familiar rectangular box is so ingrained upon our consciences that we scarcely give it a second thought.

There are photographers however, who attempt to extend or adapt this limiting convention by producing images that can be circular, panoramic, vertically elongated, or where the traditional edges of the image gradually fade away seamlessly into nothingness. These bolder experiments with the traditional rectangular format allow photographers to challenge conventional print shape and size, and deepen the level of involvement with their subject, or more realistically represent the whole process of looking with one's eyes.

Josef Sudek has, in a lifetime's work, created many wonderfully bold

monochrome prints in a stretched landscape format whose panoramic shape lends itself perfectly to his compositional style and vision. More recently, Sam Taylor-Woods' images with a camera that takes in a 360-degree view in one long sweep are a more recent example of the image-maker's frustration with the traditional rectangular format.

Experimentation with image formats is relatively straightforward in the darkroom where you can simply insert a pre-cut negative carrier into the enlarger head, frame the image on the enlarging easel using the cropping blades, or use a mask or template over the paper to create the size or shape required. If attempted digitally, the crop tool can be used along with Image Size and Canvas Size keeping both height and width in proportion.

In either case, it's important to remember that the most arresting imagery in experimental format photography is always created by the very first stage of the image production process – image capture. Re-cropping existing photographs which were seen, composed and shot within the traditional rectangular frame can look compositionally limp compared with those that are seen, composed and shot within the adapted viewfinder or format. Sometimes an alternative format is determined for you by the camera itself – toy or junkshop cameras (of which more later) can give edge bleed, and pinhole photography can provide circular ghost-like images that can be fairly sharp and detailed at the centre, then fade away gradually at the edges of the image.

Focusing/de-focusing

'One photo out of focus is a mistake, ten photos out of focus are an experimentation, one hundred photos out of focus are a style.' Author Unknown

Bretagne: Herbert Boettcher

'Creative work with the pinhole camera in combination with digital applications offers extraordinarily sophisticated possibilities for new photographic areas.'

Warning Sign: Jeremy Webb

The out-of-date film used to record this image has provided some beautifully muted colours that seem to combine well with the divided rectangular portions of the frame.

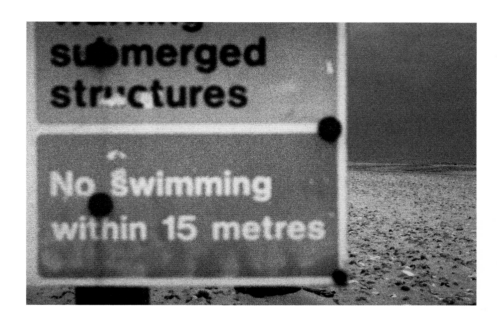

Much current advertising of cameras and lenses seems to reflect the continuously tiresome and simplistic debate over which is best – digital or film. Pin-sharp portraits or close-ups are published by either side, showing fantastic detail and sharpness – every pore of the skin visible, every frond of a fern rendered in magnificently sharp detail – as if this were the holy grail of photography.

All well and good. I admire and respect the quest for sharp, well-focused images and I also expect my own lenses to capture the greatest detail possible. But creative photography operates with different criteria, shuffled in a different order, where the ultimate goal is not achieving an almost forensic-like accuracy and sharpness of image, but in putting equipment and materials to the service of a personal vision.

And sometimes what we'd really like is a little less clarity, and a little more mystery. Deliberately unfocused images can reflect our own inability to gaze through all the muddle and clutter of the world. Sometimes the world is a deeply impenetrable place and partial or full defocusing – as opposed to 'accidentally-unfocused' pictures – can reflect this state of affairs.

Photographers have always played with depth of field: where the degree of focus within an image is determined by the aperture of the lens, and this can

be a rewardingly creative technique to employ. The area said to be 'in focus' has always been used to emphasise what we most clearly want to be seen by others. But how often do we ever throw the main subject out of focus, or perhaps deliberately put emphasis on to a seemingly innocuous minor detail to confuse the viewer and add visual 'value' to a background feature that disrupts their expectations or assumptions about what should be clear and what should not?

Sharp areas of any image can always be de-focused, but an unfocused image can never be made truly sharp again. Traditional darkroom skills can be used to defocus areas of an image, or the whole image itself with a tweak of the focusing knob. Other darkroom methods involve tilting the masking frame at a steep angle so that only a small plane of focus appears on the print.

With scanned, or digitally-captured images, Photoshop's wonderful gaussian blur can be used to defocus areas of an image. Using any selection tool with a feathering of 40+, will mark out an area you may want to de-focus, and the softness of the feathering will allow your editing work to merge gradually with the sharp areas of the image.

Images which feature focused areas and out-of-focus areas often display a greater perceived depth – they can improve a static 2D image into the illusion of a 3D image – and just like our eyes' inability to see everything in sharp focus simultaneously, from a few inches away into infinity, photographic image-making can utilise this technique with creativity and flare.

Using artists' materials and using materials artistically

In art colleges and universities the world over, art departments provide students (intentionally or otherwise) with unparalleled access to a host of fascinating materials and techniques, many of which the students are never likely to access in abundance again.

So when the photography department and art department collide, the fall-out can result in a creative laboratory of intense experimentation, which for some students, can change the whole course of their practice and future career.

The possibilities are endless. The important thing is to adopt a fluid and positive approach towards incorporating the artists' environment into your own ideas as a means of more powerfully articulating your ideas and themes.

The degree to which you mix and merge such materials into your work is naturally a personal choice, unique to you. The benefits of finding a working method using artists' materials, which finally and euphorically give 'voice' to a previously hidden vision, cannot be underestimated. The danger lies in allowing the materials to take over, or attempting to bypass what is in all honesty poor original source images.

No amount of over-painting, toning, bleaching, brushing, or over-printing can disguise a poor image in the first place, unless it is deliberately and completely obliterated, to be sacrificed to serve merely as a canvas upon which further workings can be created.

For the creative image-maker such an environment provides countless opportunities for experimentation and play:

Masking tape and other artists' materials can be incorporated into an image construction and presentation.

Gums and glues can be used for the construction of montages, or creating textures.

Rag papers, acetates, watercolour papers, canvases etc. provide different surfaces for image transfers, desktop printing and so on.

Discarded palettes or worked surfaces can be scanned as backgrounds, or textural images in their own right, or used in the presentation of images.

Acrylics and watercolours can be used for hand-colouring prints.

Brushes can be used for colour washing areas of the print, or applying bleach/toners selectively.

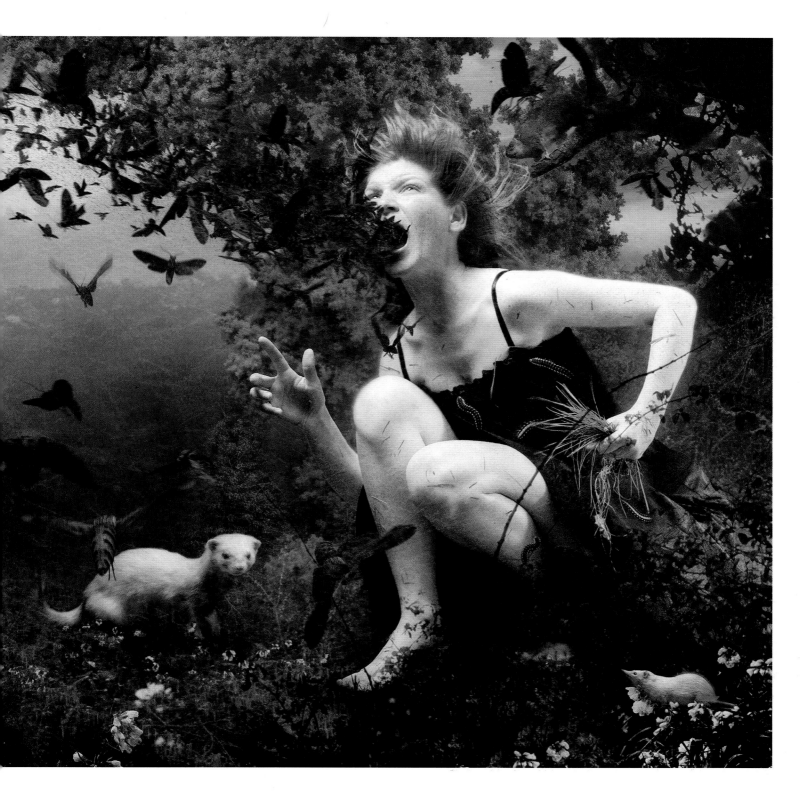

Janus CD, 'Auferstehung', cover and back: Alessandro Bavari
'The ability to mix digital and analogue broadens the creative possibilities that ten years ago were unthinkable.'

Creative use of the darkroom process

The darkroom is not ready for the graveyard just yet. The thrill and magic of seeing an image gradually appear in the dim glow of the safelight is fondly rooted in the experience of all photographers, even those I suspect, who spend the majority of their time currently in the company of the monitor and the mouse.

I should say at the outset of this section that specialist printing techniques such as Bromoil, Palladium, Gum Bichromate printing and the like are covered comprehensively by some excellent specialist books that are completely dedicated to providing thorough information on the chemistry and practicalities of these processes. Some of these books are mentioned by name in the back of this book. The following section provides a few starting points for adapting or extending the use of a simple black-and-white enlarger containing an ordinary black-and-white negative for more creative purposes. Further darkroom techniques are provided in the next chapter.

High magnification crop and enlarge
In the normal course of events, the photographer can be considered to be a selector from real-time moments, who observes the flow of life and captures an instance, which (it is hoped) will resonate with meaning and intensity for the viewer.

Sometimes we're driven to revisit our work with a willingness to look again at our past glories, but with a fresh perspective, as if seeing them for the first time through the eyes of a different artist. Take a 35mm slide mount to each frame on your contact sheet and isolate each image so that the images don't appear in competition with one another.

Scrutinise each image critically, select one image and enlarge it massively – crank that handle right up to the top and take a cropped selection of that image, a detail hugely magnified, birds in the sky for example. By raising the enlarger head up high, or even projecting an image across a darkroom wall, you can view your work in a completely new way.

Once printed, these blow-ups produce grainy images that have now become evocations, suggestions, like scenes seen through bleary eyes or tantalising hints of something made far more significant through being isolated and obscured.

Tilting the masking frame
By propping up one end of the masking frame (containing the unexposed paper) and focusing the image in the central area of the paper, it's possible to achieve prints with a narrow central plane of focus, with the remaining image area indistinct or seriously unsharp.

Curling the printing paper
Similarly, there's nothing to stop you experimenting with projecting the image on to a curled or warped piece of unexposed photographic paper. Decide where you will focus, and remember that used in this way, an enlarger lens will give depth of field in exactly the same way as a camera lens. In other words, the smaller the aperture (f.16/f.22), the greater the plane of focus, the wider the aperture providing the most shallow degree of focus.

Defocusing during exposure
Once your print exposure time has been established from your test strip, experiment by turning the focus knob slowly one way or the other during the last half of the exposure time. Images made like this show partial sharpness combined with a degree of blur.

Zooming in/out during exposure
Again, this involves adjusting the enlarger head height one way or the other during the last half of the exposure time.

Moving the paper during exposure
Whether you do this by rotation, or by moving the masking frame along one way left or right, the effects can be remarkable. Once exposure time for a straight print has been established, move the masking frame slowly and steadily (no sudden jerks) during the last half/quarter of the exposure time.

Softening the image
Using an old square soft focus filter (or a small square of plain glass 'softened up' slightly), hold the glass underneath the enlarger lens during the last part of the exposure time. Whether this is applied during the last half, or last quarter of the exposure time will depend on the degree to which your filter or piece of glass has been softened.

The effect is the reverse of what one would see if the soft focus filter were applied to a camera lens. Whereas on camera the effect would be evident in the highlight areas dispersing softly into the shadow areas, in a darkroom situation the shadow areas spill over into the highlights.

Double expose the paper
There are numerous ways of creating multiple exposure images, both digitally and photographically. One of the simplest and most immediate ways is simply to double expose the paper, either with the same negative turned upside-down or reversed, or by making a second exposure on your paper of a different negative altogether.

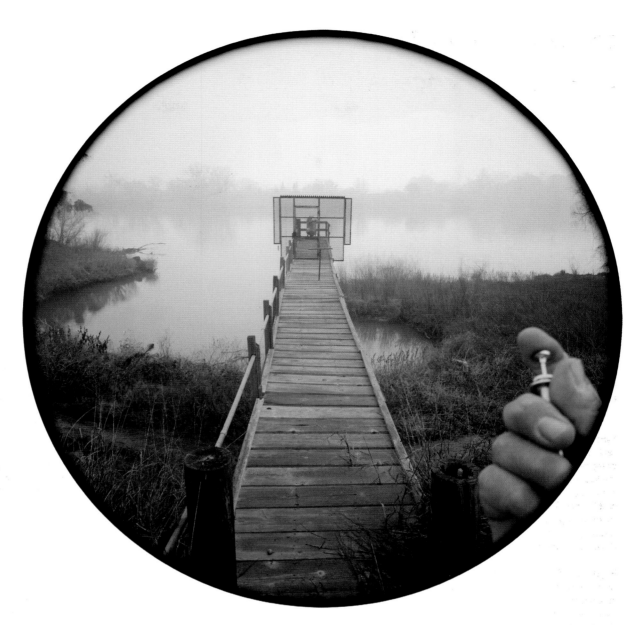

Along the Sacramento River, California: Kerik Kouklis

Does the inclusion of the artist's own hand within the image represent a self-portrait or a landscape? Or something else entirely? For Kerik Kouklis, the use of the circular image was a reaction against the panoramic rectangular format: 'The circle was as far removed from panoramic as I could get.'

'Photography has every right and every merit to claim our attention as the art of our age.' Alexander Rodchenko

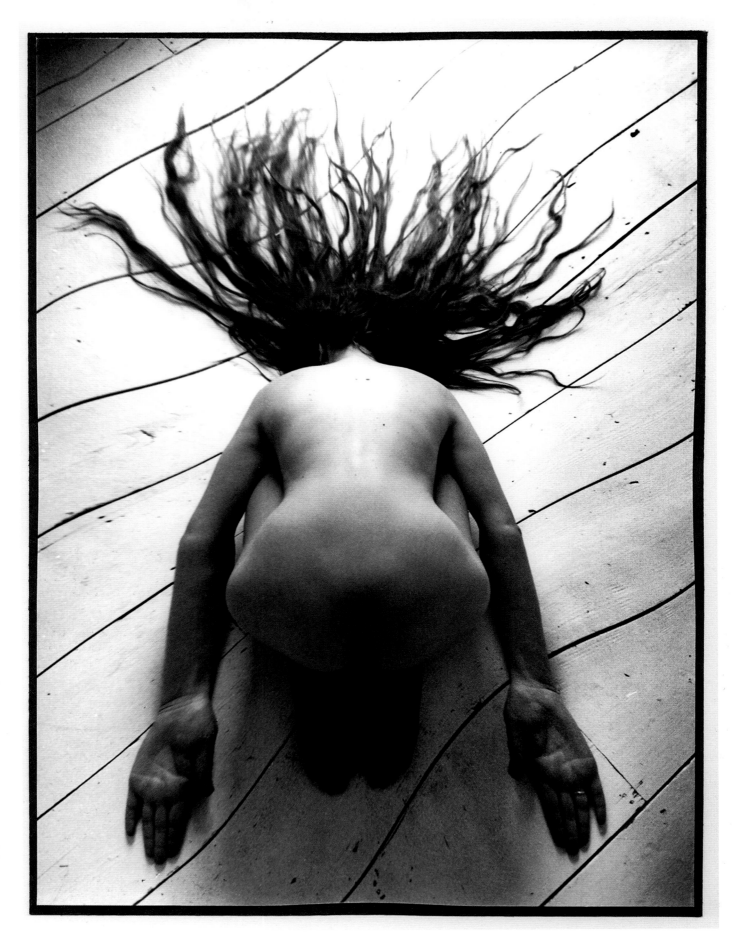

'Dodging and burning are steps to take care of mistakes God made in establishing tonal relationships.'

Ansel Adams

Depending on the density of your negatives, and the difference in density between the two, you will first have to calculate correct exposure times for each image, then reduce exposure times for both images when you make the double exposure.

Vaseline on photographic paper
Vaseline acts as a kind of barrier against the whole developing process, like a liquid mask only less precise and ten times more messy. Best used for abstracts, or when toning prints. Brush on the vaseline sparingly, with a finger prior to exposure and wipe off between stop bath and fixer, or leave on until fixing time is complete.

Experimentation of this sort is best carried out at the end of a printing session, before cleaning up, and definitely not as an unannounced surprise in a communal darkroom.

Prefixing photographic paper
Splashed-on, painted, or finger-smeared fixer will seal areas of the unexposed paper before being exposed and developed. These areas will therefore remain white since the fixer negates any effect the developer would have on the unexposed silver halides. Once the usual fixing time has elapsed, wash and dry the paper within the darkroom safelight environment before exposing it.

Again, this kind of experimentation is best carried out at the end of the day. And don't rush it – a wet masking frame or fixer-contaminated developer will only set you back.

Splashing developer
This is simply taking a less precious approach to the steady, dull rocking of the developer tray drilled relentlessly into most photographic students. With the application of a teaspoon, gloved hand, atomiser, or any number of other implements, begin to randomly splash or spray developer slowly in a careless-but-controlled fashion while holding your print safely above the developer tray and being careful not to splash anybody/anything else.

There will come a point when the effect overruns its time and what looks like the appearance of normal development takes over. With practice you can predict when this gloriously messy effect has reached its peak, and when you will then have to immerse the print into the stop bath to prevent further development.

Solarisation
One of the best-known darkroom special effects, and one which has been written about extensively. Put simply, it's like looking at a negative and positive simultaneously. With the right subject, it's worth trying out a few times, but its effect is so well-known and recognised today that it scarcely raises an eyebrow.

The process involves exposing a print for just under its normal exposure time. Then when the image is starting to appear in the developer, expose the paper to a small burst of normal light, literally a second or less, while in the developing solution. A slow but accelerating change will take place in the solution, giving the appearance of a silver-coated print. This effect is solarisation, and at this point the print is quickly removed and transferred to the stop bath to complete its processing as usual.

There are many variations on this basic procedure, but they all require a burst of light in order to achieve the solarised effect. In most cases it's a fairly unpredictable technique, so expect many failures along the way.

Creative use of Photoshop software

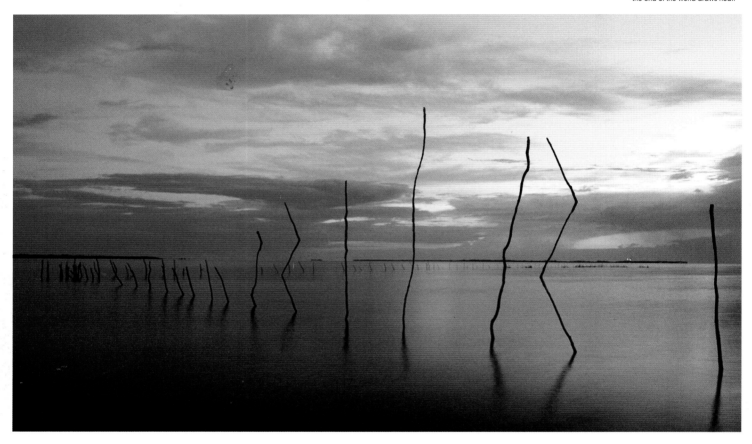

Photographers who are new to Photoshop's vast armoury of tools and techniques can behave a little like kids in a sweet shop, trying this, licking that, eyes wide open at the wonder of it all. It really is powerful stuff, and I often recommend that photographic students of an experimental persuasion spend a few weeks toying with it before attempting more serious project work. You simply have to get something out of your system – the instant joy of the distortion and warp filters, freakish effects with the Curves control, and so on. Becoming familiar with the screen environment, the concept of Layers, the History Palette and so on, is fundamental to its functionality and crucial to the 'flow' of our creative processes.

Once you can get this lot out of the way, you're faced with a massively powerful box of possibilities. Where do you start?

The answer is knowing what you want to do at the outset of your project, not relying on some fantastic effect to boost a flagging image that should rightfully be left untouched or binned. Your creative strategy is a product of your creative concept – why you took those pictures in the first place and what you were trying to say with them. Incorporated sensitively, Photoshop can aid the transportation of your vision with style and strength, or it can obscure and obliterate your work under a mish-mash of gimmicky special effects.
Many of Photoshop's best features mimic traditional photographic techniques anyway, enabling alterations in colour, tone, and softness instantly, and without the mess. As a starting point, I've set out a brief summary of the kind of creative strategies that Photoshop can assist with, along with some of the most useful techniques and features available to the photographer who is ready to edit their digitally-captured, or scanned images:

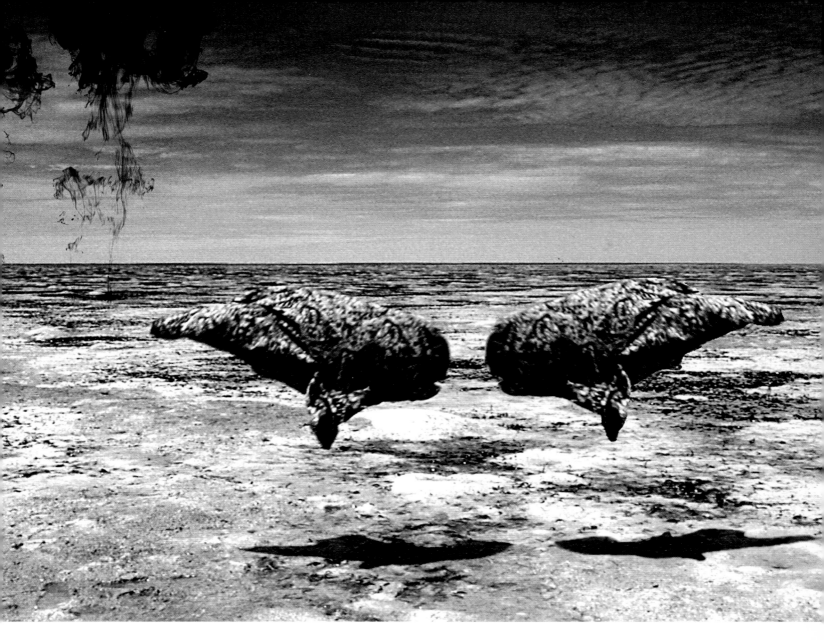

Back to basics

Before attempting anything 'experimental', always remember the first principles of photography – the notion of clear, bright whites and deep rich blacks. A grey or soft print can be improved by applying Levels to improve the overall contrast and density of the image, then add just a touch of the Unsharp Mask if necessary to boost the overall clarity of the image.

Positive/negative

With a simple click of the mouse you can view an image as a negative by going to Image > Adjust > Invert. Simply undo the move in the History Palette if this is not needed.

Repetition

Once basic techniques are mastered, complex montages can be constructed if required. Use selection tools to copy and paste elements into your montage. Each paste creates a layer above your original 'background' image (viewable in the layers palette) and these layers can soon stack up like the layers of a huge sandwich. Knowing how to make good selections and manage the resultant layers is a must if you intend to master Photoshop effectively.

Give emphasis

Use of gradients in empty layers above your background image can darken or subdue areas that guide the eye towards areas you determine. From the filter menu, lighting effects (Filter > Render > Lighting Effects) can be used similarly.

Blur

The gaussian blur filter can be a useful tool to disguise or reduce unwanted details, or to throw emphasis on to the sharp areas of your image. The blur tool from the toolbox can also be employed to soften sharp edges.

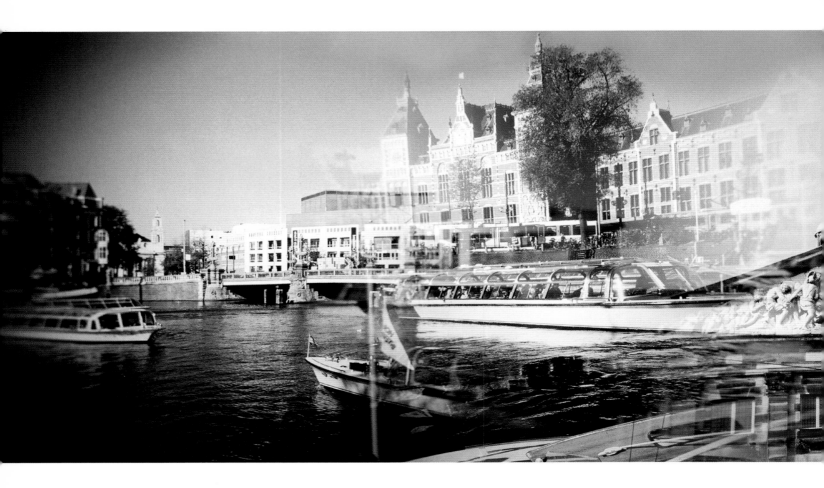

Increase grain/add noise

Digital images can be made to look more film-like by adding the effect of film grain. The filter menu (Filter > Noise > Add Noise) is your gateway here and you can apply the effect with subtlety or strength.

Change colour

Use Image > Adjust > Colour balance for subtle changes to your image or selection, then use Image > Adjust > Hue/Saturation for deeper changes to colour and colour strength.

To inject colour into black-and-white images, put the image into RGB mode (Image > Mode > RGB colour) if it wasn't scanned in RGB, then use Colour Balance to provide the basis for your colour experimentation, again, adding more extreme changes with the Hue/Saturation controls.

Duotones

Black-and-white photographers love the ease with which an ordinary black-and-white print can be transformed into a beautifully hand-toned classic at the click of a mouse. Put the image into greyscale (Image > Mode > Greyscale). Photoshop will then graciously ask you if you want to 'Discard Colour Information?', check yes, then go to Image > Mode > Duotone and use the dialogue boxes that follow to select a second ink.

Perhaps the best effects with duotones are created by selecting the kinds of inks that most closely mimic hand-toned prints – warm orange hues, subtle browns, or for cooler tones, blues and cyans.

Drop Shadow

One of Photoshop's least-used, but most effective features is its ability to place a shadow underneath a selection, which can be most effective when building a composite image. Unlike 3D modelling software, however, shadows won't follow odd contours or wrap around objects, it assumes the object or selection is to be pasted on to a flat surface, which can be limiting, but can also be used effectively in building montages where the drop shadow provides extra depth and three-dimensionality.

High pass and solarisation

The high pass filter (Filter > Other > High Pass) provides some beautifully imprecise 'fogging' effects on mono prints quickly and effectively. With the right image, the effects can be stunning. The solarise filter (Filter > Stylise > Solarise) attempts to achieve the look of a solarised print, but can be unpredictable.

Other filters/techniques for the beginner

Other areas that photographers and photo-artists might like to explore include:

Mosaic (Filter > Pixelate > Mosaic).

Diffuse (Filter > Stylise > Diffuse).

Transforming selections (copy and paste your selection, then Edit > Transform to explore the submenu of flipping horizontally and vertically, rotating, re-scaling and generally how to really push things around).

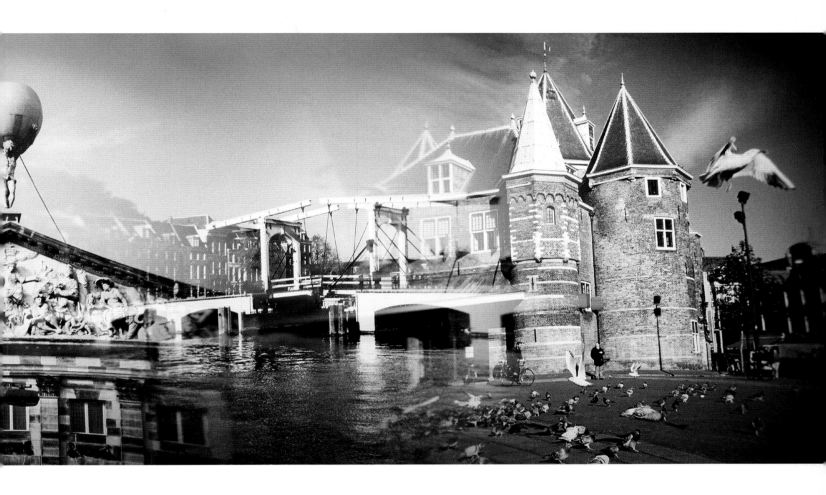

Summary

**To many image-makers the creative possibilities offered by the merging and mixing of digital with traditional techniques are profoundly exciting.
To others, it's as if the two realms dilute the power of each other, so that the resultant imagery becomes neither one thing nor the other, just process-led pastiches of pre-existing imagery.**

Amsterdam: Bob Karhof

For many of his images, Bob Karhof creates his own cameras to convey his vision and his passion for the medium of photography. For this image, he created one that blends five different exposures into one panoramic image in order to more accurately represent the experience of a multitude of moments in sequence. 'To me the art of photography is not about capturing reality in one shot that represents all. It is about challenging time and space and the borders of photography... An experience, or how I perceive an experience, is formed out of a multiple of interpretations.'

The responsibility for the image-makers who incorporate both fields into their work lies in the strength and vigour of their ideas, allied to judicious and sensitive choices where media and technique are concerned. Part of the problem lies in the fact that computers are perceived to be everywhere, hybridising this, co-ordinating that, reducing things, always transforming and appropriating things, when all they really amount to are just boxes which are fed by humans. What comes out the other end is directly related to the quality of what we shovel in.

Some critics sneer at digital image-making, mocking the lack of 'craft' involved, and complaining that the images say nothing new, forge no new sphere of artistic endeavour, and have no discernable soul. We are entering a new era where some kind of aesthetic still has to be found for digital image work. The computer is still just a tool, like any other, and knowing when to use it, where to use it, and how to use it is the same as knowing how and when to wield a mallet and chisel.

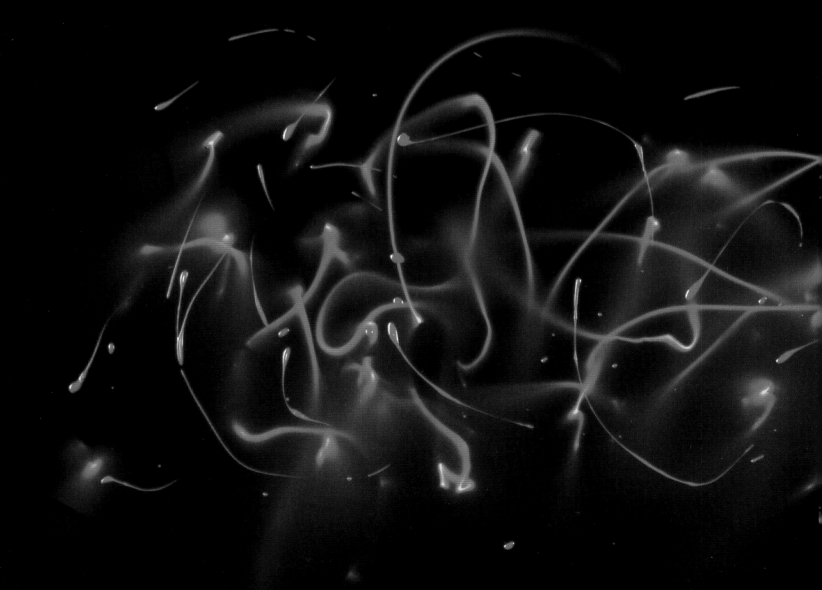

**Light Painting Dragon's Blood
Red, 2002: Rob Carter**
Coming from a photographic
background, Rob Carter began to
develop the Photogram in a highly
creative way. Each image is a
one-off, totally unique artwork.

Chapter 3
Cameraless Photo-Art

To many students of photography, the notion of 'cameraless' photographic art seems an impossibility – like painting without the paint, or sketching without the paper. This notion is based on the false assumption that only a camera can create a photographic image.

By looking at the whole range of traditional and contemporary image-making equipment, it soon becomes apparent that this simplistic notion is all but redundant these days.

This chapter looks at some of these image-production processes – some darkroom, some digital, many of which will be instantly familiar to some, and others which are not strictly 100% 'photographic' in nature, but hugely relevant in that they produce images that retain a photographic look and feel, and can be easily incorporated or adapted within a photographic project.

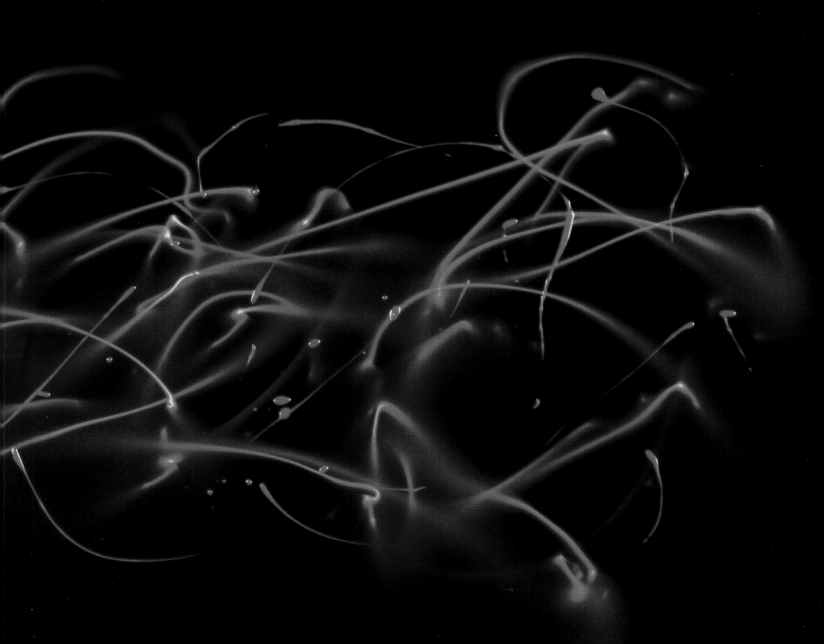

Photograms

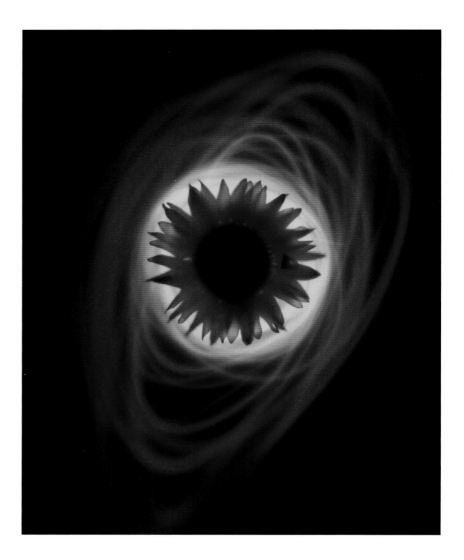

Probably the best-known photographic process that produces images without the need for a camera, the practice of making photograms is often used as an introduction to the black-and-white darkroom and as a means of demonstrating the simple principle of the action of light on photographic film.

By laying a group of objects on top of photographic paper, then exposing that paper to a timed burst of light from the enlarger, the resulting processed image shows white areas where light hasn't reached the paper (blocked by the objects' non-transparency), and black areas where light has exposed easily the paper's uncovered surface. The result is a silhouette, but in reverse.

The effect is similar to using a simple cardboard template to spray paint over. Aerosol paint will reach the paper or wall surface if exposed, but will be blocked where the template or mask was placed, thereby leaving an image of the template's shape where no paint has reached. Substitute light for spray paint, and object for template, and you begin to get the picture.

Objects that have semi-transparency such as glass, plastic, newspaper etc., will produce a negative of themselves as light is both passed through here, or blocked there, depending on the varying light-transmitting characteristics of the object itself, and objects which are not in direct contact with the paper or emulsion surface will show partial shadowing.

Some photograms take on the appearance of X-ray-like images, with semi-transparent objects rendered in reverse. As students come to appreciate that a negative creates its own template of varying degrees of transparency, they quickly make the association necessary to understand the simple photographic principle of negative/positive, where opaque or non-translucent areas of a photographic negative produce white or light tones on film, and transparent or highly translucent areas give dark or black tones due to the ease with which light can 'burn' into the film's emulsion. Quite simply, black = white and white = black.

Creating photograms is technically very simple, but artistically hard to be truly impressive with. Firstly, establish your exposure by means of a simple test strip, as you would when printing a black-and-white negative. Once you have good rich blacks and pure whites, with good overall contrast, you can begin to make them freely and fluently, adjusting exposure time if necessary according to the density of your chosen objects. From a purely practical point of view, it makes sense to construct your photograms on a piece of glass, under which the photographic paper can slide when ready, particularly where complex or unrepeatable arrangements are concerned.

Photograms are the ultimate proof that light is the real medium of photography – not cameras, lenses, chemistry, or film. The process of creating a photogram, however, is the opposite to the usual route taken by the traditional camera-operating photographer. Whereas the camera photographer begins with everything available in the external world, then subtracts to a point where he/she captures a fraction of it all, the photogram creator begins with nothing, then builds slowly by adding elements to a composition to create, in effect, an alternative world created exclusively by the artist, from nothing.

This difference shows clearly how the artistic image-maker can utilise the process of photograms in order to reflect internal concerns or personal views of the world which 'straight' photography could not address. Photograms can also be scanned and digitally edited, to continue this additive process of image construction.

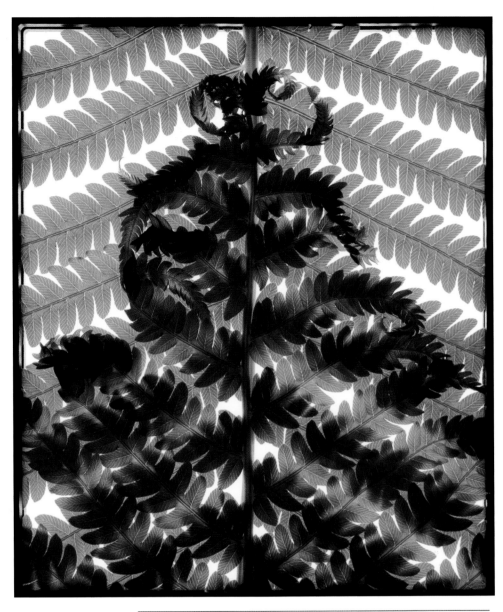

Untitled: Rob Carter

This is another beautiful photogram by Rob Carter.

Fern 1: Bill Westheimer

'Our world is filled with objects that have been rejected, are broken, or have outlived their usefulness – the unwanted. But I want them. I recycle this detritus into pictures that are vibrant, lyrical and mysterious. Broken glass becomes jewels, weeds become dancers – the familiar becomes unfamiliar and the viewer must look, and then look again.'

Extending the practice of photograms

Once the basic principle is understood, and simple enlarger-lit photograms can be produced of everyday objects – keys, glasses, plastic lighters and so on – it's time to take things further still and consider ways of developing photograms as an expressive medium. These could include:

Different lighting styles — use a pen torch to light paint for example, giving you more control, or light from different angles, different distances to the objects, try flash at a distance, from opposite ends of the room.

Consider using liquid emulsions or toning your photograms.

Use scratched acetates, OHP transparencies etc. to build up layers or several levels of different light penetration.

Use liquids, paints, oils etc. in a clear plastic tray, or in the bottom of a square fishtank.

Move your subjects during exposure — with longer exposure times, capture the journey of a small wind-up toy across the paper, or slowly move your subject during exposure.

Try pre-folding then unfolding the paper, or distressing the surface in some way.

Colour paper can be pre-exposed with a colour cast before making your photogram (this would have to take place in complete darkness, without the assistance of black-and-white darkroom safelighting conditions).

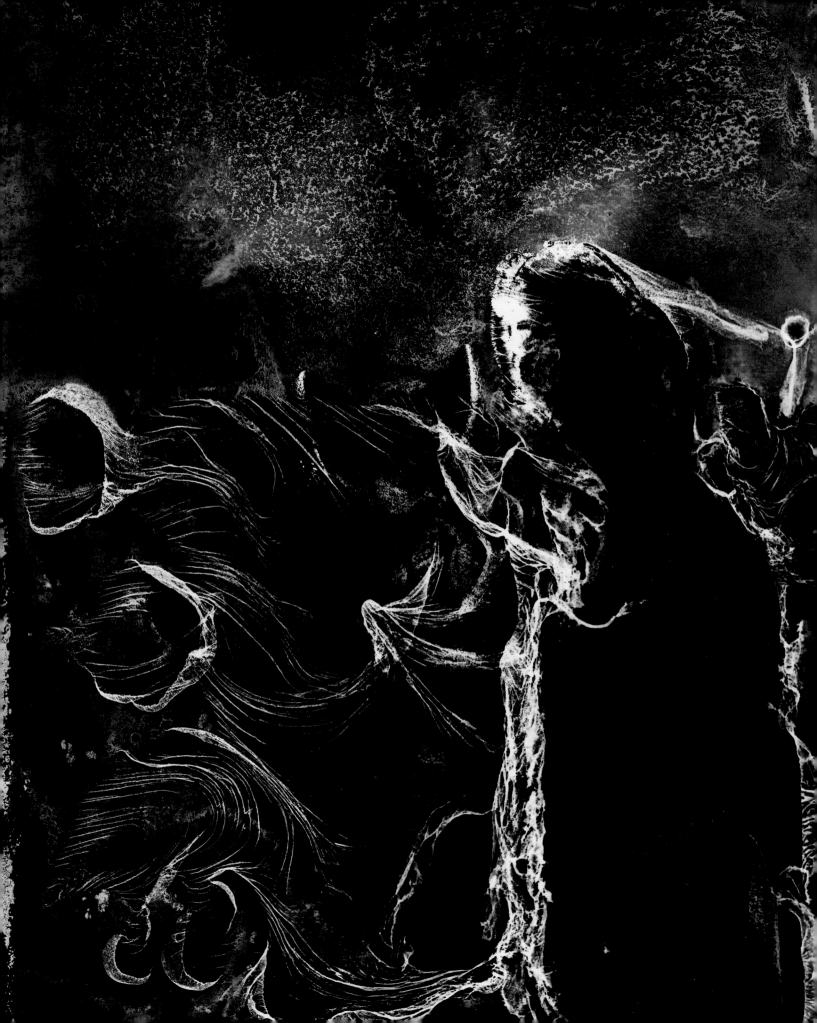

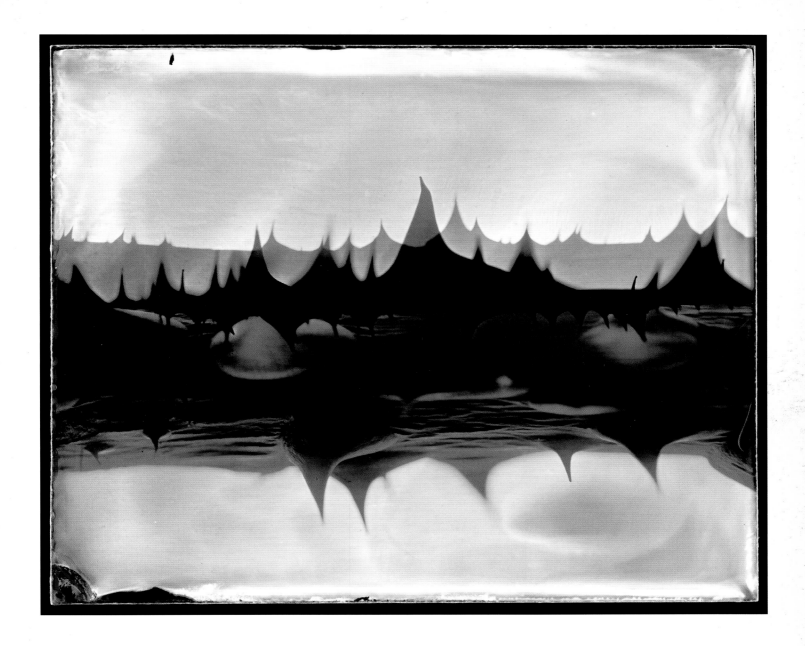

Image from 'Primal Matter' series: Lisa Folino

'I wanted to push the boundaries of the photographic medium, both physically and metaphorically, I wanted to transcend the lines between photography and two-dimensional media. Many years as a jazz musician served as inspiration for this body of work.'

Rose Cane 8: Bill Westheimer

'This image is a photogram. One piece of rose cane was placed inside the enlarger on the negative carrier and projected on to a 4.25"x5.5" collodion glass plate. Another piece of rose cane was placed on the surface of the plate during a part of the exposure. This glass plate was scanned with a flatbed scanner.'

Experimentation with cameraless images like this extends back to the 1700s, and then again in the mid-19th century with pioneers such as Henry Fox Talbot making full use of this newly-arrived art of photography. It found a natural home with the early surrealists whose abstracts inspired the great Man Ray to produce his famous 'Rayographs', and during the 1920s Laszlo Moholy-Nagy adopted the technique as a further development of his work.

Contemporary artists such as Root Cartwright and Cynthia Young have used photograms to successfully articulate highly personal visions, so any photographer who looks down on the idea of such darkroom tinkering should think again. A dedicated and determined approach to exploring this technique has resulted in personal and critical success (for some), as evidenced by the heavyweight reputations of past practitioners and by the proof that it is still a much-visited and valuable form of expression used by some of today's cameraless image enthusiasts.

Photocopiers

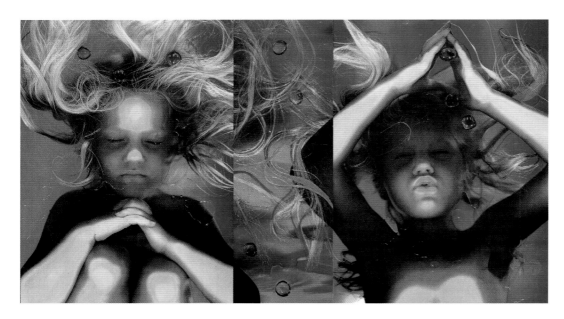

Luna: Lieve Prins

Many of Lieve Prins' themes are inspired by ancient art, visions, metaphors, and symbols. She can work 'like a painter', constructing her images like building blocks from A4 and A3 copies.

To many artists during the '70s and '80s, appropriation of the photocopier represented the victorious abuse of an essentially capitalistic tool of the establishment. The appeal of instant multiples meant that contemporary artists from Andy Warhol in the '60s and many more since, have seen the creative potential for an instrument that does not use a lens, but that somehow produces very crude, photographic images in scans, once a beam of light travels across the underside of a smooth glass plane.

Most artists have at one point or another at least thought about using or incorporating photocopier art into their work, even if only as reference or supporting materials. Those that really take to this piece of machinery make much use of the look and feel of the images' softness and strange lighting effects whereby objects lie flat on the glass surface of the copier, and often reveal interesting shadows behind due to the copier 'hood', cover, or a specially created background resting at some distance from the glass, out of focus, above the photocopied objects.

Other similarly 'unnatural' lighting effects are created by too much contrast when an object shows excessive brightness when in contact with the glass, but shows deep shadow if raised even a few millimetres above the glass copying surface.

To fully appreciate the skill with which photocopier artists can realise and assemble their works, it's necessary to go beyond our normal prejudices against the type of grim imagery which we usually assume such endeavours will

produce. Dutch artist Lieve Prins is one of the most well-known and respected practitioners of Electrography – or copy-machine art – to the rest of us. Her works are vivid and colourful montages constructed with great patience and artistry, and she has explored its creative possibilities for two decades.

As a collage-producing medium, she can realise her themes of mythology, fertility, eroticism, and so on with instant feedback from the kind of action-reaction loop which the tangible immediacy of this medium provides. To Lieve Prins, the modern colour photocopier is a 'magic box, time machine, instant photo studio, miniature theatre' – all in one.

Other practitioners such as Shirley Watts and Joe DiStefano have created meticulously-detailed works which mix painting, tiled photocopies used as a kind of base layer or canvas, and arrangements of architectural details to create human forms. Even conceptual artists have got in on the act – playing with themes of authenticity and multiplicity, decay and uniqueness. I believe there is also a museum dedicated to photocopy art at the Museo Internacional de Electrografica at Cuenca, Spain.

To any artist inspired by the use of copiers, it surely takes real dedication to go beyond the kind of trial experiments that most beginners would work with. Since the advent of the digital medium, most artists have progressed on to the scanner as the natural successor to the photocopier, and contemporary artists who use their scanners in a similarly artistic fashion have a lot to be grateful for; that the clumpy old photocopier paved the way for that little desktop marvel that now sits next to the monitor.

Scanning objects, textures and backgrounds

The modern all-singing, all-dancing desktop scanner sits proudly on our work stations, waiting for instruction. Within seconds, an arrangement of objects can reach our screens (or direct to the printer) and the results can be instantly responded to. To some artists, wary of purchasing an expensive digital camera, a desktop flatbed scanner can make a very useful and very versatile method of digital capture.

In the world of cameraless art, flatbed scanners are most useful for creating still life images, abstract collages, or for digitally collecting elements which will be incorporated into larger works, perhaps at another time. Like their close cousin the photocopier, they can turn photographers and those who work with 2D images, into hunter-gatherers since they allow artists to build collections of potential backgrounds, textures, or objects as they go, taking bits and pieces from their environments to use or save for later.

Like photograms, scanner images can be created directly on the scanner bed, with all the elements of the image present at that one time. More commonly, a scanner is used to scan individual elements with a view to assembling them later on a predetermined background or image.

Stage 1 – Image capture

Although most scanners will give about 2cm of sharp focus above the glass bed, in order to make scans of individual 3D objects most effectively, you'll need to take one or two precautions before you start. Firstly, you'll need to cover the glass bed with clean, clear acetate film to protect the glass bed from scratches. You'll then need to remove or open the lid, and create a plain white background above your object(s). The purpose of this is two-fold. Firstly it'll prevent extraneous room light from affecting the scan, and secondly it will make selecting the object in your image-editing software much easier once the scan is successfully made.

The white background can be created by any number of methods. Some photographers work with a shallow shoe-box lid with a white interior, others (depending on the subject) use white cotton or cloth, which can be loosely draped over the arrangement or object. Once you preview your object in the scanner software, be careful to crop out as much white as possible as this can confuse the exposure of the scan in much the same way as a bright or snowy scene can confuse a camera exposure meter.

Scanning resolution is one of those technical areas of expertise that – like a working knowledge of the scanning process itself – need not be understood in depth. However, even a scant knowledge of the basics will be helpful to build upon. As a general rule of thumb, a flatbed scanner providing an A4-sized scanning bed will produce sharp and detailed results at 300dpi.

Stage 2 – Editing and enhancement of the scan

Scans which are created as one-off assemblages or still life compositions have to be edited digitally so that their pictorial quality can be maximised. This generally requires adjustment within Photoshop since it is highly unusual for scans to reach the desktop without requiring further editing work.

These adjustments usually entail alterations to Levels (beware of 'clipped' scans where the histogram shows missing shadow or highlight pixels), perhaps some minor adjustments to colour balance, sharpness, saturation, and so on. It is really up to the artist to create the highest quality scan, then the highest quality image, before anything more experimental is attempted.

For scans intended as isolated objects for montage, the process is a little more involved since the photographer must select the most effective tool for isolating the object, then proceed to make a clean selection of it. Always make a duplicate copy of your background image by dragging the background layer on to the 'Create New Layer' icon at the bottom of the Layers palette, before doing such work. It protects the original if things go wrong.

To prevent the rather flat appearance of many digital montages, use the drop shadow dialogue box with its controls over shadow softness, lighting angle, and so on, to really give some three-dimensionality to your montage.

Image transfers

Image transfers quite simply enable an artist to transfer one image on to another receiving surface; be it paper, cloth, or other absorbent material. It requires that the source image and the receiving surface are prepared in a certain way (according to the properties and characteristics of the materials involved), but as cameraless art it's a lot of fun when it works.

There exists an extensive range of techniques that require far more detail than can be accommodated here – for the purposes of this book, it is best simply to introduce the concept now and allow students to delve deeper if they wish to do so, using the resources in the appendix as a start. Incorporating a much-lamented element of craft into image creation, the techniques employed are briefly outlined here and can be applied to one's own imagery as well as other media in a variety of image transfer processes.

The appeal of such images for their creators is largely in the creation of a different, more muted atmosphere to the image, one where grain, colour changes and texture are all of greater visual significance than sharp detail or descriptive clarity. Such images often impart an aura of quiet calm and classical, timeless authority, or when used with multiple transfers on to a single surface, they build complex, richly-patterned abstracts.

Image transfer techniques:

Magazine transfers
By coating a glossy magazine page with solvent (water to start with, if this doesn't work, move up to white spirit), it's possible to dissolve some printing ink before pressing the page firmly and evenly against a thick absorbent receiving paper, in whole (with a roller) or in part (by using a blunt tool to work on small areas). It's a bit hit-and-miss, but once you are on a roll it's possible to create some interesting backgrounds for over-printing, or building up intricate montages.

Newspaper transfers
The knack here lies in applying your solvent so that the newspaper is damp, not soaking wet. Trim the cutting to size then tape down along one edge so that progress can be checked without moving its position above the receiving paper. Use cotton wool to apply the solvent to the back of the newspaper by hand pressure only. If your newspaper cutting is taped into position, you can easily sneak a peek by lifting up an edge to check progress.

Black-and-white photocopier images
These can be transferred in a similar fashion, but which type of solvent to use will depend on a trial-and-error approach depending on the nature of ink used.

Laser copy and inkjet transfers
As above, inkjet prints can be transferred remarkably easily with very simple solvents, although many modern colour copier inks can be unpredictably stubborn or deliciously stable (depending on whether you're an artist or a copier ink manufacturer!).

Polaroid transfers
These are made by peeling the negative portion of a polaroid image away from its attached print immediately after exposure and pressing it against damp receiving paper with a roller. Timings for such techniques are critical, but the results can be dramatic.

Polaroid image transfers are by far the most well-known type of image transfer technique available, and further information on such techniques can be obtained from Polaroid, as well as a vast number of independent publications.

NB In all these processes, good health and safety practices should be observed. Always follow the safety precautions on solvents and work with plenty of ventilation and in situations where such work can be carried out safely.

Family Closet: Donna Fay Allen
'For me, creative vision is about seeing possibilities.'

Image transfer tools and materials

Receiving surfaces such as printmaking paper, watercolour papers etc.	Cotton wool and brushes for detailed work.
Rollers for press-rolling source images on to their receiving surfaces.	Variety of solvents necessary for priming the source images, or receiving surfaces. These range from water, to white spirit, to acetone solvents, and clear gels.

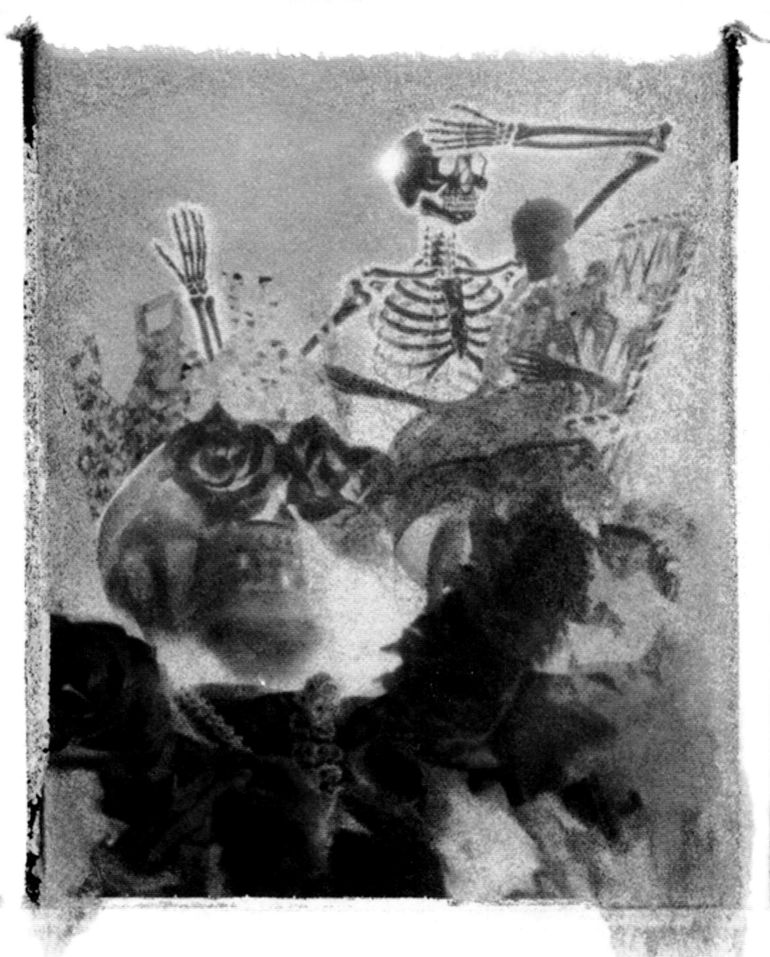

Printing through

'With care and planning, double exposure prints and montages can be created which exceed the limitations inherent in these processes.'

Intricate leaf patterns, insect wings, feathers, newsprint, loosely-woven cloth can all be placed in the negative carrier of a simple black-and-white enlarger and projected on to photo-sensitive paper. These flat, translucent materials take the place of a traditional negative and their varying densities make them usable templates of opaqueness and transparency just like a traditional film negative.

For these images, this technique bypasses the necessity for a camera lens to capture the subjects, and once correct exposures are determined, it becomes possible to extend the technique further by over-printing such images on to pre-exposed (but un-processed) traditional monochrome prints.

Images produced by this technique are in effect, a kind of projected photogram, and despite their simple elegance, the danger of becoming process-led or using unoriginal, tried-and-tested subjects is ever-present.

Use it with originality, or combined with other processes, and it could be a valuable creative ally. Such practices could include scanning and digitally editing the resulting prints, or constructing a larger tiled display of small prints to create one large piece of work.

Printing slides and colour negatives as black-and-white prints

Wings: Donna Fay Allen
Printing through the wings contained within glass slide mounts allowed the creation of a negative, which was then contact-printed into a positive image using warm-toned fibre-based paper. Of her photographs, Donna says: 'I believe that part of my fascination is to capture some of the emotions the discoverers of the photographic process might have felt. Each image seems a small marvel.'

This can be achieved with a very simple darkroom set-up and I've seen results that range from the truly awful to the truly astonishing.

Printing a slide or transparency with a black-and-white enlarger will obviously produce a mono negative print. The trouble is, the colours don't translate easily into our expectations of black-and-white tones, so the results can be patchy to say the least. They can also show excessive contrast, which the traditional multigrade system finds hard to cope with.

That said, some interesting special effects can be achieved with graphic images of non-specific subjects, and these can inform later works or be re-scanned and adopted as montage backgrounds or base canvases if required.

Colour negatives, under normal circumstances, do not produce black-and-white prints when processed in the black-and-white darkroom due to many of the reasons given above. They also contain an orange mask that disrupts the whole process further.

Although there are specialist materials on the market, which allow for the printing of colour on to black-and-white papers, the best type of imagery to use for such work usually involves simple, clear, graphic subjects as opposed to colour negatives which are busy, cluttered and indistinct. Again, with care and planning, double exposure prints and montages can be created which exceed the limitations inherent in these processes.

Computer as camera – the art of screengrabs

It often amazes me that so few artists use screengrabs in their digital artworks. A simple mouse click freezes what's on your screen in an instant as if a camera lies inside your monitor taking its pictures from behind the screen. For the Mac you hit the Shift key + Command key + 3, simultaneously.

Of course, it's not what you've got, but what you do with it that counts, and screengrabs on their own are nothing much to shout about. Merged and mingled with other screengrabs, however, within a self-reflexive body of work (i.e. digital art about digital art), could perhaps trigger some very interesting outcomes using the visual language of the monitor screen (i.e. its tools, progress bars, dialogue boxes etc.) as the basis for experimentation.

Naturally, any such work requires compliance with all current copyright law before other people's imagery can be appropriated in recognisable form for such work. Better still, re-work some of your own digital imagery into new forms using the screengrab technique. With an open-minded and fluid approach to experimentation, it's possible to weave together screengrabs from other software interfaces, 3D modelling meshes, even the scroll bars and toolboxes of quite ordinary word-processing programs could be employed, using the integrating power of Photoshop to select and combine the layers.

Neg Machine 5: Jeremy Webb
One of a series created from found materials that underwent a series of copy, paste, and flipping manoeuvres within Photoshop to achieve the stark graphic quality.

Notebook scan: Jeremy Webb
These digital 'doodles' were the result of experiments with screengrabs, merging and layering various elements together, and although they are still 'on the back burner', I keep small reference prints nearby for when further inspiration strikes.

Summary

in an accessible context. This makes it harder to piece together a coherent history of cameraless photography such as it is, or to trace its diverse threads of experimentation probing away through the decades under the more visible weight of 'traditional' lens-based photography.

Most of these artists stick to purely photographic processes, others use digital technology to assimilate and organise their imagery, or as a means of presentation. The digital era once again offers up yet more opportunities to extend the practice of cameraless photography through its capabilities for instant capture-and-view, and multiple means of distribution, collaboration and presentation.

There are a great many photographers and artists out there who all use their cameraless photography to express their creative vision, each one as unique as the artist themselves. The work of these artists proves (if such proof were needed) that a lens is not entirely necessary to photographically communicate an expressive and individual voice to the world. What it takes perhaps is the imagination and motivation to think laterally about the action of light on surfaces, about time, movement and abstraction, and about what might just be possible if we allow ourselves to explore our inner visions with rigour and personal insight.

If the whole idea of cameraless photography is a new concept to you, you won't be on your own. Because of the range and variety of its many forms it has quite naturally fragmented and dispersed widely with only the occasional gallery show pulling together some of its better-known successes

Chapter 4
Montage

Montage has held hands with the practice of photography for a long time. Virtually since the birth of the medium, photographers have identified and exploited the medium's ability to mimic the perceived reality of a photographic image, create something fantastical or surreal out of the everyday, or use montage to transmit a slick piece of cause-related propaganda. As a political weapon, the success of montage lies in its ability to communicate something simple and immediate, presented with directness and stark economy. To many, it's the photographic equivalent of the cartoon or caricature, where anything is possible and anything can be said.

It still surprises me that montage is as popular today as it seems to be. In these early years of a new millennium it becomes harder and harder to be impressed by any image contained within a rectangular box. We've been exposed to special effects from Hollywood, high impact advertising and every stroll down an urban street subjects us to the processing of several thousand visual messages for our brains to assimilate. How can montage (as yet another mode of visual communication) still be impressive?

With computers it has become easier still to bypass all that sticky glue and scissors nonsense with a simple cut-and-paste montage. Now that it's easy to do in Photoshop, does that make it any more potent? Any more powerful? Or is it just another technical gimmick best left alone? Montage is best put to the service of specific ideas or concepts, designed in the mind from the outset – not casually thrown into the mix whilst idly doodling with an image on your screen.

Photoshop is a powerful and very convenient tool for creating montage. But it is everywhere. As a creative technique it can't be beaten for sheer fun and communication effectiveness. It means the image originator can have complete control of the process and if an image is impossible to create from the usual shoot and process route, literally anything is possible with a spot of montage.

Use it carefully however. You really do have to ask yourself whether just because something can be done, does that mean that it should be done? As the creator of a montage, are you able to offer something uniquely different, does it service your personal vision or just add to the mass of manipulated imagery which is spawned by a million Photoshop users every day?

Untitled: Jeremy Webb
The raw materials came from specimen jars photographed in a biology lab at the college where I teach. I tried to create a symmetrical and highly structured pattern from the various parts floating in their jars and attempted to invite the viewer to recognise and respond to the shape and pattern first; before any recognition of what the image is actually composed of.

Montage

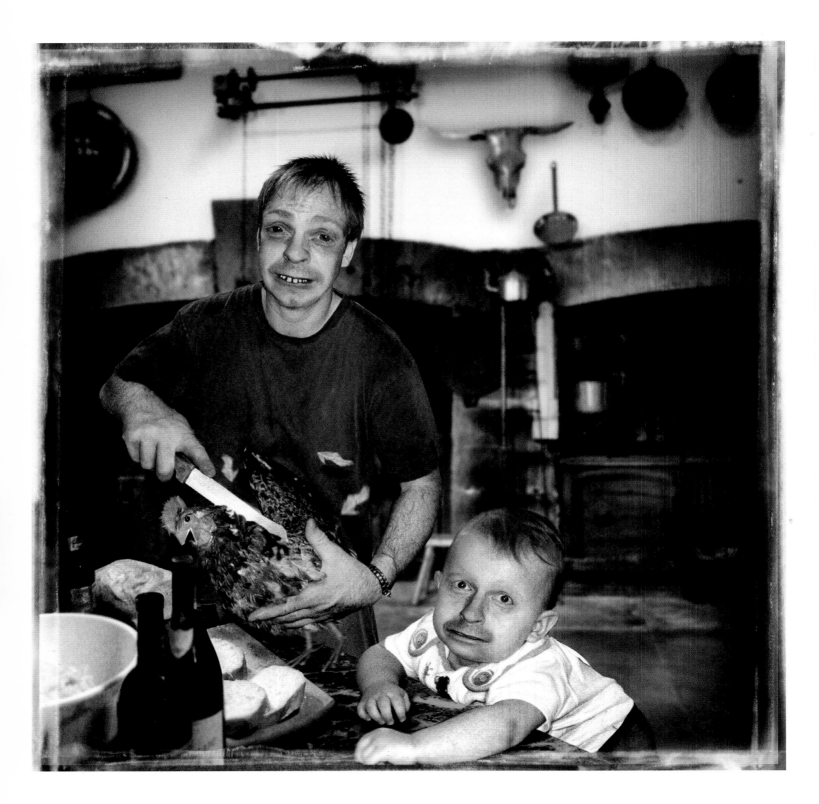

The Sadness of Dinner (Western Gothic series): Patrick Loehr

Patrick Loehr came to reject photography as a means of documenting subjects, preferring instead 'to use photography as a medium for creating subjects'. His digital images are carefully composed from many different negatives, often working with 15–20 separate layers in Photoshop.

For originality in this field avoid fairies, angels, woodland nymphs, anything with wings, anything flying, or any of that mythological stuff which gives digital montage such a bad name.

Use it to say something you feel passionate about, smack them in the face with the truth. Develop a theme which will grow and spawn new, further ideas to create a unified body of work rather than a jumble of one-off stunners.

And decide at an early stage whether the means of production will be evident to all, or disguised as if to 'fake' a real photograph – this approach will help you to develop your own unique style.

Don't be tempted to throw too many ideas into the pot. Stick to the inclusion of only a few elements unless your montage specifically calls for a larger collection of elements.

Bring out the designer in you – incorporate other materials, acetates, cloth, text, transparent materials etc.

Exercise: Spontaneous montage

Sometimes that blank piece of paper is just too scary! If you're feeling a touch self-conscious or artistically inhibited at the prospect, try a little fun to loosen you up by building a montage based on one of your personal themes or interests, or select one of the themes below if you prefer something less close-to-home

tactile	inversion	intimate	burst	infant	benign

Try and work fluidly, with a completely open mind. Make a commitment to ditch any thoughts which relate to outcome, end product, or negativity. Instead, start tearing out pictures from magazines or using your own imagery and build a montage intuitively. Let it take its own course, find its own route, rambling and unspecific if necessary. The important thing is to go through the process as uninhibited as possible – even if you stray from the original idea.

If inspiration still seems some way off, ask yourself in all seriousness, whether you've been conditioned by art snobbery or the current vogue for documentary 'realism' and other notions of 'high art', or whether you've actually had the opportunity to play in such a way without those critical voices nagging away at you. There is still hope, but you'll have to kick those nagging voices into touch somehow.

To refine your thoughts further, ask yourself which of the following appeals more to your artistic intuition:

Montage that attempts to fool us, to cover its own tracks, faking a photo
or
Montage that makes no attempt to hide its fakery, even enjoys its deception?

Montage that appears to be deliberately surreal
or
Montage that appears to convey a real happening/occurrence?

Montage of the high impact, slap-in-the face variety
or
Montage of a quieter, softer, more subtle style, intention and meaning less penetrable?

Montage and design

'Of course, there will always be those who look only at technique, who ask "how", while others of a more curious nature will ask "why". Personally, I have always preferred inspiration to information.' Man Ray

Whether traditional or digital, the issue of how and where to place these assorted elements into a composition is something that all artists have to grapple with. Without attention paid to the overall design, the montage can appear slapdash, lifeless, or sloppy – or worse, all three. Give your montage a defining structure to hold the elements together in a dynamic arrangement and the montage becomes engaging, memorable, and strong.

There is a huge range of design 'templates' and strategies that can be used by the photographic artist to build a montage, avoiding the appearance of a scrapbook page where the only recognisable style is the disorganised tumbling of bits and pieces on to an empty page.

A kind of back-to-basics approach to simple design principles helps, and here's a couple of design ideas to begin with, aimed at providing a few structures or templates for more compelling montages:

Spiral leading the eye • Symmetry/mandala • Dynamic use of space •

Radial convergence • Rule of thirds • Repetition • Movement

It's my own personal experience that some photographers need a little help in this department – intuitively using their fine compositional skills when clicking the shutter and abstracting from a bigger picture, but somehow at a loss when preparing a framework for the blank page. Collecting a range of these ideas or templates together is easy enough – as a personal library in a notebook for example, or simply tucking these gems away for future reference to use them as and when required.

The Uncertainty Principle, #10–8: Warren Padula

'In the viewfinder of every camera there are lines, dots, icons, grids, and other information superimposed over the image. You're supposed to ignore the overlay when you make the photo. There's an illusion of science in the viewfinder that is lost in the print. So I use my own rudimentary vocabulary to restore the feeling of the viewfinder.'

Untitled – part of Folded Axis Study: Jeffrey D. Mathias

'The image is made from two negatives exposed at different moments or under different conditions from the same camera position. Prior to this, an axis is discovered upon which the image will be folded completely on to itself. This is accomplished by printing with both negatives simultaneously with one negative reversed. Consideration is also made during exposure and processing of the films for the combined density of both films as they will print with the Platinum Palladium process.'

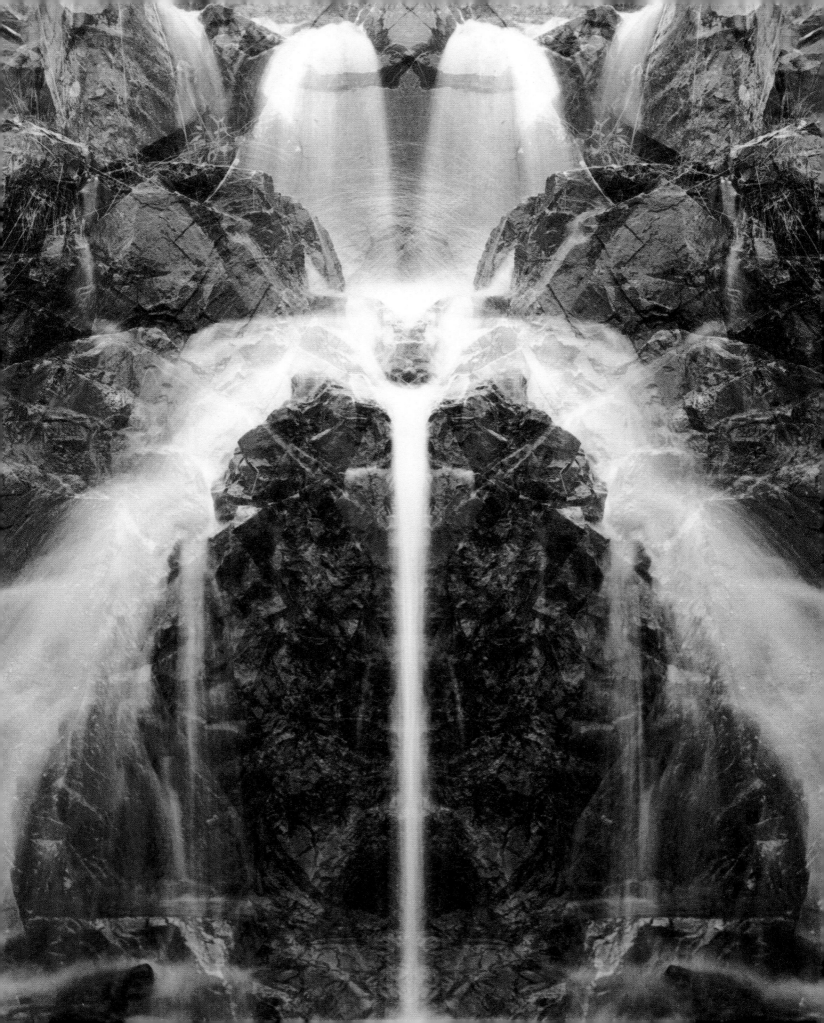

Traditional techniques

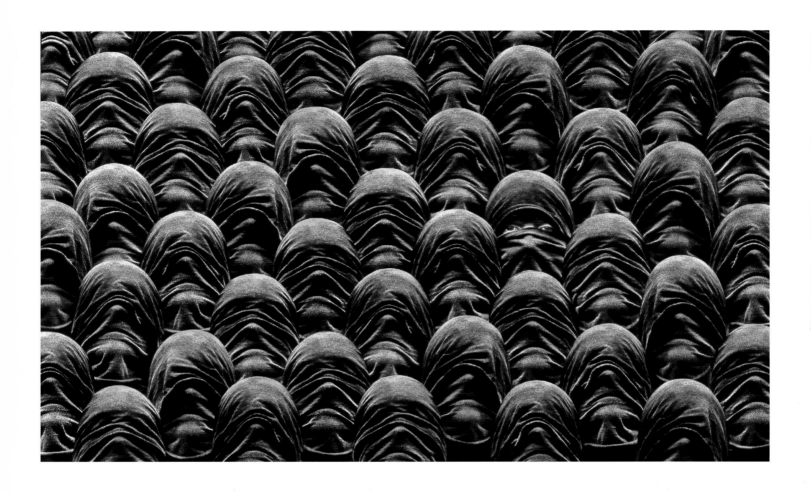

Let's face it, why would anyone want to make a cut-out-and-paste montage when you can do it with Photoshop in half the time and with much less mess? The idea seems almost antiquated, as if already belonging to a bygone era. OK, so we know that computers can take on almost any task and do it much faster than anything else, but there are many solid reasons why traditional techniques in montage have an advantage over the cut-and-paste montage of pixels on a Mac – especially when it comes to creating montages of four or more different elements.

Being able to spread out one's source images and materials at the start is a big plus. You may have already become highly aware that many of these creative photography-based techniques appeal to the artist whose primary driving force is self-expression and who is willing to start from nothing and build, as opposed to more 'realist' practitioners who can pull from everything a fragment which is significant.

In traditional montage, being able to lay everything out in front of you, to have the luxury of space so as to notice juxtapositions, ironies, contrasts and so on, has the advantage over a desktop monitor where only a few images can really be seen simultaneously inside the small window of a computer screen.

There's no reason why a cut-and-paste montage can't be scanned and tidied up in Photoshop. Most of today's montages are either re-photographed anyway, to complete the 'flattening' process, or scanned in to create a digital file that can then be used to output the work in a variety of print sizes.

If materials have been used where cut edges are clearly visible, or where differences in contrast or highlight colour are just too noticeable, then Photoshop can be used as a fine editing tool to finish the process. Overall, it's hard to ignore the case for simply creating a montage manually, and using digital imaging software to finish the job.

Digital techniques

Today it's impossible to go anywhere or do anything without tripping over the stacks of digital montage images that exist everywhere we turn – in advertising, product packaging, poster sites, book jackets, and so on. Just about the only place where we don't see it is in today's newspapers, which are operating under a new code of ethics intended to eliminate digitally-edited work in favour of traditional journalistic integrity and objectivity.

The technique itself is relatively straightforward. At its most basic form it involves the following procedure. Within Photoshop, open two images, one as a background or base canvas, the other to include a subject to select (or isolate) from that image in order to place it into the background image. By choosing the most appropriate selection tool from the toolbox, select the subject, copy it, highlight the background image and paste the subject into it.

The beauty of creating really arresting digital montage work lies in the ability of the practitioner to get one or two basic ground rules right. So much bad digital montage is created with unfeathered selections or by importing montage elements with vastly different resolutions to the base canvas. A bit of time and effort put into the preparation of materials earlier in the process always helps to iron out these differences (unless of course they are truly intentional) in order to create what I suspect many artists are after – a montage which is coherent, cohesive and compelling.

Thrown 1: Jeremy Webb
Digital montage.

Flower D: Jeremy Webb
The source image for this
montage was a single latex glove
photographed on a lightbox, then
copied, layered, and coloured in
Photoshop several times before
the addition of a drop shadow to
provide visual separation
between the 'petals'.

Some tips for successful digital montage:

—Prepare your montage elements
If possible, make the image resolution the same as that of the background
image (or blank canvas if you create a new file). If your background is 300dpi,
change the resolution of any images you will be selecting to 300dpi (Image >
Image size) prior to making your selections and assuming that you are not
intending to significantly enlarge or reduce them once pasted.

—Isolate your intended selection
Selections are always easier to copy and paste elsewhere if they are isolated
against a simple, pure white background. If your montage elements can be
photographed against a pure white background, even better.

Use the Magic Wand tool to easily pick up the background colour (i.e.
white), then choose Select Inverse (Select > Inverse) to pick up everything but
the background colour. Once this is achieved, simply copy and paste the
subject into your background image or base canvas, or simply drag the
selection across into the background image window.

—Feathering
This term refers to the degree to which a selection edge is softened, and is critical
to the process of digital montage. If you use any of the marquee tools or the lasso
tools to select with, check the feathering in Options. A low value of one or two will
provide a selection with a very crisp edge to it. Higher values of six or seven might
be more suitable for slightly softer edges, or even larger values still of 40 or 50 will
provide very soft selection edges where the boundary or edge will be massively
blurred and fade away gradually. Any value up to 250 can be set but most
feathering values for montage work usually range from between one to 100.

—Defringe command
This is useful for eliminating the kind of halo or fringe effect which can surround a
pasted selection – especially if copied from a background of a very different
colour or contrast. Such effects can ruin the appearance of a credible and well-
executed montage, so if this effect appears on your pasted or dragged selection,
set a width of one or two pixels, then OK the dialogue box, and your pasted
selection should lose that unwanted effect. Further light sweeps with the eraser
tool at the edges of a selection could also be used to fine-tune the effect.

—Anti-aliasing
This is a similar effect to feathering in that it slightly blurs the pixels at the edge of
a selection. In doing so it helps to reduce those jagged, pixelated edges which
are often most visible on the diagonally-running edges of selections that have
been pasted.

—Opening and saving your montages
Montages are best served by using the PSD file type from those available. This
file type retains picture information without any compression and is highly suitable
for working with the layers that digital montages require. Once the image is
flattened, it can be saved as a TIFF file for publication or printing, and you could
save a copy also as a JPEG at 72dpi for emailing to prospective galleries,
publishers, or friends.

Images can be opened or closed without the requirement for multiple layers
to be merged down before being printed. In this way, digital montages can be
worked on at different session times, their many layers moved, edited or tweaked
indefinitely. Remember though, that once you decide to flatten the image, or
merge down one layer on to the one below, the move is permanent, once the file
has been saved and closed.

—Finishing touches
Sometimes, digital montages that show elements from many different sources
require a kind of 'stylistic unification' to bind the contents convincingly.

There are a variety of different ways this can be achieved in Photoshop. The
montage once flattened can be turned into a duotone, or given a subtle colour
bias using the colour balance dialogue box, or for stronger colour changes, the
hue/saturation controls. Before flattening, individual elements in their layers can
be blurred using gaussian blur. Montages can even be finished with one or two of
the more subtle effects from the filter menu. Diffuse glow, for example, or noise,
where a touch of film-like grain can be added quite effectively. These adjustments
can also help to disguise differences in resolution, contrast, colour cast, and so on
between competing layers.

Montage and multiple exposure

A multiple exposure occurs when a single frame of film is used to capture two or more images. Multiple exposure techniques have much in common with the whole area of montage in the sense that images produced by both procedures can be built up steadily over a period of time and are not created in an instant, but gathered together stage by stage. Multiple exposure images can require a great deal of care and consideration in their construction as first one exposure, then another, are laid down in much the same way that Photoshop layers are.

Again, with Photoshop, the phrase 'Anything's possible' surfaces time and time again. What's the point of making camera multiple exposures with all that fiddly 35mm film when Photoshop can easily stick one image on top of another in seconds? And change its opacity? And alter its position?

It's true that digital image editing has pretty much muscled-out the kind of multiple exposures that used to be achieved by a camera. However, despite the current theory that digital capture is King, there remain two lens-based techniques of multiple exposure that die-hard fans of emulsion and the craft of traditional camera skills still have left to play with:

Camera-originated multiple exposures
Achievable with many quite ordinary 35mm cameras that have a double exposure facility (the camera manual should tell you this), whereby the shutter is wound on as normal after the first exposure, but the film is held in place – often by holding on to a small film rewind/release button at the base of the camera. Quite simply, you have to take your first exposure with your second and subsequent exposure directly on top i.e. without advancing the film frame forwards.

If you plan to take multiple images, one on top of the other, then you'll have to experiment with the exposure. As usual, black-and-white materials will be much more tolerant of exposure variation than colour; you'll find that the more images you try to pile on, the more dense the negative becomes.

It can be a hit-and-miss process, and bracketing of exposures is a must. If you intend to photograph a stationary environment for example, with one figure in different positions for the subsequent exposures, you will need to put the camera on a tripod in order to keep the camera position unchanged.

One interesting off-shoot of camera-originated multiple exposures is the use of masking filters, which craftily expose one half of the frame for the first exposure (by blocking off the light with a sliding 'door'), then expose the other half of the frame for the second. Hoya used to make one which was very popular in those far-flung days when camera filters were new and highly impressive, but making someone appear to have an identical twin standing three feet from them on the other side of the frame soon lost much of its powerful initial appeal.

Over time, these masking filters became more and more complex and photographers used different shapes and sizes of doors so that they started to create their own multi-masks with a variety of lifting doors and flaps to expose different portions of the frame at different times. To date, this is the area of multiple exposure imagery where the most innovative and exciting work of this type can be found.

'Ultimately, my hope is to amaze myself. The anticipation of discovering new possibilities becomes my greatest joy.'

Jerry Uelsmann

Animal Spirit:
Donna Hamil Talman
Many of Donna's images are created using alternative photographic processes such as cyanotype, which allow her greater freedom of expression than with conventional materials. Combined with her subject matter, this meant that 'the conceptual fit was good – ancient content with antique processes, and the images come from a culture that honoured nature, so I like the idea that prints are developed in the sun rather than with chemicals.'

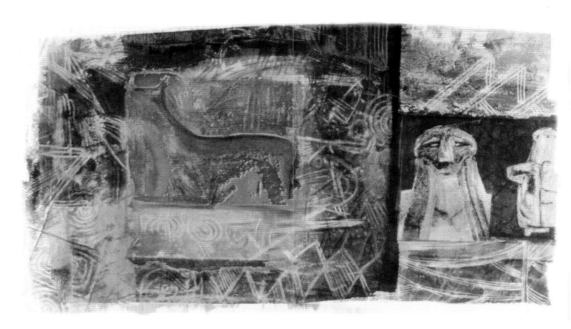

—The negative sandwich
What could be simpler than putting two negatives together in the same enlarger? Some interesting abstracts can be achieved, but choose image pairs carefully as density differences between the negatives can mean that one negative overpowers the other since only one exposure is required for both negatives.

—Combination printing
This is a more refined and precise means of creating darkroom multiple exposures and requires preparation and skill to carry out effectively. It uses the principle of the camera masking filter outlined on the opposite page where different parts of the unexposed paper area are masked-off at different times.

Let's imagine that we want to create an image of an eye in the middle of a snooker ball. One exposure is made of the snooker ball. This first exposure is made as normal except that a circular mask is placed in the centre of the snooker ball to block the light reaching this area.

A second negative of someone's eye wide open is then inserted into the enlarger, the whole of the area surrounding the central area of the snooker ball image (exposed but not yet visible) is then masked off, usually by the off-cut or surround from which the first mask was made. This leaves only the centre of the snooker ball available to expose to, so the second exposure is made into that area. Job done.

Alright, so its not quite as simple as that – exposure times have to be worked out in advance, the enlarger head would have to be a different height and marked on its centre column, and so on. For many students of darkroom technique, the whole process can be easier to manage if a second enlarger is available for the second exposure.

Having said all that, the example above provides at least the basic principle for this technique and many photographers – after a stuttering start – go on to produce some fine imagery of this kind, albeit with better raw materials than eyes and snooker balls.

Darkroom-originated multiple exposures
These can be carried out in a number of ways, but all the methods effectively produce the same thing – two or more different exposures made on the same piece of photographic paper. Here are the best known variations on this theme:

—Simple double exposure
Make one exposure as normal, then select a different negative (its exposure time determined previously) and expose on top of the first exposure. Process as normal. Simple double exposures like these usually require exposure times for both images reduced by 25–50% in order that the final image is not too dense.

More creative adaptations to this basic procedure could involve a whole range of techniques applied to the second exposure, such as:

making the second exposure at maximum magnification to add grain;

allowing it to move, or the enlarger to slowly swivel during exposure;

de-focusing during exposure;

making your second exposure from a slide or transparency.

Summary

'Trust that little voice in your head that says "Wouldn't it be interesting if..." And then do it.' Duane Michals, 'More Joy of Photography' by Eastman Kodak

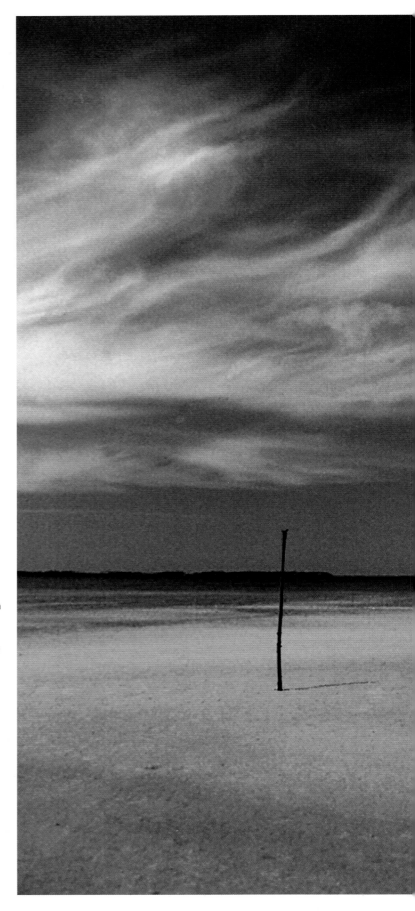

Untitled: Jeremy Webb
One of a series of digitally manipulated landscapes featuring starkly bare horizons used to stage a series of unnatural vertical intrusions.

Montage crosses boundaries – it exists within photography, as it does within art in general, and it's interesting to note that the phrase was originally applied to early cinema and the experimental cutting and re-positioning of segments and sequences. Today its influences extend into installation art, video art, and any number of permutations and hybrids of these and other emerging artforms.

There are so many inspiring examples of montage out there that even compiling a short list of suggested artists for further inspiration is an insult to those great names who will inevitably be left off the list. So I'd like to mention just a few names in passing:

Hanna Hoch, John Heartfield, and the German Dadaists
Max Ernst and the Surrealists
Helen Chadwick's 'One Flesh' 1985 collage of photocopies
Peter Blake, Robert Heinecken, and 1960s' Pop Art
Storm Thorgerson and most of his brilliant album covers
Dave McKeans' 'The Particle Tarot'
Kimura Tsunehisa and Mari Mahr

If primary school was the last time you played around with scissors and glue, have a go at montage as you might like it.

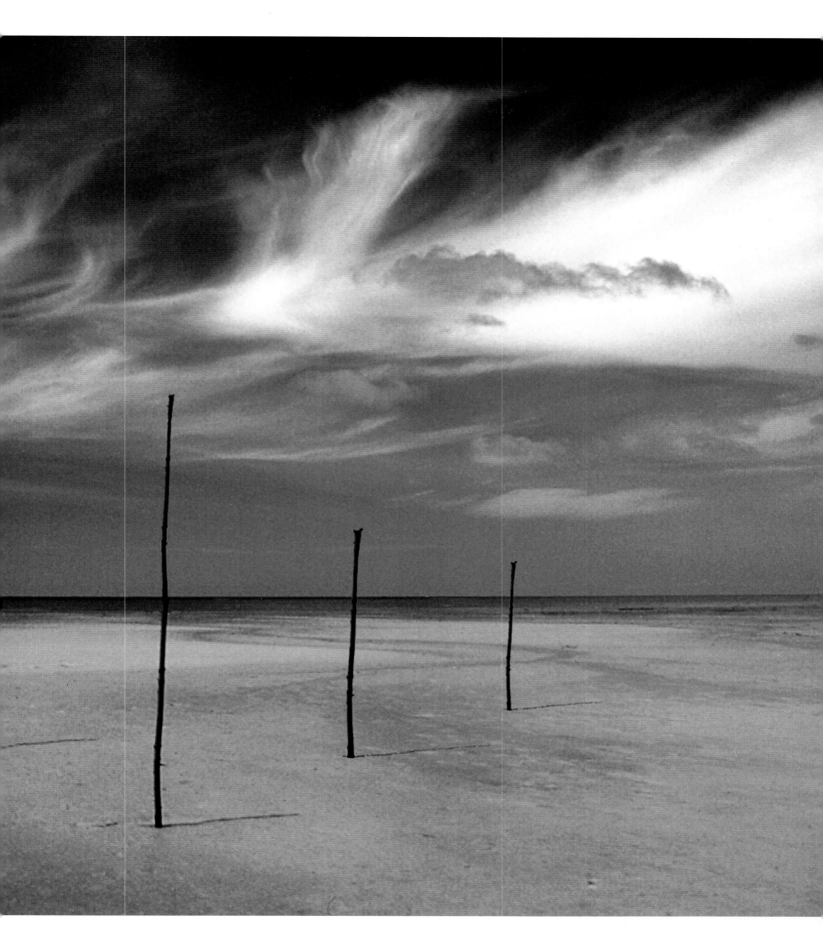

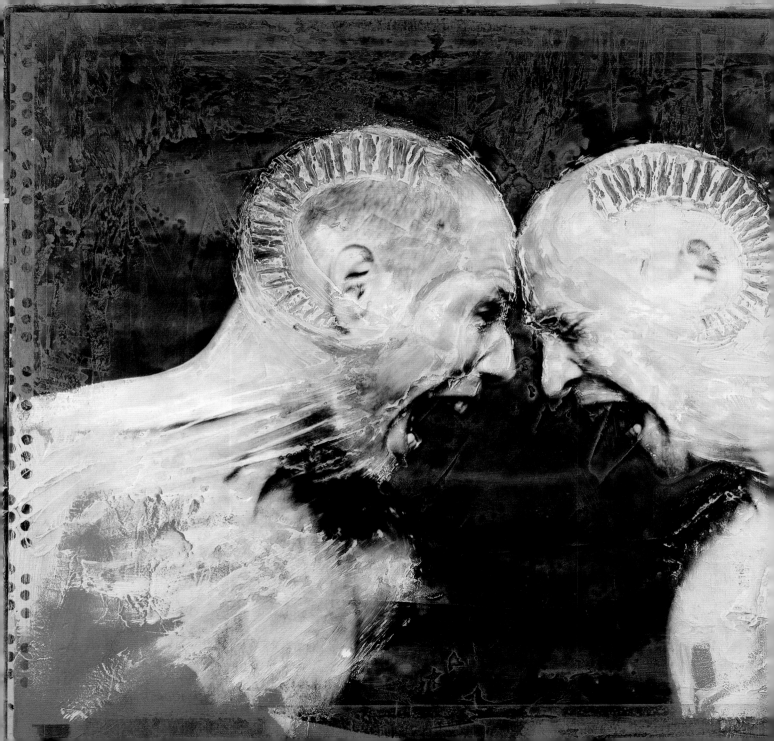

Chapter 5
Distressing Films and Papers

Cornada: Floris Andrea

The energy and vitality imparted
by this image is created in part by
the expressive use of paint and
mixed media.

To some photographers, the very idea of deliberate mutilation of the emulsion is a strange concept to grasp. We learn from the very outset of our photographic education to handle negatives correctly, to handle unexposed photographic paper with dry hands and fingers, and to keep sharp objects well away from sensitive film surfaces. We're back to those rules again, and just round the corner winks the tempting thrill of abandoning some of those cold, clinical dos and don'ts in favour of a less careful approach to image-making.

Not that deliberately distressing your images isn't a serious business, mind. It takes a decidedly expressionist photographer to follow this route, and using such procedures as part of one's workflow amounts to sudden and irreversible u-turns from a forward direction of creation to what seems like a backward step of partial destruction.

Sometimes these distressing techniques are developed as the result of chance on the part of the photographer at some stage during a traditional chemical bath, or mistakes (so often the mother of invention) have resulted in an unexpectedly engaging image.

Throughout this chapter, the usual appliance of health and safety measures is vital to safe working practices and conditions. Chemical processes should be carried-out in well-ventilated areas set apart from other hazardous chemicals and with protective gloves where necessary. Other techniques demand – through sheer common sense – their own safety measures in order that safe working practices are maintained.

In the coming sections I'll introduce some distressing techniques which can be applied to the process of photographic image-making, but I feel it's important to state here once more that artists should give serious thought to whether these techniques enhance their work or whether they detract from it. Applied sensitively and appropriately they remind their creators and viewers alike that photography does not exist in the fourth dimension – photographs are physical, tangible things which are imperfect, prone to decay and they age over time. Photographs that are output to digital media as well as traditional emulsion have a substantial importance of their own and in a world full of mass duplication at the flick of a switch, making these physical marks is for many photographic artists, a way of underlining the importance and uniqueness of the artist as creator.

Staining

**Birsa, King of Gomorrah,
Looks at own Destiny:
Alessandro Bavari**
Bavari's rich imagination creates
stunning images achieved with
the help of a highly productive
coexistence between film and
digital media.

This may not be considered by some to be worthy of inclusion under the umbrella term 'Distressing', but I regard it as more accessible and far less predictable than die-hard chemical favourites like Sepia or Selenium toning, and it therefore retains its place underneath this umbrella term.

Tea, as we all know, is the best drink of the day. 'The cup that cheers but never inebriates', as my grandmother would say. Leave out the milk and sugar and you have the ideal staining bath for black-and-white prints. Better still, it can be done outside the darkroom and without stringent health and safety measures.

Ideally, it should be very strong tea, the kind that's left stewing in a pot twenty minutes after it's too stewed for anyone to want a second cup. Used in a developing tray like any other chemical bath, the tannic acid seeps inside the paper to leave a warm, orange tone, which is more pronounced the warmer the tea and the longer the duration immersed. Between 75–85 degrees is considered the ideal temperature.

Some devotees advocate tea leaves over tea bags, and resin-coated papers are preferable to fibre-based papers, which can show a blotchy effect. Even fruit-flavoured teas can be used – strawberry or peach for pinky/reddish hues, and so on. Apparently coffee as a stainer is not all it's cracked up to be, but some people have had success using weak instant coffee.

Time, and an open-minded experimental approach are required for this kind of work. No doubt it can be applied to selected areas with cotton wool, or splashed-on randomly without requiring the full immersion of the whole print. Either way, it can be a lot of fun and a cost-free use of everyday substances so you could even claim your works feature reclaimed and recycled materials.

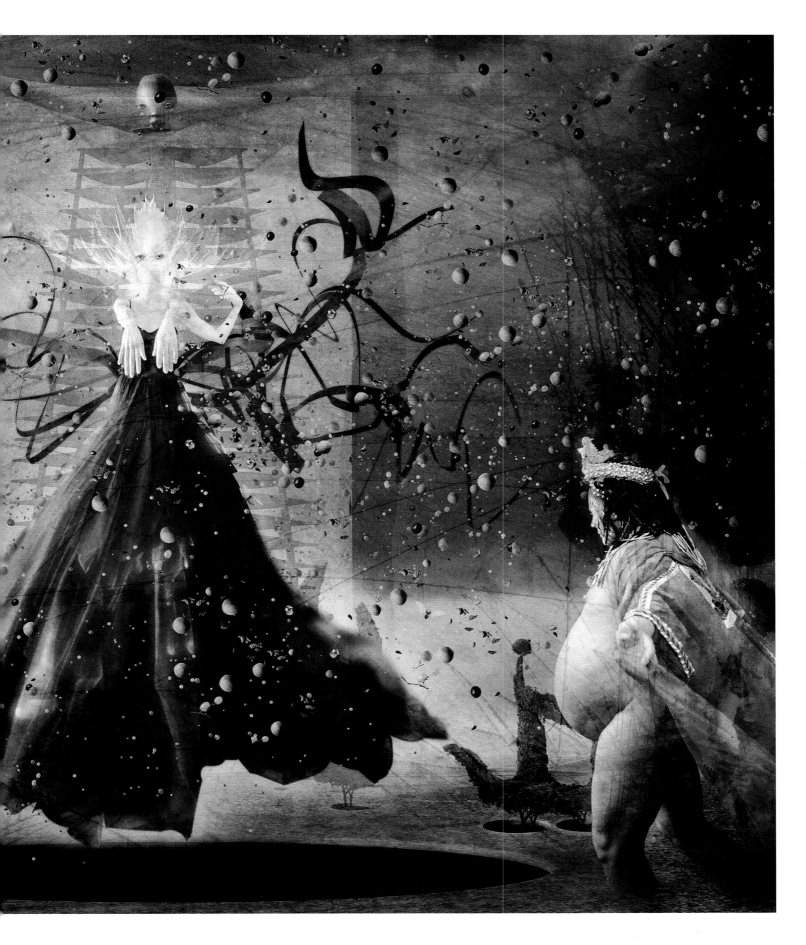

Burning

Peter's Back: Jeremy Webb
The action of bleach on colour
transparency film can be
unpredictable, so experiments
should always be carried out
on copies or duplicates of your
originals.

I used to take a rather perverse delight in taking the negatives off poor,
defenceless students, then demanding their cigarette lighters and slowly
roasting their images outside the doors to the photography department. Not to
destroy their work you understand (or their confidence either for that matter),
simply to jolt their world if they were beginning to explore the medium laterally
in those early days of their processing and printing education, and willing to
be introduced to more physical and expressive ideas.

A small simple flame teased underneath a negative or positive piece of film will
– if applied carefully and in a safely-controlled environment – allow the
emulsion and backing layer to blister and crack rather than instantly evaporate
into flames. The bubbling effects and disintegration of the emulsion will be best
seen once cooled and the negative is enlarged or the transparency projected.

If you don't want to melt your originals, apply the heat to duplicate slides or
negatives, but bear in mind that any piece of film can crumple and crease quite
badly if 'over-cooked', making it impossible to re-insert into the enlarger
negative carrier, or slide mount. The trick is not to let the film burn, but allow it to
smoulder and melt. Melting and cooling photographic film makes the area
quite brittle and thin, so flattening it again can make it crack open quite badly.

If you don't want to duplicate your original you could always partially melt a
processed, but empty piece of film, like the first empty frame of a film that was
exposed while loading the camera. By sandwiching this melted negative with
an undamaged one, some interesting double images could be printed.

Always remember to take proper precautions when attempting this kind of
work. Don't breathe in any fumes – so the use of face mask and goggles is a
must – and work on only one frame at a time with a good source of water
nearby, just in case.

Bleaching

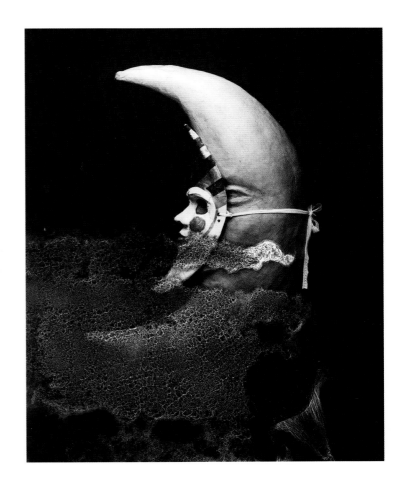

La Luna: Lisa Folino

'As an artist, I have always been
drawn to what exists below the
surface. As a child, I remember
drawing with crayons, then
covering the entire paper with
black India ink, letting it dry and
then scratching away the surface.
Suddenly a whole new world
would emerge. This experience
has been one of many that have
inspired me to experiment and
manipulate the negative.'

**There are well-known chemical bleaches that are sold specifically for the
purpose of 'reducing' the intensity of an image during processing or toning,
and there are bleaches which are intended to be applied selectively by
brush, post-processing. And then there is Domestos. Ordinary household
bleach (and other similarly corrosive household substances) can create
some devastating effects on a film's emulsion.**

Preparation for such work requires the usual eye and face protection, rubber
gloves, darkroom apron, and a large print tray (12" x 16" or bigger) for spills
and drips, set above or next to a sink with running water in front of a well-lit
open window.

By applying undiluted thick household bleach with a tiny sable brush, or
similar to those used for print spotting, you can dab or brush bleach directly on
to the surface of a transparency held between tweezers. Once this first
application is worked in for a minute or so, rinse off the residue left on the brush
under running water, and repeat the process.

After three or four applications, a noticeable thinning of the transparency
occurs as the bleach literally eats its way through the film, exposing first a vivid
blue colour, which within a further five or ten seconds then turns transparent,
having completely destroyed the latent image. The knack here is to recognise
the vivid blue stage of the process and arrest any further bleaching by taking
the image immediately to the running cold water before further rapid erosion
of the image occurs.

The running water can be used as a kind of temporary stop bath if
necessary, halting the accelerating bleaching in one part of the emulsion while
giving you the opportunity to examine the image with window light before
returning to the process to apply the bleach on to a different part. Naturally, the
larger the film format, the easier the process becomes.

It's a deliciously unpredictable effect which brings a hefty element of risk to
the image-making process, but with practice and good judgement, this can be
a very rewarding procedure. Transparencies distressed in this way should then
be hung to dry in room temperature conditions.

The big drawback to bleaching in this way is that the over-riding colour is
always blue, although older transparency emulsions from the '60s and '70s
have delivered quite beautiful yellows and greens brought out by the bleach.
Transparencies which have been bleached then scanned, can easily have their
blue colour edited within Photoshop.

Similar rapid deterioration of the image layer takes place on prints too, but
without the vivid blue appearance found on transparency film. For some, the
process is too rapid, and the bleach too strong, but I've never personally found
any great success by diluting the bleach. I enjoy the thrill of the unexpected,
and the opportunity to create further montages by making slide sandwiches of
merged and mingling colour and form.

I also enjoy my physical battle with a chemistry that accelerates rapidly,
and in a society so obsessed with being 'in control' of everything, this is an area
of photographic image-making over which I have less control than normal, and
I quite like that too.

Rough handling
of materials

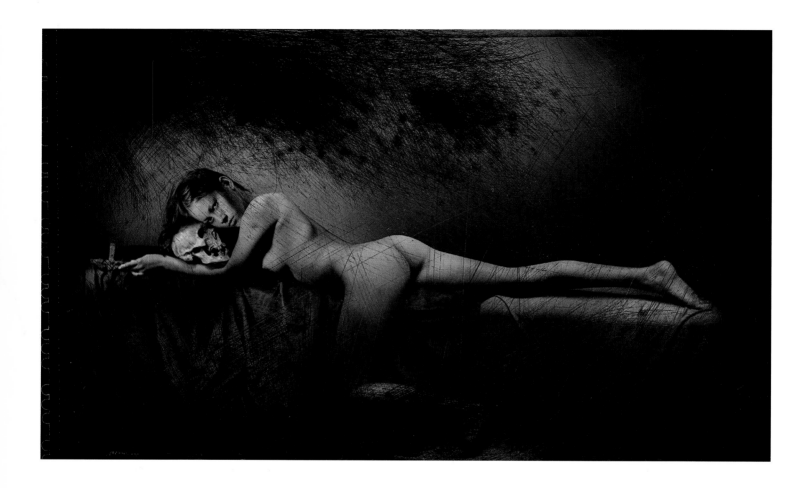

There have been times in the past when in order to achieve a distressed appearance to a particular image, I've taken processed sheet film out of the drying cabinet and simply let it slip to the floor.

Worse still, I've left it there for a whole week before picking it up. During that week I might kick it across the room, scrape it with my foot over the grit in the floor, or if I was feeling particularly happy that day, grind it into some chemical spill under the darkroom sink.

The intention is always the same, to simply extend the processing of that image by beating it up a little (or a lot) prior to printing – by living with it sloppily so that it picks up scratches, hairs, specks of this and that, chemical stains and all manner of darkroom floor detritus. Once the damage has been done the resulting film is dried carefully and grit-free before entering my

enlarger or scanner, although sometimes an extra special bit of grit would be sealed-in with Sellotape.

Results achieved in a shorter time period just don't look right, so in the end, I came to the conclusion that a week was about the right amount of time in which to achieve a random, naturally-occurring, and naturally-distressed look rather than a contrived and forced effect achieved by shortening the lifespan of this strangely cathartic beating-up process.

Living lazily with one's materials like this allows the world of chance and chaos to impact on your images and for some, this can be a very healthy occurrence, especially if your work could do with a little less precision and craft, and a bit more personalising. Again, don't apply this to your originals, use extra shots (planned for at the shooting stage if necessary) rather than your one-off, one-and-only, otherwise it's the photographer who ends up getting distressed, not the film.

Scratching

A kind of Lady Macbeth:
Emil Schildt
Polaroid Type 55 film, light painted, with the resulting negative partially sanded.

Notebook scan: Jeremy Webb
Polaroids scratched and sanded, for later use in digital project work.

Using a sharp implement to damage photographic film can bring a further level of artistry to the image, but like so many of the alternative processes and procedures available to the photographer, one has to have sound reasoning for using it consistently. I would urge anyone with even the slightest flickering of interest sparked by the idea to at least have a go with a piece of old film.

With the blade of a pair of scissors, or a small screwdriver, simply scrape away at the emulsion in lines, zig-zags, swirling motions, and so on, to leave white marks behind, usually with varying degrees of strength depending on the depth of scratching used. I've often found that slightly blunt implements work better than razor sharp ones, which can cut through the film rather than damage its surface or some of its layers to various depths.

Again, it makes no sense to obliterate your originals, so where possible use duplicates, spares, or use blank pieces of film to montage with other negatives or positives.

Once your initial experiments are complete, and you have a feel for the process, think about why you might use such a technique. Scratching could be employed:

To create borders or to emphasise in a bold way the nature of the photographic 'box'.

To conceal individual elements within an image – literally to 'rub them out'.

To emphasise individual elements within an image – to lead the eye towards someone or something.

As a subject: it may appeal to abstract photographers, or those with an interest in exposing the microscopic or unseen.

As emotional expression: no other technique can quite match scratching for its ability to impart an emotional response – predominantly anger.

I might be proved wrong, but as far as I am aware, scratching cannot be replicated within Photoshop. It's a very personal and human response, so attempts to create a facsimile effect in image-editing software (even with a graphics tablet) would be pointless and ineffectual.

Sure, you can use the tools to create a likeness effect, but there is an immediately physical personality in hand-scratched images which digital image editing just can't match. Who says Photoshop can do everything?

Sanding

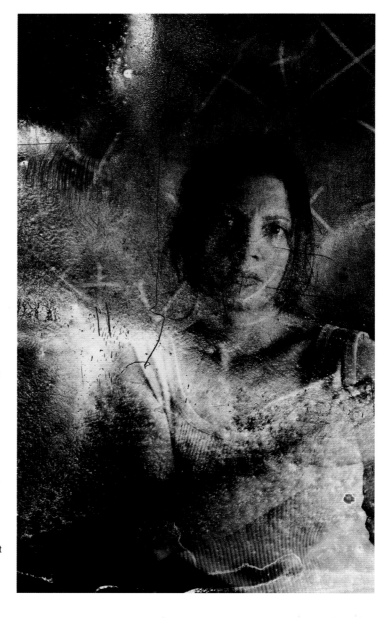

As a distressing technique, used to intervene manually into the physical processing of an image, staining has much in common with scratching, except to say of course that it is a much more extreme form.

Most photographic artists who employ this technique do so on print, working with other non-photographic materials like paints and varnishes, rather than applied directly to the negative, although I've seen it carried out with beautifully-controlled carelessness on 5" x 4" sheet film in the past, using a fine grade paper.

It's really up to the individual artist to create their own path if they consider taking sand paper to film emulsion. Photographic artists who are predisposed to referencing the very nature of photography in their work may enjoy the opportunity to expose the transitory illusion of so-called photographic reality, while abstract or expressionist artists may use it to impart their responses to ideas of time, decay, or pattern. Otherwise, artists who work with mixed media on large canvases might usefully employ such a technique to emphasise, guide the eye, or blend their imagery together.

Adapting such a physical technique to the digital image could involve applying it to a variety of digital papers, inkjet prints, and even inkjet transparencies on clear acetates could yield some interesting results. It's not everyone's idea of an alternative process, but for those photographers who want to add some physicality back into their practice, it's worth giving it a go. Discarded results can always be scanned in for backgrounds, or incorporated into digital projects.

Self-Portrait: Lisa Folino

'Through experimentation and observation I have physically manipulated and altered the negative to create new structures from old ones. Taking inspiration from the alchemists, my image-making deals with the complexities of change; the alterations from one state or form to another.'

Toy Car, Winterton: Jeremy Webb

This image is from a series of landscapes from the Norfolk coastline, taken on out-of-date print film.

Natural decay over time

Like any distressing technique, there are degrees of decaying, from gentle disturbance to downright destruction – a half-developed, unfixed, black-and-white print left in the waste bin for a week has suffered its own form of natural decay, perhaps without its creator even knowing. Similarly, those yellowing, dog-eared prints from ancient family photo albums taken over 50 years ago were once flat, smooth, black-and-white prints before the slow, but sustained ravages of time and handling.

As photographic artists we can choose to take charge of these ageing and decaying processes and despite the unpredictability of such methods, we have at least some influence over the speed of their progression. The basic raw materials required are a little knowledge and a lot of vegetable matter.

Burying your slides, negatives or prints under the soil will expose them to the destructive action of millions of microbes, soil acidity or alkalinity, rain water, man-made and naturally-occurring chemicals, insects, and other dark destroyers who'd like to get their teeth into your photographic works of art.

The effects can be devastatingly difficult to predict, and what may work well in your own back garden for example, might not work so well in your neighbour's garden. From my own experiments I found that two to three days were enough to impart a decidedly distressed look to both my colour prints, and my resin-coated black-and-whites, which are apparently much harder to decay in this manner than less well-protected fibre-based papers. What this says about the state of the soil in my garden I don't know, but if I'd left them longer than this I know I'd only have blank pieces of stained paper, so rapid was the rate of their decay.

A much easier way to achieve similar results is to take a more laboratory-like approach; grab a portion of that same environment and bring it indoors. By placing your prints and negatives in sealable plastic bags with the vegetable matter, or by using darkroom trays with cling film over the top, it's possible to add soil, leaf matter, vegetable peelings, and all kinds of organic material and just leave it for a few days to stew.

Monitor any changes regularly, as leaves in particular contain many useful bacteria, fungi, and micro-organisms that will add to this 'living waste' and the general speed of decay. Colour changes can occur in a blotchy and random fashion, and any attempts to raise the room temperature or humidity will encourage the process of decay.

In short, put into reverse everything you've ever learnt about handling photographic materials. Create a warm, damp, dirty place for microscopic creatures to thrive in, and you won't go far wrong.

Action of sunlight on photographs

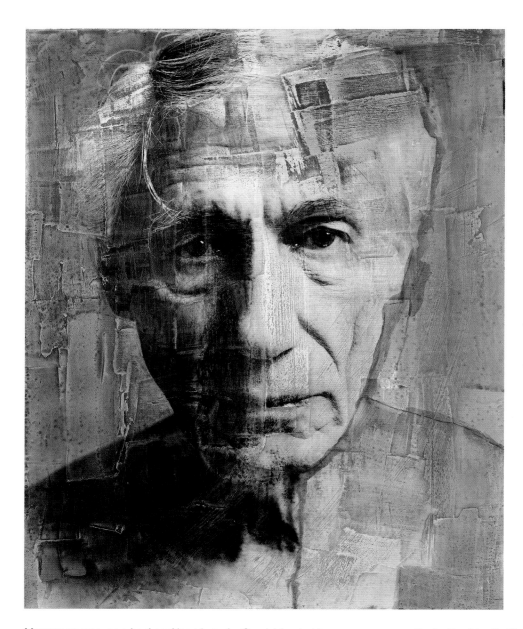

Wim Crouwell: Floris Andrea
Another 'Andreatype' that mixes and merges varying layers of paint and emulsion before processing. A certain controlled 'sloppiness' helps to create these uniquely hand-crafted images.

Many years ago, on a backpacking trip to the Greek Islands, I became fascinated by the many restaurant and taverna windows where the owners had placed tempting menus with photographs of their dishes and ice creams available, or the photographs were heat-sealed and laminated as menus placed on tables outside in the baking hot sun.

What most intrigued me was the colour of these photographs – predominantly blue and cyan, as if all other colours were bleached-out and removed. And this is what the constant light and heat of the sunshine had achieved.

Replicating this effect is another form of natural decay over time and can be achieved by duplicating the same hot, overly-bright conditions. All it requires is the foresight to fix your prints to the inside of your sunniest window in late spring, and the patience to wait for a few months for the end result to occur.

Today, colour print papers may be more stable than they once were and the process may not be quite so easy to achieve within the same timespan. But just when I think the world has moved on and these effects can no longer be seen, I find myself walking down some new high street and there they are again – a pet shop window full of little blue kittens, or a sofa repair shop apparently full of wonderfully bleached, blue sofas.

Summary

My Dear Kala: Emil Schildt

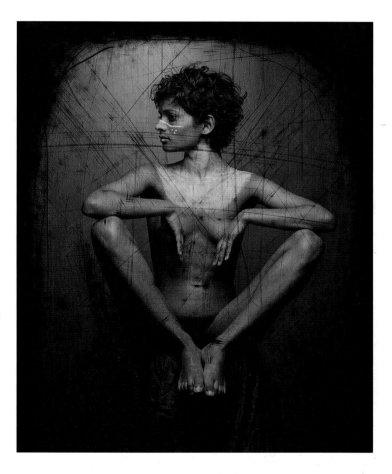

On the face of it, all the techniques outlined in this chapter are only available to the traditional film photographer with little to show for photographers who capture their source images digitally.

However, that does not mean to say that digital imaging techniques cannot be applied once film or prints are scanned. One of the greatest challenges that creative photographers face when utilising the combined powers of film and Photoshop is knowing quite when to stop, and meeting this challenge is a matter of judgement acquired from the discipline of treating both worlds with equal respect and from self-knowledge based on experience.

This sharing of film with digital is very much at the heart of the whole concept of 'Creative Vision', as it allows photographic artists to select wisely the best from both worlds, on a 'fit for purpose' basis. It also demands that their imagery is not driven by the techniques or materials, but by a rigorous and passionate urge to communicate their vision without recourse to current fashions or trends.

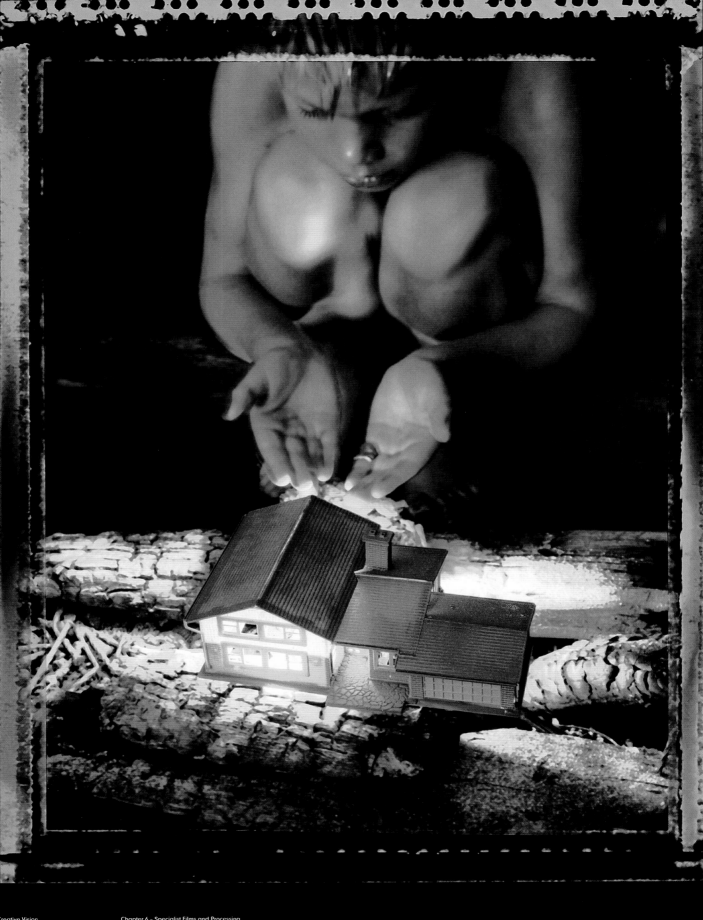

Chapter 6
Specialist Films
and Processing

Recent years have seen massive changes in the whole spectrum of photographic film, as manufacturers and their frantic R&D departments attempt to anticipate and respond to sweeping changes in both professional and consumer purchasing of film, against a rising tide of increasing digital usage.

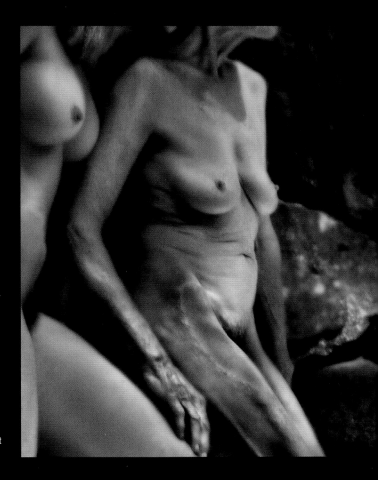

Various forecasts that major manufacturers will cease production of film altogether get much coverage in the trade press, and even manage occasionally to infiltrate our dailies. But the reliability of such forecasting remains unproven. Currently, many people in the industry find hope for the life of film in the more specialised niche market of black-and-white and specialist films, and materials which seem to be holding their own, while the amateur photographer's much-used colour print film finally surrenders to digital capture.

Pity the poor old APS system. Once heralded as a completely new and consumer-friendly camera system (still based on traditional film, but presented in a new format), this had a short shelf life before being squeezed out of the market by rising digital sales. Having gone the way of Betamax, and minidisc cameras, one wonders if these cameras will one day become vintage collectors' items.

The purpose of this section, however, is not to regale you with technical facts and figures regarding all the major film brands and types, since these change availability and specifications on a regular basis, but to show how some of the more steady and reliable specialist films and uncommon processes can be used for creative advantage by photographers who feel that a little experimentation might be necessary.

From the Wilderness Camp series: David Hlynsky
5" X 4" field camera, Polaroid Type 55 film. 'A genuine artist has no other choice. One might aspire to an artistic life, but those who are successful at it could never see themselves not making art.

Creativity is a response to a primal itch... Art is the practice of capturing one's own surprise. One can train one's self to stop and take note. With repeated practice, one can recognise smaller and smaller itches to record finer and finer surprises.'

Transitive: Rebecca Martinez
This beautifully toned image is full of so many things that make photography such an exciting and powerful medium to work with – skilful composition, craftsmanship, suggestions and nuances, warmth, contact, waiting, age, wisdom, youth, texture, closeness, fragility, strength, tone, depth, mystery, and

above all else, humanity. It offers up so many uncertainties. And yet the power of this image crystalises in a moment of calm assurance at the point of physical contact between the two women. Rebecca Martinez has in recent years found 'a natural ease with photography (that) lets me realise my own artistic vision with no boundaries set by others.'

Infrared film

There's nothing complex or impenetrable about the experience of shooting and viewing infrared (IR) images. Quite simply, they introduce you to a parallel universe, which is unseen by the human eye, but is nevertheless a 'true' representation of colour just the same – it's just that our human eyes can't see light beyond a certain wavelength, which IR film can.

The human eye can see light roughly between 400–700nm (nanometres) or roughly violet to red. IR light can be recorded photographically between 700–925nm, which is outside the spectrum of light visible to the human eye.

IR films are made with extended sensitivity and record light that is reflected from various surfaces, not light which magically 'emanates' from somewhere or something. There are a variety of colour transparency and black-and-white IR films available, and recording images with this kind of film produces many strange results – green foliage turns red, skies become deep blue/black, human skin can turn a very pale green – all of which present the photographer and viewer with a kind of alternative reality unavailable to the eye except through the medium of IR photography.

Black-and-white IR photography
Extended sensitivity means just that. Because these films are able to record 'normal' light and the 'invisible' infrared light, the lens will require a filter to block all or most of the normal light reaching the film, but allow the IR light through. Not doing so would result in a densely overexposed frame of film that has been exposed to a huge range of different light wavelengths.

Most popular IR black-and-white films include:
Kodak High Speed Infrared film (normally rated at ISO 200)
Ilford SFX 200, which is less sensitive than Kodak or Konica as it records up to 740nm
Konica R750 which, due to its lower recommended ISO setting, shows less grain than other black-and-white IR films

Photographers who practice IR photography in black and white normally use a yellow or red filter over the lens, which achieves that glowing, grainy and slightly ethereal IR 'look' and allows the photographer the luxury of being able to see through the viewfinder. These filters also capture some of the visible light spectrum, which can interfere with a more complete IR effect that other photographers crave.

These more extreme IR fans are happiest using more powerful filters for monochrome IR, which block out all the visible light spectrum except IR, but are virtually impossible to see through with the naked eye. For this reason, pre-focusing with as much depth of field is recommended. The Wratten series of filters from Kodak are the most well-known (numbers 87 or 88A or 88B). Otherwise, try filter manufacturers such as Hoya or Lee, who make a variety of screwthread and square gels that are inserted into a universal filter holder attached to the lens.

All IR films should be loaded in complete darkness, so use a changing bag or darkroom to load and remove film – otherwise it's a case of diving under the duvet at night.

Exposures are calculated using the camera's TTL meter, with the filter attached to the lens, but these can sometimes be a little unpredictable so it's best to bracket your exposures at least through the early stages of your initiation into this weird and wonderful world of monochrome infrared.

Colour infrared photography
Much of the same weird science and careful approach that applies to black-and-white infrared film also applies to colour. Films should be dealt with in complete darkness – if your camera has a film 'window' in the back of the camera through which the film cassette can be seen, this should be taped over with thick gaffer tape.

Kodak Ektachrome Infrared EIR is the leading colour transparency IR film – sensitive up to 900nm, it's used with a yellow filter (Wratten No.12) in most instances and rated at ISO 200. Unfiltered, it produces purple/pink effects that can be quite attractive if such an effect is required. Otherwise it can be used with green, red and orange filters for a variety of weird and gloriously unpredictable results.

Bracketing of exposures is once again recommended, but check with your processing lab that they can process it using standard E6 colour processing before handing it over.

Tips for successful infrared photography

Colour IR film is best stored frozen and thawed at least 24 hours prior to use.

A tripod could be useful, especially if shooting with slower speed films like the Konica R750, or where greater depth of field is required by using a slower shutter speed.

Once you get a feeling for the film, try to pre-visualise what your subjects will look like.

Keep at it. Many photographers take a while to adapt to the eccentricities and uncertainties of this medium, but keeping a notebook as you go should provide useful back-up information in your experiments with your first few films.

Shooting in bright sunlight is always best, usually between 10.00am and 2pm. Dull conditions just don't throw enough light around.

Creative photographers should consider their subject matter very carefully. Many of us will instantly recall having seen the most common type of image produced using colour IR film – trees in the landscape rendered in vivid red.

Nature is heavily overused as a subject, and it's not surprising, since the effects of IR light are probably most remarkable when recording vegetation or the landscape. Astonishing and bizarre as these unseen colours are, that alone is not enough reason to duplicate the mass of natural history imagery that already exists out there. The real creative benefits of using IR film come when representing subjects that are overseen or overlooked, subjects whose traditional modes of representation are completely taken for granted.

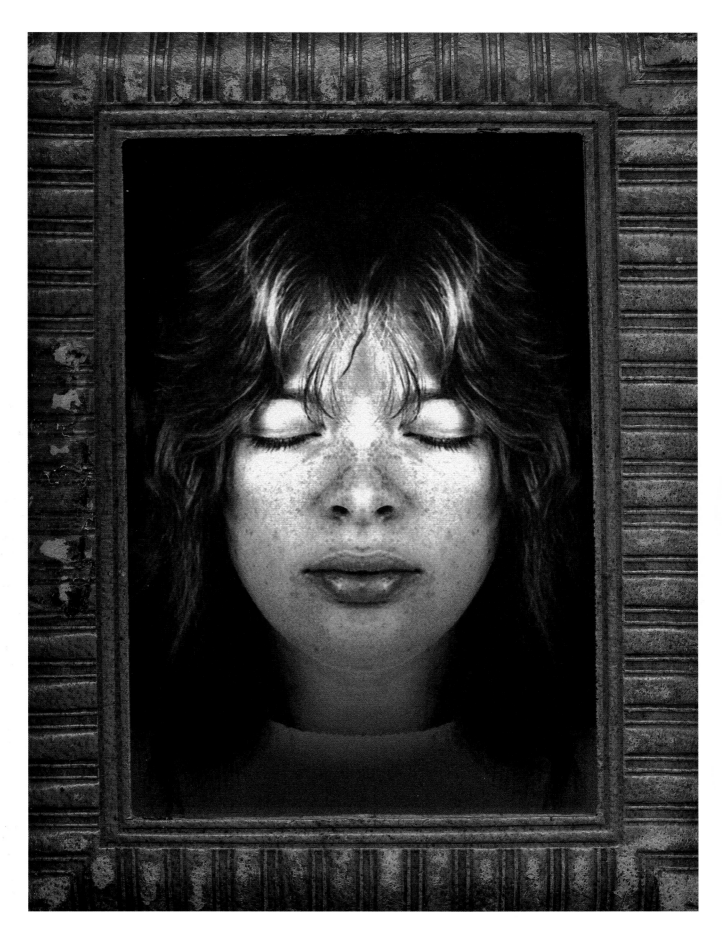

Ultraviolet

Like infrared photography, ultraviolet light enables us to witness an unseen world. Unlike infrared photography, it's much harder to calculate exposure effectively, and is generally a less user-friendly technique all round.

Returning to the visible and invisible spectrum again, ultraviolet (UV) light represents humanly 'invisible' light below 400nm and results obtained from UV photography can appear uncannily similar to IR – soft shadows, even in harsh sunlight, diffused and scattered light effects in landscapes, and so on.

Ultraviolet is used extensively in scientific applications of photography – forensics, archaeology, medical photography etc. – because its light can reveal hidden faults, cracks, or unseen clues that would remain invisible to the human eye. Such scientific applications are usually the result of UV flourescence photography where it is the light that is being filtered, as opposed to the film.

A recent advertising campaign to encourage beach-goers to apply plenty of sunscreen made full use of UV light by showing a beach full of stunning model types distressingly aged and spotty by the effects of the sun as they grinned and pouted in front of the camera. Advertising once again provides the visual contrast of beauty and the beast to powerful effect.

Creatively, it's possible to photograph the effects of ultraviolet light either by the use of bright, clear sunlight if outdoors, or by special UV lamps called 'black lights', which are flourescent tubes, if indoors. A UV-pass filter is placed on the lens (Wratten 18A), which allows UV light through but absorbs any visible light. Its density means that long exposures are a necessity in most cases, unless used with specialist UV flash.

Focusing requires experimentation, as does exposure, so no single, neat theory applies here – just trial and error. Many photographers are simply reduced to attempting to use the smallest possible lens aperture in order to gain the best possible depth of field. In this way any discrepancies between visible light wavelengths and UV light wavelengths are taken care of – fingers crossed.

Other problems are caused by the very nature of modern lenses themselves. Some UV light will pass through all glass, but for the very best UV-passing capability, you'll have to fork out a small fortune for special quartz-flouride lenses, or make the best of what you have. For most of us, the best lenses to use are older fixed-focus lenses with fewer lens elements, less lens coatings, and generally less glass for the UV light waves to cut through.

Film for this purpose is either colour transparency or black and white. Colour negative film is not recommended because of the film manufacturers' increasing efforts to placate their holiday-snapping customers' troubles with UV haze on the beach or in the mountains, so these films tend to include UV screens to screen out those hazy horizons and flared landscapes.

Overall, ultraviolet light photography would appear to be a lot more hassle compared to the easier-to-achieve effects of infrared. There are, however, many photographers out there who carve this niche successfully – getting the equipment right from the start and persisting beyond any initial technical difficulties. A simple web search will throw up a wealth of galleries, technical advice, and discussion forums regarding both IR and UV photography, and there is also good advice out there for digital IR and UV photography too.

High-speed film

Untitled: Jeremy Webb
The use of ultraviolet light and flourescent paints can be a powerful combination.

The term 'high speed' refers to a film's sensitivity to light. Just to get the ball rolling, let's try to nutshell the basics of modern film sensitivity:

Films that are rated at speeds of below ISO 100 are called slow films and are most useful to photographers when fine, sharp detail is of paramount importance since these films traditionally show very little grain. Such 'slow' films are manufactured to 'expect' good, bright lighting as they don't cope quite so well with dim lighting conditions, where slow film plus low light equal a slow shutter speed and wide aperture, leading to blurred images and not much in focus. So, not ideal for most photographers then.

A tripod therefore becomes necessary for the use of a slow shutter speed (eliminating blur or camera shake), to combine with a small lens aperture in order to make an accurate exposure and gain good depth of field.

So films that have a higher ISO rating of 200–800 are called high speed films and are better suited to lower lighting conditions (giving the user greater depth of field from smaller lens apertures and faster shutter speeds). Super-fast films rated between ISO 800–3200 are able to cope with lower lighting conditions still, and can provide hand-held exposures with good depth of field in very poorly-lit scenes without requiring flash or additional lighting.

'If faster or high speed films give so much more exposure control with fast shutter speeds and greater depth of field, why don't photographers use them all the time?' You may well be thinking.

Traditionally, the negative side to using high speed film has everything to do with the visibility of the film grain, which is so much more apparent in faster or higher speed film. What they gain in exposure control, they lose in higher grain visibility.

At least that used to be the case. Most film manufacturers try to make today's faster films as grainless as possible, so although many superfast high speed films still give that wonderful 'sandy' appearance of grain, with others the grain really has to be brought out by deliberately over-developing or push-processing the film.

Creative photographers rejoice! The kind of grain apparent in higher speed films is for many, very much a desired effect despite the attempts by many film manufacturers to eradicate this 'nuisance' altogether in the race to obliterate the appearance of grain once and for all.

The insular world of (photographic) film buffs is prone to pick over the minutest scientific detail in its reviews of high speed films, pointing out flaws in colour rendition here, inability to record shadow detail there, graphs, charts, and all manner of bumph, when film use comes down to a simple matter of experimentation and personal choice.

Broadly speaking, you need to ask yourself five key questions:
What are you going to photograph?
How much light is available?
How much depth of field is required (or what would your preferred lens aperture be)?
Are my subjects moving or stationary?
Do you need to use a tripod?

If you're about to do a fashion shoot on the beach in the midday sun, for example, a slow film like Kodachrome 64 or Fuji Velvia with an ISO of 50 would be ideal. If you intend to shoot sleazy urban alleyways at dusk, then a film like Fuji 800 or 1600 will allow you to achieve this without the cumbersome tripod.

For best results using grainy high-speed films, you could try using some of the following films and printing them to large sizes of say 12" x 16" or more for very visible grain effects:

Colour negative
Fujicolour Press 1600 colour negative film
Konica 1600 Centuria colour negative film
Kodak ISO 800 colour negative film

Black and white
Kodak Tri-X ISO 400 (but can be push-processed to higher ISO speeds)
Ilford Delta 400 (can be rated up to ISO 3200 simply by altering development)
Ilford XP2 (a 'chromogenic' b&w film requiring standard C-41 colour process)

Even if your films don't deliver the amount of grain you'd like to see, digital image processing can add artificial film grain using the Add Noise option from the Photoshop filter menu. Remember that these filters can be added selectively and don't have to be applied universally to the whole image area.

Polaroid

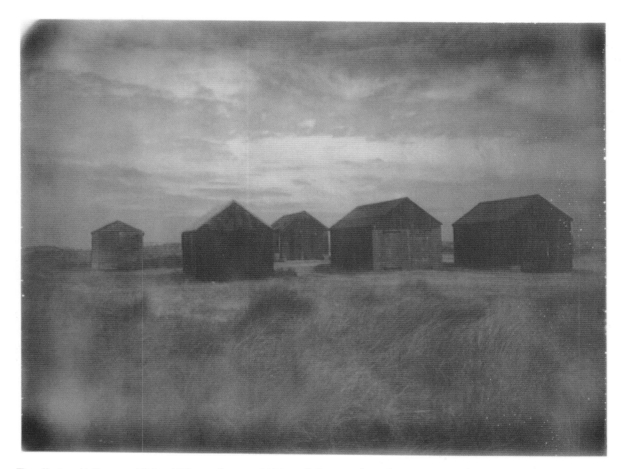

Winterton Huts: Jeremy Webb
Junk shop cameras are a lucky dip, but even the 'failures' have a certain charm of their own. An old Polaroid Swinger provided me with an image that has almost disappeared back into its own emulsion, but the distant subject seems to be just strong enough to escape being swallowed up by the dark, foggy surface of the picture.

The effect and influence of Polaroid film on the recent history of photography deserves a library all of its own, such is the power of its creative pedigree among film enthusiasts and dabblers alike. Its appeal can be summed up in one word – instant.

Since the '60s Polaroid has developed and created a highly versatile and responsive niche in instant images: no waiting around for C-41 processing or picking up films the next day. It produces both cameras and film, and has rarely if ever stopped to rest on its laurels or failed to keep up a steady pace of development and innovation.

For the creative photographer, Polaroid materials offer an almost limitless range of materials and techniques to play with – direct manipulation of the developing print, image transfers, emulsion lifts, prints from Polaroid negatives and many more besides. Artists have responded well to a film unlike any other and have adapted, tweaked, pulled and pushed, bullied and squeezed it into a huge variety of alternative and highly personalised techniques.

This mass-appropriation of Polaroid film by artists has spawned a diverse range of personal visions which return the process of image-making back into the hands of the artists themselves, not the anonymous and unseen labs or machines that seem to process the rest of the world's colour imagery. This direct and very physical contact with its chemistry once again reminds us of the very human process of artistic creation.

Sadly, just because absolutely anyone can become a Polaroid artist, it doesn't necessarily follow that they should. There seem to be millions of them out there, and unfortunately many of the most prominent examples on internet galleries and art sites show an over-reliance on technique at the expense of any truly interesting or passionately-revealed content.

Direct image manipulation of the developing emulsion seems to be the worst culprit, closely followed by endless ghostly transfers of rustic French windows or dreamy girls in floppy hats. I've personally found work of more integrity and vision on the sites of those who don't actually declare themselves to be 'Polaroid artists' at all, but who are simply strong, contemporary photographers just the same, and who happen to use Polaroid as another aspect of their work as a whole. There is also much to recommend in photographers who use straight Polaroid photography or Polaroid montages and collages, without the need for manipulating, lifting or transferring of any kind.

A more thorough review of the many types of film and image processing techniques available is beyond the scope of the space we have available here, so the best thing I can do at this point is simply to lead those with an interest in exploring this medium to some of the links and resources at the end sections of this book.

Deliberate colour casts

Flock of Seagulls: Lance Keimig

Sometimes the square format allows bold compositions like this one, where a single flowing division separates strongly opposing colours. 'The title of this photograph literally comes from a flock of seagulls that drifted through the image on the slow moving river in the background over the course of a ten minute exposure. The birds are unrecognisable as seagulls, but were recorded on the film as white streaks that look like waves in the water. Although I was aware of the birds at the time I took the photograph, they were not really significant until I printed the negative. It is this potential to record things that escape human perception, that make photographing at night so intriguing.'

Rather than seeking to eliminate the many strange colours produced by different light wavelengths on photographic film, we can if we choose, turn the situation round and use these 'unwanted' colour casts to our creative advantage. The unwritten laws of photography state that these nuisances should be filtered out so that only neutrally-rendered skin tones and accurate colour prevail.

I beg to differ. Try to resist reaching for the filters. The most commonly recognised colour casts appear when we attempt to take photographs on daylight-balanced colour film of subjects lit by ordinary domestic bulbs.

The results are usually orange due to the orange/red light of roughly 3000 kelvins that emanates from them. Daylight is usually around 5000k–6000k, which is a more bluey-white light. Filters such as a Wratten 80B remove this red component from light of this colour temperature to record a more neutral colour. With good exposures and plenty of bracketing, this light when unfiltered can produce some very interesting results if used with portraits, or perhaps nude or figurative studies. The orange glow produced can impart a soft and very subtle emotional response, or can be captured brashly, almost informally, to maximise bold or graphic imagery.

Let's not forget that it works the other way round too. Load a tungsten-balanced film, which is manufactured to render warm light neutrally, and use it outdoors to produce wonderfully cold, blue tones. Overexpose the shot and some scenes look like they've been lit by the moon.

Rather than stick an amber 81C filter over the lens to correct this, it's possible to exploit the film's characteristics and use it unfiltered for a whole range of ideas; from landscape, to fashion, to portraiture. It might not be everyone's cup of tea, but for those who enjoy the opportunity to impart a little more mood and emotion in their imagery, it might be worth a try.

The other well-known colour cast that film photographers have always attempted to eliminate, is the sickly green pallor created by ordinary strip-lights in millions of homes and offices. These days strip-lights are more likely to be daylight-balanced for the health, safety and comfort of office workers, but older strip-lights do still exist in more places than you might imagine.

Traditionally an FL-D filter, which is pale purple in appearance, would filter out this unpleasant green cast, but if you want to take interior shots unfiltered by strip-light, you could be in for some gruesomely claustrophobic imagery.

Cross-processing

Like so many interesting and 'artistic' effects, cross-processing is the result of doing exactly what you shouldn't do – processing slide film in colour negative film chemistry (C-41), or processing colour negative film in colour slide processing chemistry (E6).

The results range from unnecessarily 'wacky' to subtly altered, with variable changes to the contrast and colour. To many people, the technique is over-used and out of style, and it certainly had its heyday in the late '80s when fashion shoots and magazine covers were full of colour portraits and more arty spreads, which were the result of this technique.

Perhaps enough time has elapsed now, between that heady bygone era and today's thirst for revivalism and reinvention for it to become trendy again. Among photography's 'alternative processing' community it has maintained a steady place alongside a wide range of marginal, but popular processes and techniques, yet I suspect that it's appearance in mainstream media has been subsumed by the quick and easy proliferation of digital processes within modern printing technology.

It takes some experimentation to get things right, and even then it's hard to predict the outcome. However, it appears to be a universally acknowledged truth that the best subjects to use should be colourful, simple or bold compositions with clear shapes and forms, evenly lit with fairly flat lighting. The reason for this last requirement has everything to do with the way that contrast produced by cross-processing can obliterate highlights and/or shadows.

Some photographers prefer to overexpose their film by one stop to increase colour saturation, others recommend rating the film as normal and bracketing their exposures. Only your own personal trials will provide the right answer for you, so if you find yourself on the verge of experimentation with cross-processing, have a notebook handy to log exposures and lighting distances because you never know – you might just create that one magical moment and not remember how you got there.

Legend, hype and myth would have us believe that Kodak film is better suited to this procedure than Fuji film, but I've seen works made with Agfa that produced some beautifully warmed-up blues, other images in Konica ISO 100 slide film, and also many tungsten-balanced films such as Fuji 64T or Ektachrome 160T, which produced some of the more extreme-end results. The film manufacturers themselves seem reluctant to issue much information on cross-processing tests or techniques, which is a little surprising and suggests they might disapprove of such abusive treatment meted out to their emulsions.

For good all-round, more predictable results of slide film to colour negative processing try Kodak Ektachrome 100, Fujichrome 400 (rated as normal or at ISO 800), or Fuji Provia 400. For negative film-to-slide processing, there is a wide range of emulsions, all of which have their own clique of devotees and none of which seem to be head and shoulders above any other, so I'll leave that one there for others to debate.

Once your film is exposed, check with a professional lab that they will be happy to take your film and cross-process it. Some one-hour high street mini labs will cross-process films, others won't touch it, claiming that to do so would contaminate their chemicals (although this is not the case). Whatever you do, make clear your instructions, in person if need be. To the staff that operate minilabs, such 'non-standard' requests dropped off anonymously for processing could be treated as mistakes and films might be placed back with their own type before being processed in their usual fashion.

There is a number of digital techniques that mimic the cross-processed look of film and many of these are available as standard tutorials on a vast range of websites along with other information on other alternative processes. As with so much content on the web, any standard Google-type search will unearth the good, the bad, and the downright ugly and some of these tutorials are unnecessarily complex while others are too simplistic or ineffective.

If you want to try experimenting to find your own way of creating cross-processed style digital images, you'll find that your experiments could entail experiments with the following features in Photoshop:

Create an adjustment layer over your background image and fill it with a solid colour. By using the opacity control and blending modes in the layers palette, it's possible to create subtle (or strong) colour casts and that slightly 'foggy' look of cross-processed film, of characteristic blue-blacks and slightly muddied highlights.

Other methods involve editing individual colours using their respective colour channels, or duplicating the background to create a layer between the background and the adjustment layer, which can then be blurred to between 10–20 pixels, then its opacity reduced to 40%. This softer, blurred middle layer can quite effectively imitate the soft look of some cross-processed images.

Untitled: Mark Holthusen

The square format again provides the framework for a bold composition. On the face of it there is so much 'wrong' with this image, and yet it works so well photographically because of its directness and the photographer's own stylistic intuition and skill.

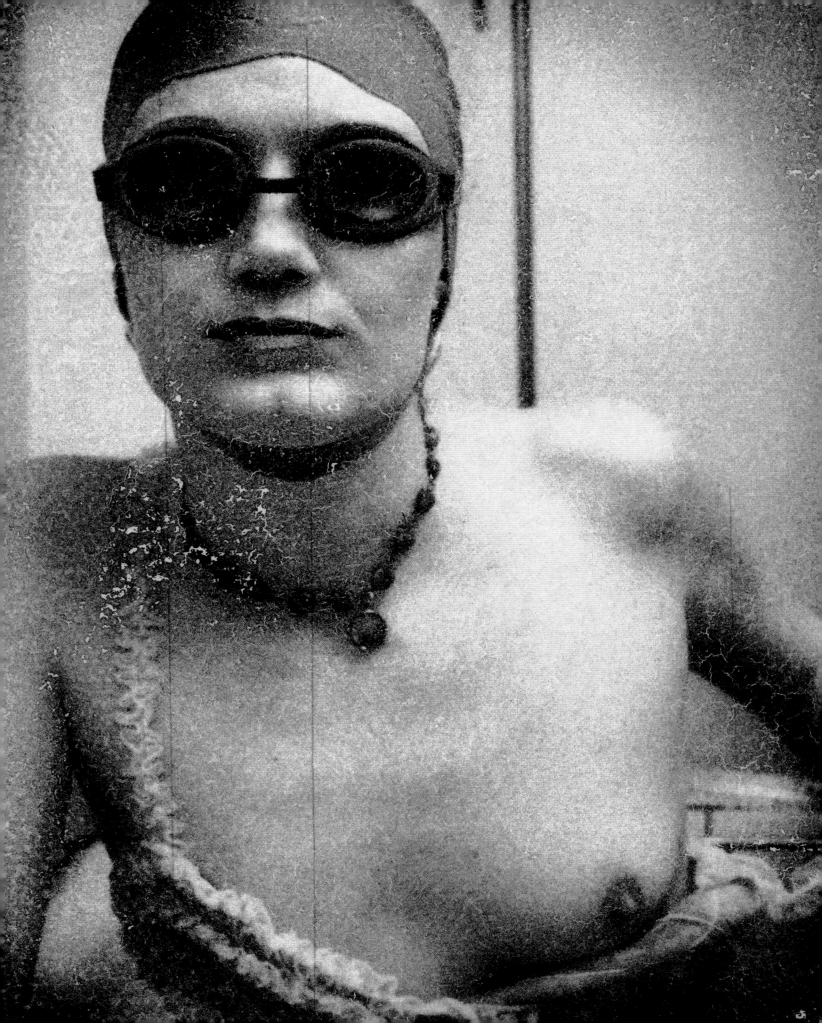

Deliberate reticulation

Reticulation is the appearance of grain patterns on film emulsion. In extreme cases it creates cracks or crinkles that resemble random mud cracks or cracked glaze, but it is most commonly seen as excessive grain. It's caused by extreme and sudden swelling of the emulsion due to heating the film in solutions above normal chemical processing temperatures.

Years ago, it used to be fairly easy to create this effect on black-and-white film, but in recent years, films have 'improved" considerably so that they can handle the extremes of temperature that our newly-arrived, jet-setting lifestyles and extreme adventure holidays provide us with.

The traditional way to create reticulation in black-and-white film is by creating extreme differences between one chemical bath and another. By using a cold developer solution and stop bath below ten degrees Celsius (and increasing the development time to compensate for the lower temperature), you can then fix the film in a much hotter solution – not boiling, but almost too hot to touch comfortably.

This sudden and unexpected expansion between the film emulsion and its base should provide the reticulated effect. But many modern films (and chemicals) contain extremely effective hardeners, which can prevent this 'mistake' from occurring as it used to do so easily.

A more reliable, but less established method involves freezing the film before giving it a really hot wash. Such methods have been developed to counteract the ever-improving nature of those hardeners once again.

If hardeners are the problem, they are also surely the answer. Photographers are used to creating their own chemicals these days, and using a reputable supplier such as Silverprint (UK) makes it possible for photographers to create their own non-hardening fixers, or to buy non-hardening fixers like Sprint, which is specially formulated for photographers who work with toning and alternative processes. If such fixers are created to fix but not harden, then it becomes possible to reticulate the film once out of the non-hardening fixer by immersing it in hot water. At least that's the theory. The practice still proves a little harder to predict.

Toning

Take a good, long look at the black-and-white images in this book and you'll find that many of them are not black and white at all, but contain a recognisable colour or cast which is most visible in the mid-tones, and adds a special 'warmth' or evokes the feeling of something far more precious and crafted than its flat presentation. Many toned prints seem to radiate or project a kind of luminescence all of their own.

Amongst contemporary photographers, the art of toning black-and-white prints is as popular today as ever, and to many photographers, the addition of toning to the process of image creation as a whole is as essential as the fix and the wash.

Apart from the visual impact of toners on photographic images, they can also serve a useful purpose in preservation and permanence. Selenium toning in particular is the most reliable toner for ensuring that your images are preserved for generations – way beyond our own lifetimes. Unfortunately, most untoned black-and-white prints will not last as long as those that have been carefully toned in Selenium.

There are literally thousands of books and articles that deal with the specifics of toning. For those that are new to this process, the best I can do here is offer an introduction to the technique in general terms and urge those whose interests may have been sparked to enjoy the works of those contributors presented here.

The most common types of toner are:

Sepia toner – which produces that much-used, aged-looking, brown effect as if faded and discoloured over time. Available as a sodium sulphide bath (with accompanying 'rotten egg' smell) or a more controllable sodium thiocarbamide toner, which allows you to control the degree of toning from a mild-yellowing to a rich golden brown.

Gold toner – usually produces increased contrast and can create a wonderful sheen to the print. It is also runner-up to Selenium toner in terms of its image stability and permanence and has for many darkroom workers replaced it as it is less toxic.

Blue toner – although it's possible to buy or create toners for just about any colour under the sun, blue always seems to be the most popular of the colder colours of the spectrum. Usually simple and straightforward to produce, such prints can sometimes look uncannily like cyanotypes.

Selenium toner – can create some beautifully subtle effects – highlights can appear silvery, the blacks of some papers turn slightly purple or burgundy, others turn a very soft blue or red. Contrast is usually increased and the appearance of the finished print is much richer than before.

Sonja: Fritz Liedtke

'I often shoot both Polaroid 665 and TMY 400 of the same images. The Polaroid gives both instant feedback, and adds the element of unpredictability to shooting: Will it solarise? Will the edges pull and develop uniformally? It is also a delight to have both a negative and a beautiful black-and-white Polaroid print of the same exposure. Shooting 5" x 4" slows me down, making me think and work differently than working with smaller formats. It also tends to be an ice-breaker with subjects. (I'm often asked if this is an old camera like they used in the Wild West, and does it have a flash that explodes?)'

The toning process

Most toning would follow something like the following procedure:
1. Pre-soak prints in water, perhaps washing in running water if required
2. Immerse print in bleach bath with gentle agitation until image fades
3. Wash off bleach
4. Immerse print in toner solution for specified/suggested time to add colour
5. Wash off toner thoroughly
6. Fix again and wash thoroughly

A basic grasp of the most popular toning methods is not hard to achieve. Minimum requirements are:
Space (within which to work safely)
Running water
Good ventilation
Darkroom trays, tongs etc.
Prints – fibre-based papers are more suitable than resin-coated papers
Toning solutions (usually supplied with, or requiring a suitable bleach)

For best practice any toning should be carried out in good daylight and the following issues should be considered:
For most toning purposes prints should be correctly and adequately fixed, and washed thoroughly. Many toners require prints to be pre-soaked or washed.
Ensure that all trays, measuring flasks and all equipment are clean and free from contamination.
Plan and prepare your workspace in advance so that dripping prints don't have to be carried across the room before washing, or that accidental spills can be dealt with safely.

Although Selenium toner is the most widely used toner, it is highly dangerous and requires the most stringent measures to safeguard health – safety eyewear, rubber gloves, tongs, face mask, etc. Always read the safety instructions and never take shortcuts.

Fortunately for digital darkroom aficionados, these safety measures are laughingly dismissed. Part of the old world order, you see. These days digital artists can create beautifully-toned images using Photoshop's wonderful duotones facility, can't they?

Well, although Photoshop can create wonders and do marvels with the click of a mouse and all the rest of it, compare a hand-printed, hand-processed, hand-toned print with a photoshop duotone, and it's the photographers who turn away sniggering. No contest.

While the tech-heads can quote output resolution figures, pixels per centimetre, ink technology, and all the rest of it, the fine art print still projects its sheer class in the face of its brattish digital cousin. Don't get me wrong, I'm a huge fan of the duotone facility and I use it regularly, but there are times when prints produced by the traditional darkroom have the capacity to leave their audience breathless and stunned by their depth and detail.

Out-of-date films
and papers

The thrill of using outdated film materials lies in the risk factor. You know it won't be quite like normal film with those 'correct' colours and its even development, but you hope it'll be bad – not too bad that the image is totally obliterated by the ravages of time, but bad enough to look faded and jaded and like it's got history.

Expressionist and artistic photographers love to use out-of-date film because it speaks volumes about the nature of photography itself – temporal, belonging to the past, impermanent, fragile, valuable, transient, with a deeper kind of contract or exchange taking place between it and the viewer. The image becomes an interpretation of life, not an attempt to portray truth in a single instant.

This reflects the photograph's very physical nature as a crafted artefact, rather than as a limp 'reflection of reality'. It also means that successful images created from outdated film have a unique identity of their own, unlike mass media images or slick imagery created cleanly and clinically in the commercial world.

The problem for photographers lies in finding materials that are out of date enough to provide the faded colours and patchy look. Film stock that is six months or a year out of date may not look too bad (despite what the film manufacturers might claim). You really need film at least ten years out of date for the best effects.

You can find outdated film stock at car boot sales, on e-bay, through businesses who've recently 'turned digital' and abandoned their film past, and even some of the less metropolitan photographic retailers who have old stock rooms and old stock to go with it (I've personally found this last option particularly valuable in obtaining 25-year-old photographic paper that had cracked emulsion and very poor contrast). It never hurts to ask, and you never know what it might unearth.

If you can't find the really vintage stuff of ten years or older, there are ways to prematurely 'aging' ordinary film, and some of the most revealing insights into these kinds of procedures are available to view on Photo.net's discussion forums, in this instance, under a thread calling for responses to using outdated film for distortion effects.

Many of the respondents to discussion threads like these offer a wide range of techniques to prematurely age their film, such as leaving it on a radiator, leaving it on a hot car dashboard for three to six months, or putting it in an incubator. One gentleman's reply included the following suggestions:

'Think of all the things you're not supposed to do with film and try them. For example, leave it on the back window shelf of a car for a number of weeks, or put it on a radiator so it gets accelerated aging from the high temperature. Leave it in your trousers' pocket after exposure and wash them. This gave me great bubbled effects where the emulsion was attacked by the detergent. Leave it in a biscuit tin with an open container of hydrogen peroxide beside it possibly even at an elevated temperature. Finally get a gas hypering kit from Luminos and over-hype the film. This should bring up the base fog level to the point where the images will only barely be seen if done long enough.'

Winterton Breakwater:
Jeremy Webb
This image was created on film
over 25 years old.

Pinhole photography

Of all today's alternative photography techniques, pinhole photography is perhaps the most widely-practiced and discussed, but strangely misplaced as an item in the 'alternative' box. There is nothing alternative about it. Pinhole photography is the simplest, most pure form of photography around. All cameras are based on the simple principle that light rays passing through a small aperture will reveal an inverted image on a flat plane in a darkened space. That's it. That's what pinhole is and that's what modern photography is all about too.

It even predates the so-called 'invention' of photography. Renaissance painters used pinhole projections to help them achieve correct proportions and perspectives.

Today, modern pinhole cameras are created from biscuit tins, shoe boxes, tin cans, empty blacked-out rooms, even wheelie bins. Whatever the size, they all share common features – a light-tight space with front and rear (equivalent to a camera's focal length); a flat surface at the rear of the space, which receives the image, and a tiny hole at the front of the space, which allows exterior light to pass through the space and on to the rear receiving surface. Remind you of anything? The human eye perhaps?

Mouth series: Justin Quinnell
Only the truly eccentric genius would take photography this far – inside his own mouth looking out, for a series of devastatingly comic images of finger nail biting, bathtime, and a quick visit to the Lincoln Memorial.

Pinhole images share a number of interesting characteristics:

Soft, diffused image quality

Long exposures are required (often in minutes, sometimes in hours)

Massive depth of field is possible, with near foreground and far horizon in focus

Panoramas, overlapping images and distorted perspective are all possible using the basic pinhole method

These characteristics of pinhole images invite a range of creative responses:

Soft image quality can be usefully employed to disguise, diffuse, reduce, or mask subject matter

Long exposures allow photographers to condense the passage of time within one frame, recording movement in one long exposure

Depth of field allows dynamic and distorted compositions impossible to achieve with an ordinary glass lens

Panoramas and overlaps creatively extend the format of the traditional viewfinder 'box'

A certain amount of trial and experimentation is inevitable when constructing and testing a pinhole camera. The camera housing interior should be painted matt black and be absolutely lightproof. This can be checked by leaving an unexposed piece of black-and-white paper inside it for a few minutes with the pinhole covered up, taking it outside into bright light, then processing it. The paper should naturally remain white to indicate that the camera housing is light proof. The pinhole itself should be neat, circular and very fine. Kitchen foil can be used, but a flattened portion of a foil tray or flan case is stronger. Use a fine needle to make the hole – the smaller the hole, the longer the exposure will be and the sharper the image.

When testing for exposure, remember that there's no traditional viewfinder as such, so you have to make sure it's pointed accurately towards the subject you intend, and anchored firmly so that it will not blow over in the wind, or succumb to camera shake. Shorter distances between the pinhole and the film create wide-angle cameras, and longer focal lengths are required for telephoto effects, which also require a slightly larger hole of between 0.5mm–1mm diameter.

To begin with, make test exposures using ordinary black-and-white photographic paper. Once accurate exposure times have been calculated, these 'paper negatives' can be contact printed, rephotographed, or even digitally scanned and easily inverted. Ideas and instructions for pinhole cameras are everywhere at the moment. It really is astonishingly cheap to make one, and the only real investment is your time. Pinhole cameras really can bring the fun back to photography and because they require the bare minimum of technical knowledge, it can be a truly democratic medium. Spare some time at the weekend, involve the kids, nephews, nieces, neighbours if you can.

Junk shop and
toy cameras

If ever proof were needed that mass-produced technology is not the absolute pinnacle of modern photographic achievement, the continuing popularity of these inferior cameras is surely it.

Hydrant: Michelle Bates
Holga cameras allow photographers the chance to slow down and strip back the layers that obscure our observation of the world. 'I love the weird frame the Holga creates, as well as the ease of using a light, cheap plastic camera. I've been using it since 1991 and love it!'

Mercifully, a dedicated and talented band of photographers throughout the world are championing the cause of these sometimes rare, sometimes obsolete cameras for the simple reason that they produce imprecise, ghostly, and unpredictable images. The modern-day all-singing all-dancing megapixel or multimode camera is not for these photographers – too standardised, too easy, the images too homogeneous and precise, too bland in other words. Toy or junk shop camera users love the rough edges, the vignetting, the light leaks, and the dressing-down of photography.

It seems also to be an area of photography that has been appropriated heavily by American photographers, with their European cousins lagging some way behind, but I suspect that this is merely reflective of their love for alternative photographic processes in general. Many US-based photographers enjoy exploring the whole range of 'alternative' processes, and using toy cameras is just another aspect of this enjoyment.

The most interesting photography produced by toy camera users lies in the ability of the image-maker to align their creative vision with the camera's simplicity. To many, the stripping away of superficiality in order to get to the heart of someone or something is a strong motivation, and I personally feel that much of the best work offers up a simple, direct, and very honest snapshot of everyday life, which invites the viewer to explore the ordinary as though it were extra-ordinary, as if witnessed with the wide-eyed curiosity of a child.

Sunset Beach, December 31, 2000:
Christopher Evans

'I use cheap, usually low quality cameras, mostly found at flea markets, antique shops and camera shows. I attempt to capture everyday things from my life and my surroundings, hopefully showing people these things in a new way.'

Averill Park No.7, 2004:
Ray Carofano

Taken with Kodak T-Max film, the print colouration is achieved by the use of tea, and an organic yellow dye made by Berg. 'I'm inspired by the poetic value and mystical quality in the delicate balance of the landscape.'

This is not art driven by tools and materials, but something more akin to a sympathetic coexistence whereby the vision of the photographer seeks and finds the tool to transport the photographer's vision most directly. Amid all the chaos and clutter of the world around us, the best of these images speak to us calmly and quietly, and sometimes with great self-assurance.

By far the most popular of the toy cameras is the Holga – plastic lens, unreliable shutter speed (something around the 1/100th second mark but it's anyone's guess really), and two exposure settings for sunny and normal. What could be simpler? These cameras also let light in, so strange blobs and streaks of dark or coloured light are often visible on Holga-produced images, usually around the edges of the frame, which itself can often be noticeably vignetted. The film used is 120 roll film, which produces 6cm x 4.5cm negatives and multiple exposures are often an unexpected pleasure since the shutter can be pressed any number of times before the operator remembers (or forgets) to wind on.

The Holga is actually based on an earlier toy camera called the Diana, which alas is now extinct, although they do crop up at auctions and collectors' fairs where they can command huge prices.

Junk shop cameras can range from old Polaroid 'Swingers' to old Kodak box brownies, and I've found a few bargains at bric-a-brac stalls too. I've picked up an old box brownie that produced some wonderfully soft-focus cliff landscapes with superb edge bleed effects. I've also found some Polaroid bargains that

were passed on to a jumble sale stall because they were simply outdated, but still perfectly useable models, although being old, they had their own little quirks and idiosyncrasies.

You might strike lucky and pick up a real collector's item by scouring these junk shops if you're really dedicated. Some stall holders have little appreciation of what photographic equipment they have. An old camera is an old camera, and while many of them really are junk, could you spot an old Horseman 5" x 4" camera if you tripped over it?

Using these rudimentary and simplistic cameras is a way of 'unlearning' much of that clutter that surrounds photography and sometimes takes our eye off the ball. We're forced to concentrate squarely on the picture, rather than give undue attention to shooting modes or equipment issues. Sometimes photography comes with so much baggage about what's right and what's wrong, what's in and what's out, that we need to take a step back and reclaim the freedom to look at life again without the weight of this unhelpful baggage.

My first camera was a Kodak Instamatic 126. It had a viewfinder, a silver shutter button and a ridged winding-on wheel. Oh yes, and two exposure modes, one with a little picture of clouds on, and next to it a little picture of a smiley sun. The photographs I take now using outdated cameras help me to keep in touch with the thrill of photography, which I first experienced as a young boy and I'm not about to give that up for anything.

Summary

Wharf: Eliza Massey

'My strongest images occur when I have no preconceived ideas of what the image will be, but let my inner senses take over.'

Many readers may be completely unfamiliar with film speed, processing techniques, or traditional photographic concerns since their whole production process is the fast, dry route of digital capture and digital output. All well and good.

But as the world turns to digital at a rapidly increasing speed, some traditional film and camera manufacturers are falling by the wayside or simply keeling over completely in a bid to offer their products to an ever-shrinking demand. This gives rise to unsurpassable opportunities for experimentation on cheap, discounted materials which may be totally extinct in a few years' time. It should always be remembered that if you embrace the digital realm and adore the power of pixels, you can still, just as easily, use traditional film and camera capture without having to fork-out for a digital camera.

In an age of instant feedback, film takes longer, and I'm sure we could come up with a thousand different reasons why digital capture is superior. But the real proof of photography's pudding is all in the print, the image, the result on the wall, and our response to it, and there seems little point in spending a small fortune on a high-end digital camera, downloading the files to Photoshop for a bit of digital "dirtying-up" with grain or vignetting, when discontinued sheet film or junk shop cameras can provide such beautiful imprecision and imperfection in any case.

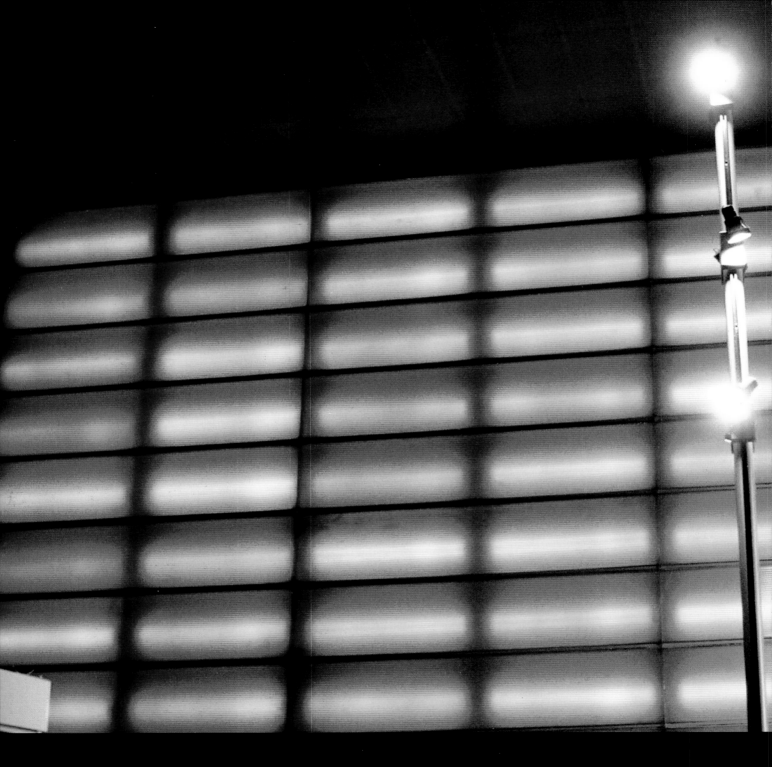

It's also a place w
beyond that whic
event, captured c
allows those that
simply look.

This is not to
the only ones to c
physical evidenc
appropriation of
evident in 'straigl
images that, with
photographer to
precisely the aga
expression in the

Today, for me
speeding, crude
we find the time t
Where's the payk
visual enlightenm

Untitled: Jeremy Webb

The Inner World

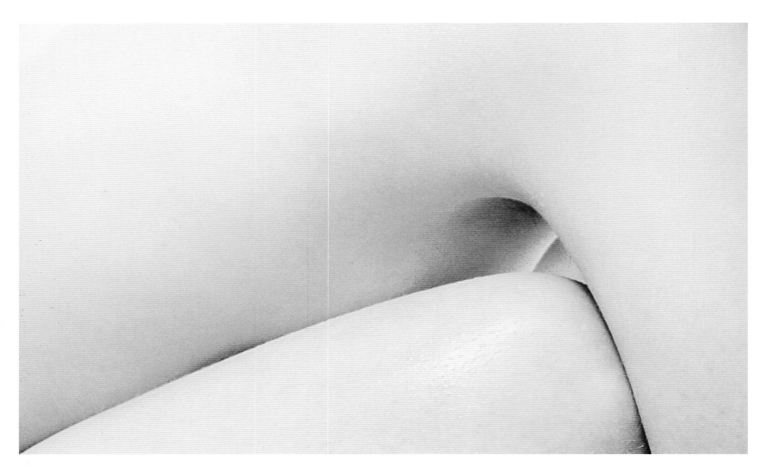

The answer might lie in our simplistic Pavlovian notions of cause and effect, of action followed by reward. We've lost that simple ability to stand in front of an image and allow it to unfold to us, for us to become an empty vessel that can be poured into, to open up, Zen-like and allow it to happen. We need to relinquish some of that precious control and allow an image to speak for itself.

Sometimes I like to remain in awe of something I don't fully understand – questions lead far more interesting lives than answers.

Perhaps it's just a question of reconfiguring the relationship between ourselves and the image so that we turn self/active <> image/passive into self/passive <> image/active. At other times we need to try less hard or discard that complex head full of judgement, expectation and anticipation by adopting a more meditative approach to images.

I suspect we need to reappraise our relationships with our subjects, to be that empty vessel again, ready to absorb, to open up totally in quiet contemplation, to allow us to be given to – not taking or extracting something from it ourselves. Photographs have a unique ability to 'give life' to their subjects when viewed, to preserve and reanimate them time and time again by continuous interaction with them, but photographs are also moments to accommodate the viewer, not just to amplify the past.

Many of the world's creative and talented artists acknowledge and fully appreciate the inner world and an open-mindedness and positivity required for their visions: 'Nothing bores me. I find time management fascinating. Accountancy: fascinating,' Keith Tyson (The Sunday Times). I once heard the Canadian photographer Jeff Wall discuss photographs as 'fissures through which energy seeps' with an audience when discussing the power of the photographic image.

The inner world provides an opportunity to unlock a kind of parallel alternative mirror to a more objective, exterior reality. This can be achieved through the manufacture of artificial realities via constructed environments, or multiple combinations of image and text, or with unusual combinations of materials.

James Casebere produced some artificial yet strangely familiar interiors in miniature that capture the energy and mystery of 'real' interior space. By creating atmosphere and emotional charge with careful lighting and use of space, their dark corners tease the viewer to peer deeper or to back away just as they would in actuality. Bright light appears to be just round the corner, flooding in from above or perhaps an opening into another world offering hope or enlightenment. Projected from these photographs, I always sense a dual discomfort of imaginative excitement and fear, knowing that you are being pulled into these artificial spaces to explore them simply by choosing to interact with the image.

'My photographs are really about me. I think all art, to some extent, is about the maker.'

Keith Carter, 1996, from 'Photographs: 25 years'

Crouch: Jeremy Webb **Untitled: Jeremy Webb**

Simple, clean lines portioning
space in a harmonious
arrangement. Abstract by
reduction.

Alternatively, your inner world may drive you to record the mundane and the ordinary as poetic symbols of life. The Korean photographer Lim Young Kyun's deeply-rooted Buddhist beliefs infuse his images with a respectful prayer-like response to the most everyday scenes of empty plates, windowsills and the stuff of day-to-day living.

Olivia Parker's beautiful still lifes are far more than simple arrangements of ordinary objects. Transformed with the vision of an artist, her 'Signs of Life' series reflects just that – inner visions of the rich fabric of life, sensual and evocative, triggering notions of life's big themes: birth, death, love, wanting, and so on, as well as being beautifully composed arrangements in their own right.

The imagery encountered by exploring the known visual world more closely and its relationship with the symbolic world, which can also be experienced, is one which photographic artists have always responded to. Alfred Steiglitz, Walter Chappell and Minor White all developed their concepts of Equivalence based on this duality and articulated these surface and sub-surface parallels which resulted from it through their work.

When the dual presence of outer reality and inner vision lead to symbolic images, or images with multiple meanings, the temptation is always there to create allegorical or metaphorical images using symbolic visual language to execute it. This is best avoided if the parallels are too obvious or too crude, and best left to chance rather than careful crafting of a situation to create it. This danger might be better explained by John Szarkowski who, in 'Looking at Photographs: 100 pictures from the collection of the Museum of Modern Art' wrote:

'As a rule, photography has not been especially generous to those of her followers possessed by the romantic imagination, but every student of the medium will have his own considerable list of conspicuous exceptions. The romantic temper is distinguished by its quickness to find universal meanings in specific facts...It is one thing to write about seeing the world in a grain of sand, and eternity in a flower, etc., and another thing to make a convincing picture of the idea. Photography especially has generally worked best when it has tried to discover the differences between the world and grain of sand, rather than belabor their similarities.'

The task then, is to become one of those 'conspicuous exceptions' and side-step the temptation for easy allegory, cheesy metaphor, or contrived multiple meanings. Abandon that over-worked ego, allow chance and spontaneity in, and let your inner world fuel a new kind of curiosity allied to a respectful and open-minded approach to the external world.

Abstracts

Coil 1: Jeremy Webb

No camera was used in this abstract, which features a small, curled piece of paper copied end-on by a desktop scanner. Other modifications to the image were made using a variety of Photoshop filters. Despite the simplicity of its conception, it still remains one of my highest-selling prints.

What is it about the abstract that still appeals so much? Fed up with reality? Descriptive representation become boring? Maybe something in us just needs an eyeful that doesn't seem to make immediate sense.

The best abstracts can resonate deeply with our inner selves, since that is where most abstracts are received, or generated from – a desire to reflect or create inner realities. Photography is traditionally viewed by many outsiders as a medium that establishes facts, tells the truth, or 'reflects' reality. A family photograph becomes a record of proof, that someone was in a specific place and their presence there is proved by the existence of the photograph.

Unlike painting, which has a long and lasting legacy of fantasy, abstract expressionism, and the unreal, photographers and their audience become suspicious when associating the idea of the abstract with the practice of photography. Decades of news journalism, war photography, even moon landings have placed photography for many, within the realm of the factual with only a few lone mavericks initially, extending its boundaries by looking to the inner world of the senses and emotions with the photographic medium.

Abstract photography itself is a relatively young phenomenon; the Abstract Expressionist movement within painting only really began to make serious waves after the second world war. Today the influence of those painters is immense, from Jackson Pollock's 'action' paintings, to a more minimal and meditative movement spearheaded by artists like Mark Rothko and Barnett Newman. Abstract painting has always been a more physical means of expression (not least, the painter's ability to cover vast canvases) and also a process which took longer from concept to outcome and wasn't dependent on time-sensitive chemicals and processes, light changing and fading, in short, a process that the artist could indulge in when he/she chose.

Abstract painters were naturally curious and pushed hard at many boundaries including the use of other materials within their paintings to achieve their creative ends. Mark Rothko for example, used egg mixed with pigment to provide a certain sheen when required.

Abstract painting's historical legacy cannot be disputed. There's no photographic equivalent to the cathartic, gut-felt splash of daubs of paint on a canvas. That physicality of the abstract-in-creation can never be mimicked by pushing pixels around a screen, or the decision to select one shutter speed over another, but there are means by which that very physical act of creation can be returned to the medium of photography.

The darkroom is the obvious place, experimenting intuitively with chemicals, timings, and techniques that start as germs of inspiration and experimentation, and are then nurtured into images that communicate something meaningful. Some of these techniques are discussed elsewhere in this book. The best starting point for personally-rewarding abstract photography is the emotional vocabulary and self-awareness of the photographer. This is far more important than any tool or surface employed in the creation of abstracts.

Creating abstracts with the camera is another, more popular field altogether. Photographers have always used the close-up as a means of abstracting the world, and this remains one of the most effective and powerful uses of the medium today. By going in close to the patterns made by light on a wall of chipped and flaking paint for example, the photographer ignores the distant shot of a wall, creates something more meaningful by abstracting the scene and taking an image which is about the wall, as well as perhaps saying something more universal about ourselves (back again, to the concept of

Equivalence), the nature of physical matter, the nature of light, and perhaps even the nature of photography itself. Abstraction by viewpoint is the product of selection and reduction – a fragment extracted from a much bigger scene for example, rather than the use of photographic chemistry used to mimic the nature of paint or liquids in the production of an abstract from nothing, on to a surface.

Abstractions by selection can force us to confront subject matter we would ordinarily dismiss. I might be repulsed by the image of an open sewer which is neatly framed by the photographic 'box' and its edges, and my engagement with that image would cease at that point. Were I to come across a close up of its various substances, shapes, colours as an abstraction, I'd be intrigued by the aesthetic qualities presented to me before my brain had even recognised what the substance of that image was. Abstraction reminds us that the known universe can still be a mystery, and that even the most unpromising of subjects can be transformed by the medium of photography into miniature landscapes possessed of an extraordinary power to affect us.

Abstracts can also be created by deliberately de-focusing the lens to leave traces of barely recognisable shapes and outlines that appeal to our brains' desire to make visual sense of the image. Deliberate slow shutter speed selection or deliberate camera shake/movement also create images full of movement. Try shutter speeds of 1/15th sec or 1/8th sec with deliberate

camera shake and see what you get. If you really want to get the visual juices flowing, try using a 36-exp film and fire it off randomly around the room. This may seem extreme (or even extremely wasteful), but once you have the contact sheet you can use the power of your perceptual eye to isolate a set of three or perhaps six abstracts from a set of 36 images, or use the process of cropping to actually create your abstracts from pre-existing film.

However they are created, abstracts seem to meet a deep need in us. At their most basic level they are (at first contact) unfathomable, in that our brains are more expectant of the empirical, the factual, the recognisable and the 'real'. Some abstracts present us with a confusion – what are we dealing with here? And how are we supposed to deal with it? Our busy little heads are crammed-full of all manner of junk and expectation, conditioned to process pictures that are 'of something'. Images that ask us to approach them with an open mind are challenging, and we are too familiar with the safe, cerebral field of certainty to allow that image to simply reveal itself to us.

The best examples of photographic abstracts are almost certainly in monochrome, where textures, patterns, light and shade, and different assemblages of tone, become the elements which, when manipulated or configured by a skilled eye, speak emotionally to an audience who recognise, something special. Colour abstracts are a more recent phenomenon, mainly due to the later arrival and dissemination of colour papers and processing chemistry into the arena. Because of the known effects of colour on our senses, colour photography abstracts tend to have the added factor of greater impact. The use of colour can literally stop us in our tracks, but there remains the notion that monochrome abstracts have longevity, the ability to hold our interest and attention long after any initial 'hit' has passed.

A childlike sense of play is an important factor in the ability to see, or create abstracts. It takes a different approach, and comes I suspect from a different part of the brain. The ability to see abstracts photographically is an essential factor in the development of a creative vision. Seeing and creating them on a regular basis can become a steadying, unifying force in the life of a creative photographic artist.

Green Stem 3: Jeremy Webb
The background consists of squashed ink trapped between a glass slide mount, and scanned into Photoshop. The green column is created by possibly the most remarkable Photoshop plug-in ever, Kai's Power Tools 5, and the wonderful Frax program.

Untitled: Jeremy Webb
From a series of still lifes featuring reclaimed waste.

Light as a subject

Consider the qualities and terms we use to describe light – unforgiving, heavenly, radiant, soft, harsh, intimate, colourful, misty, revealing, to name but a few. The concept of light has a unique language associated with it, all of its own. From the ascent of man up the evolutionary ladder, light is the foundation behind the structure of our days: when we hunt, sleep, eat, or bathe. It's essential to our sense of safety, vulnerability, danger, good or evil, sexuality, spirituality, and religious beliefs. No wonder it's such an appealing subject to photograph.

I was never really tuned into the fact that I had actually been shooting light as a subject in its own right for years, until recently. Every year for as long as I could remember at about the same time (late-Feb to mid-March), I'd notice the sun stretching longer and brighter rays around my home and studio. It would pick things out in narrow beams, or reveal textures in carpets, floors and walls I never knew existed. Sometimes I'd deliberately set still lifes up in a corner of the house and work quickly before the sun moved on slowly, but inevitably to a different patch.

Light is a photographer's best friend and worst enemy. It's also the currency of photography since no photographic 'transaction' can take place without it.

Photographers need to understand light in order to appreciate its effect on our moods and emotions. It can transform the most mundane urban setting into a staggering scene of cinematic beauty. It can uncover hidden character and personality in the everyday, give depth to the dull, and turn the human form into an erotic, sensual masterpiece.

So much of the traditional photographer's kit is designed in an attempt to control or modify light – bouncers, reflectors, flash, tungsten, filters, lightbox. Photographers latched on pretty quickly that by using the photographic medium, they were using the perfect medium to capture its nuances and qualities.

Light abstracts are my own personal way of paying homage to this vast subject. I try to create miniature landscapes of the mind where shadows and multiple reflections compete or tumble between unidentifiable features which in the end remain as markers or points to serve a particular compositional 'flow'. I'm conscious also, of the symbolic value of light. To me it speaks of life, hope, awareness, and so I try to find situations where it occurs naturally and like so many photographers, prefer the form-revealing nature of black-and-white where colour so often seems like a rude interruption. Even most of my colour light shots are monochromatic.

There are times when I can be a bit shaky about whether I'm really interested in photographing the subject, or whether I'm actually more fascinated by the light that shows up something more revealing, something that

has a greater visual pulling force than the object or subject intended. Photographing light in this way has become for me a kind of episodic style exercise, able to excite the imagination and flex those creative muscles again in the pursuit of a more pure compositional style. I don't pretend to do anything of earth-shattering importance with it. It's simply a way of keeping photographically 'fit' by going back to basics and utilising the minimum requirements for a photographic image to take place.

'There was this almost clichéd image of a little girl in a straw hat in profile, leaning against a tree and holding a basket of kittens. But it stopped me dead in my tracks, and I can pinpoint that it was, in some respects, a small epiphany in my life; because what stopped me wasn't the picture so much – it was the light. She was just completely rimmed in light.' Keith Carter, 'Photographs: 25 years'

Getting the most from light

What would a series of portraits look like if they were all taken by the soft light of a car's interior rooflight? Or lit with the cold blue light of a television screen, or car headlights? They may be described as portraits of quite specific subjects, but the quality of light used to illuminate them would remain the single unifying feature of such a shoot.

Using light imaginatively encouraged one photographer to fix lights to his skis and photograph himself (having left a camera on a tripod with an open shutter at the bottom of the run), skiing down the mountainside. His route was visible as traces of light zigzagging their way down the slopes. Far less extreme opportunities to use light creatively mean that even the humble slide projector can make one of the most fascinating light sources available – especially if used as a low raking light across textured surfaces, or by projecting images on to unusual surfaces.

Different styles of lighting can make fascinating subjects for in-depth portfolios – backlighting, sidelighting, top lighting, or under-lighting. What if they were applied to completely inappropriate subjects? Light can be bounced between mirrors, split by a prism, or diffused through soft muslin. Absorbing and vibrant images can always be created from the light that surrounds you. It all depends how you temporarily trap it and manipulate it.

On The Floor: Emil Schildt
A light-painted nude by Emil Schildt. 'Some people call the painted light effect from light painting, "opera lighting, grand and beautiful".'

Common household lighting materials

Greaseproof paper – use to diffuse harsh spot lights.	White card or sheets – acts as a soft reflector, ideal for portraits around the home or for 'bouncing' light back into shadow areas.
Aluminium foil – use to reflect light back on to shadow areas, can appear 'shimmering'.	Light tent – basic light tents can be built around a simple box-like framework and covered with a thin sheet to provide a softly-lit 'stage'.
Black card – use to absorb light and create deeper, more dramatic shadows.	

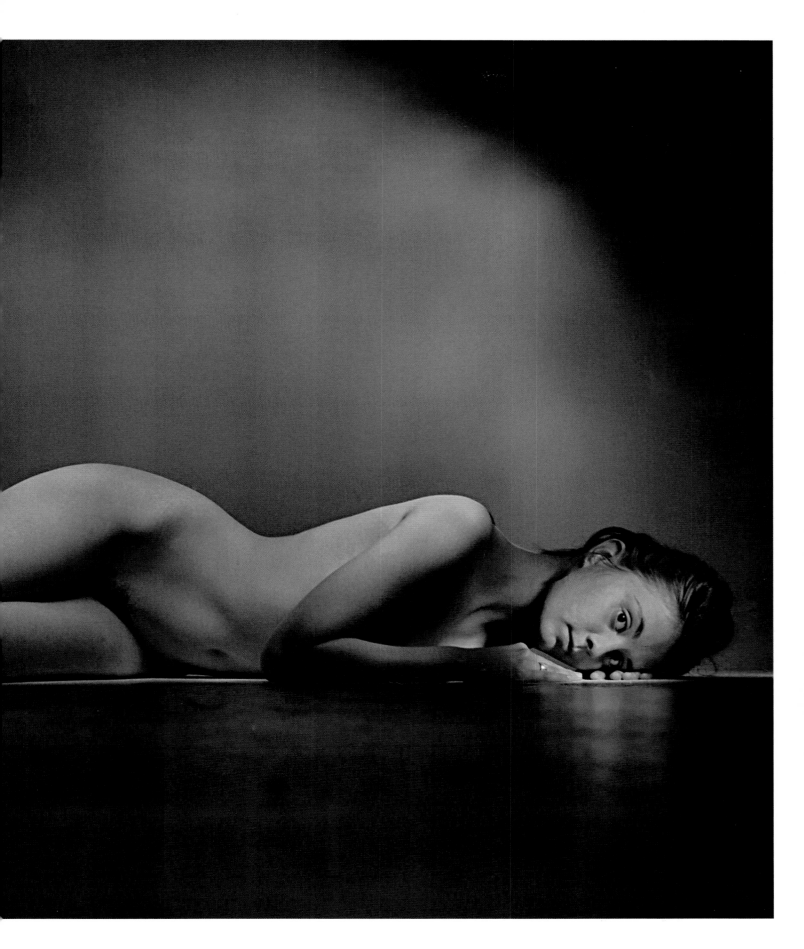

Summary:
fact or fabrication?

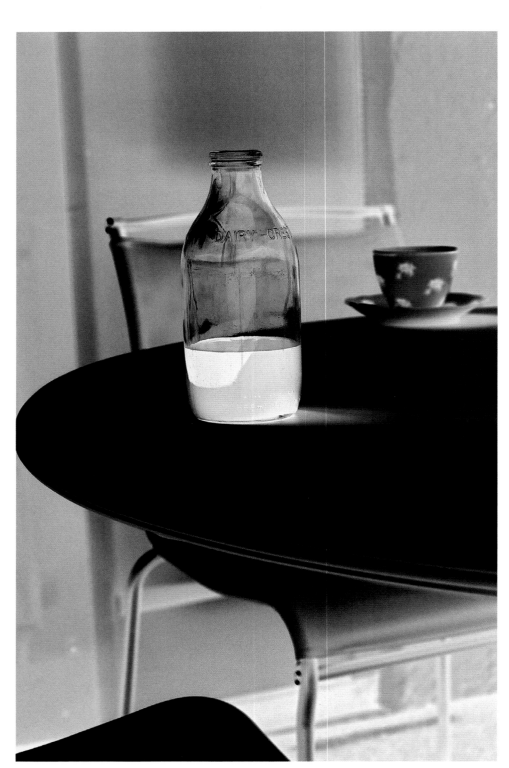

Black Milk: Jeremy Webb

Inspired by the title of a Massive
Attack song, this image was shot
on film before scanning to digital
for a simple Image > Invert within
Photoshop. Having turned the
image back into a negative,
I leave the viewer to work out the
actual colour of the milk when it
was shot.

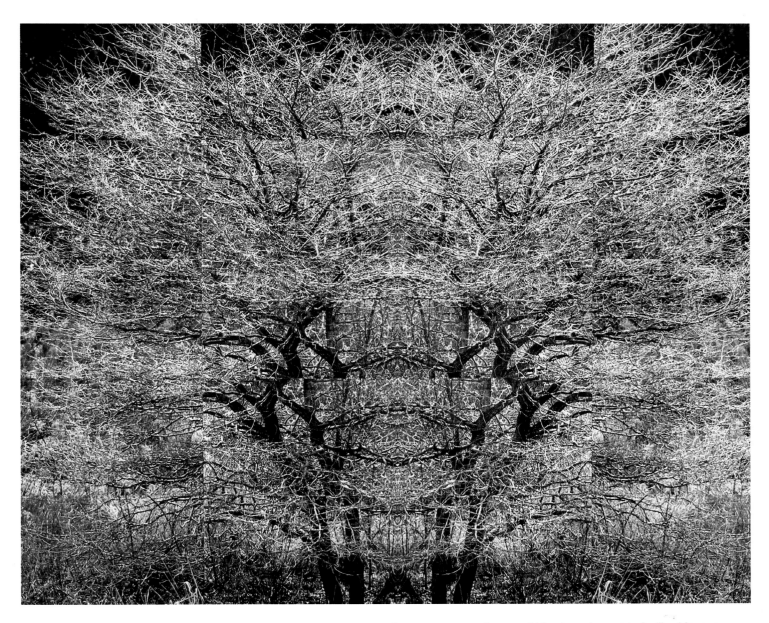

Mural 626 from 'The Veil' series: Stephen Livick

20 different images printed on watercolour paper and mounted on four-ply 100% rag-matt board, no digital manipulation used. 'In our highly materialistic culture, time, money and possessions take precedence over the flow of the spirit. Living lives dominated by ego and the hollow pursuit of success, our collective consciousness is closed and cramped. We cling to this lifestyle believing that we're in control of every aspect of our existence. And yet underlying this veneer of success is a powerful and creative life force that animates everyone and everything in a generative cycle of becoming. My deep awareness of this vital energy grows daily. I have little glimpses of it, often when I'm concentrating and working in the field. It is as if the veil between this dimension and the next is drawn back, for a split second, and then closes up again. I sense something very powerful beyond.'

In many ways, your inner world (and your inner vision) will guide your approach to your photography – whether you reflect back to the world a strand of real life made remarkable by your personal selectivity, or choose to give voice to your inner realities by transmitting its value through constructive use of materials. These are not polar opposites, merely two approaches out of many, and thankfully the art world has given us many different photographers exploring a wide range of these different approaches throughout their careers.

The study of work by other photographers can be immensely inspiring to those seeking fresh sparks of creativity. I've mentioned a few personal favourites by name, and there's also the work of the many featured photographers within these pages, but there are so many great photographers out there whose inner worlds have charged or driven their creative force.

From contemporary photographers such as Wolfgang Tilmans, to lesser-known (but historically significant) photographers like Clarence John Laughlin, these photographers give their talents to the world, and although it may seem that their practices are worlds apart from each other (as evidenced by the uniqueness of their images), they are all united and linked by their artistry, and recognise the value of these powerful interior forces to fuel their curiosity and feed their passion for creating photography.

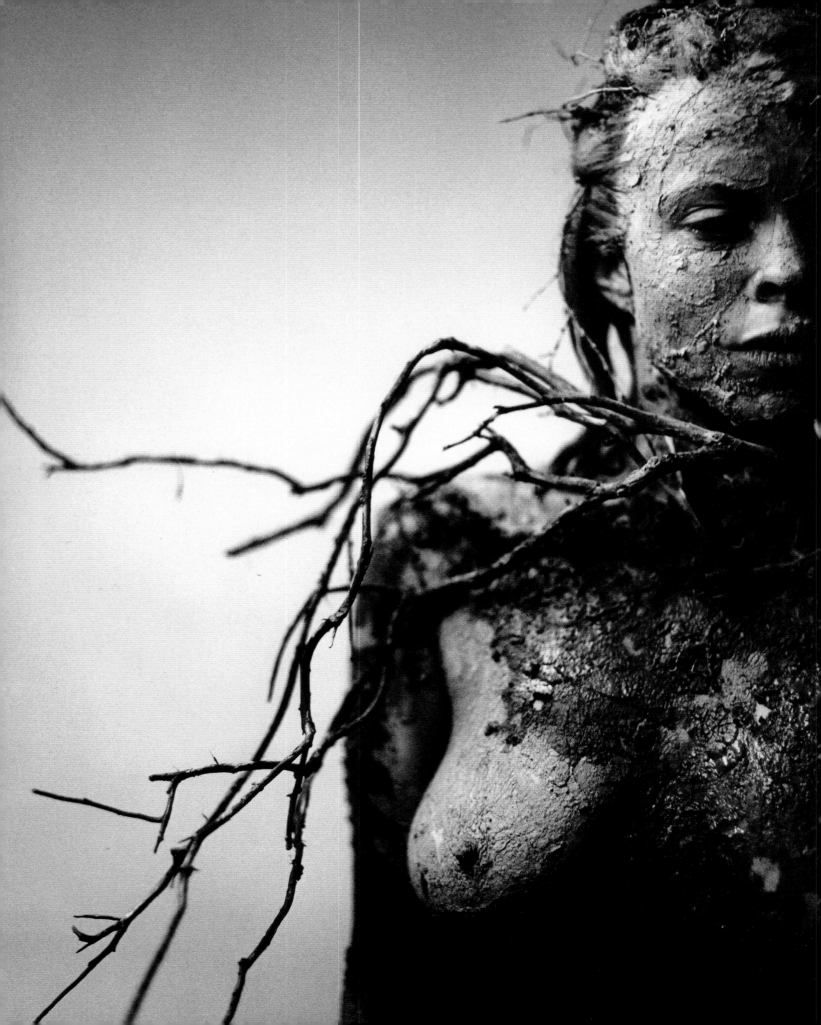

Image from Fragment series: Andrew Law

'I have a clear obsession about image-making that lives inside me all day and everyday. Although I can't realise everything that comes to mind, all of my ideas and visions live on different bits and pieces of paper that accumulate in one huge creative box.'

Muse: Louviere + Vanessa

This creative collaboration is an artistic partnership who share 'an obsessive enjoyment... to create beautiful and mystifying scenarios by introducing unexpected combinations of elements, things we've carefully thought out, but do not know how they will end... like the sense of your last dream that slowly erases itself leaving only the core feelings. It is this pairing of brute sense and intellect that motivates our images.'

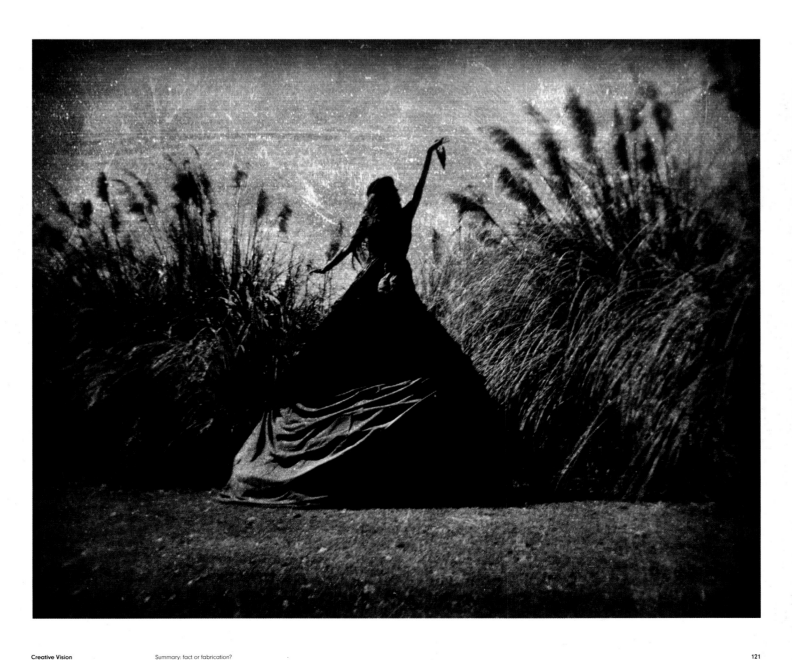

Abstracts and ideas, accidents and fragments, however vague, always find a place in my notebooks. They usually remain there 'marinating' or stewing on their own or with others, and often seem to create their own lives, regardless of my conscious intentions.

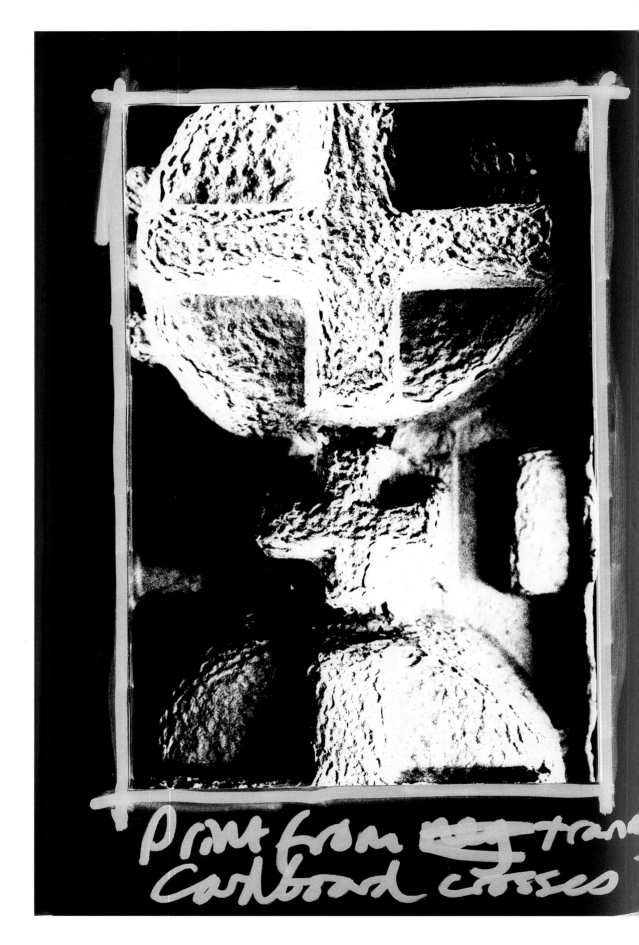

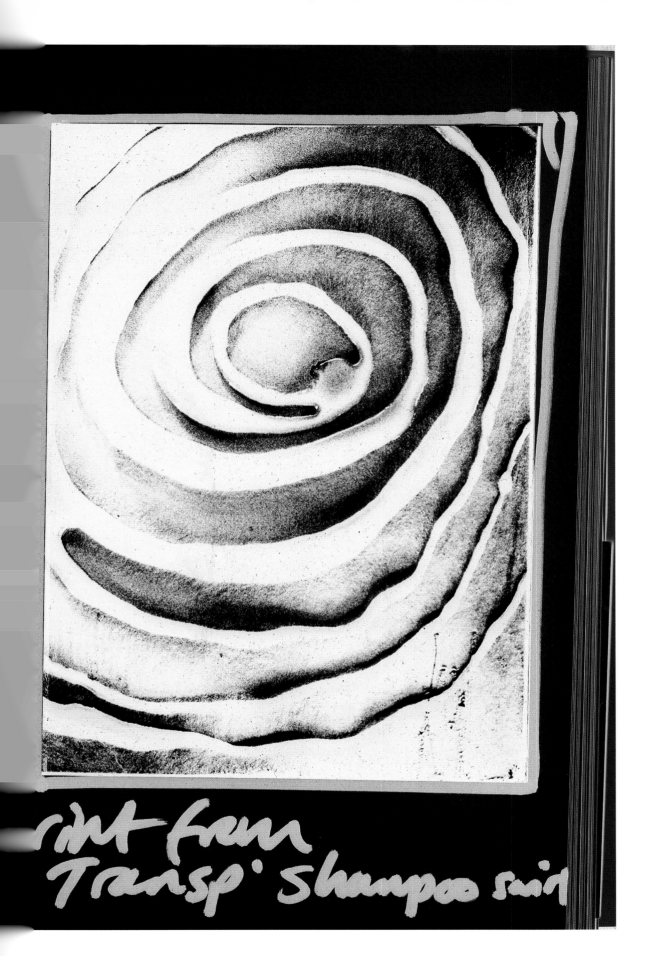

shot from
Transp' Shampoo swirl

Roller Ball, Minneapolis MN:
Gordon Stettinius
This is a beautifully-observed
scene taken from the viewpoint of
a child, through a sea of legs.
The toning and vignetting of
the print also help to evoke a
memory or dream-like
appearance to the image.

Picacho Peak, AZ October 2002,
Nickersons: Troy Paiva
Troy Paiva takes his light painting into the
great outdoors to craft these colourful
and slightly surreal night landscapes. 'I
used an early '60s vintage manual
Canon 35mm camera. Exposure was
done at night, during a full moon and I
used various light sources covered with
theatrical gels to light paint the subjects.
Each exposure was about five minutes
long. There's no digital enhancement
of these images.'

Chapter 8
The Outer World

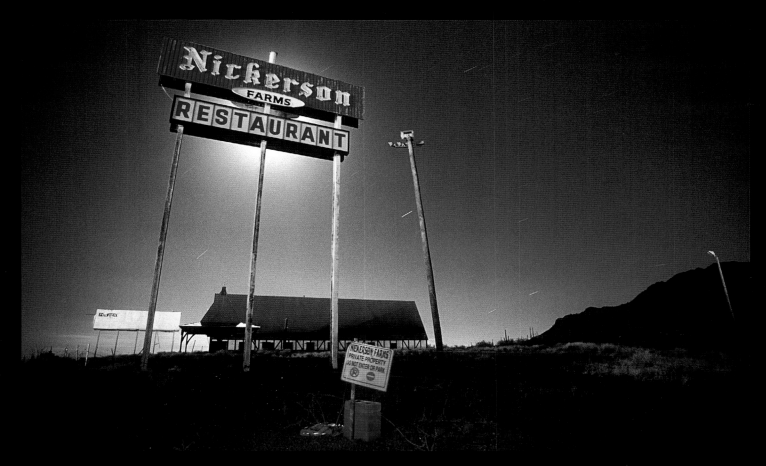

The outer world referred to is 'the stuff of life', the physical evidence that we are actually here. It is the flotsam and jetsam of everyday life, the people, and things that make up the planet, and is recorded by photographers who frequently (though not exclusively) offer a view of the world where their subjects speak for themselves through 'straight' photography with minimum artistic intervention or influence from the photographer.

It goes without saying that simply by raising the camera to your eye, framing and photographing your subject, you are making creative choices and operating artistically. Unmediated photography is not even possible with satellites or cctv because even then, it is humans who choose what these cameras are pointed at, and if photography is a two-way process, mediation occurs by the mere act of humankind interacting with the resultant images.

Without going too far down this philosophical line, it simply means that photographers who operate predominantly with a desire to show the world as it is rather than as it should/could/would be, will in the main adopt a more objective, neutral approach to their photography, even though they may be driven by a highly subjective creativity from within.

This section is more concerned with how creative photographers can utilise a variety of different approaches that more directly embrace the outer, physical world around us while still communicating vision with clarity and passion. Truly exterior or open photography is unfairly dismissed by creative people as somehow artless or soulless, lacking passion or vision by conspicuously avoiding any crude creative intervention, yet has often been celebrated as a strand of photography more 'worthy' and more true to photography's roots. Although such works still seem to have more value to the critic, academic, and the theorist than the photographer and his/her audience, there are ways of minimising these 'crude' processes of photography without your work appearing dull or artless.

Hopefully there are some straightforward ideas here which extend ideas on the potential of photography-based practice still further while maintaining a stronger, more direct link with the physical world 'out there'. Many of these concepts bypass the requirement for specialist materials and techniques (which can convey more directly a photographer's inner self-expressive realities), but concentrate on adaptations or extensions to the single, static photographic image, or address the issues raised by attempting to describe or portray the outside reality we perceive with the limitations of this 'butterfly collecting' medium of ours.

Series and sequences

Sometimes a single image is just not enough. Not enough to convey the intricacies and complexities of a subject or to do it justice. Rather than attempt to convey the impossible with one image, many photographers use series or sequences to present their works in an extended photographic format that can really add substance and depth to a project.

A series generally shows a range of related images featuring one subject or interpretation within one setting, at one place. Sequences tend to extend the simple series usually by having the images appear in a generally chronological order.

Each frame adds something extra to the one before, or assists the viewer by presenting work in a template that unifies the work into a synergistic whole, adding information and meaning in the process.

There may be many good reasons for creating these series or sequences. The simplest and most recognisable use is in the demonstration of the effect of

time on a subject: before and after. Other potential uses for this extended form of still imagery include:

To tell a story (narrative)
To include more than one point of view
To animate a subject
To show the architecture or space of an environment which would be impossible with a single image
To show more than one time frame in a set of images

Documentary projects are often presented together as a series of images in book or exhibition form. By doing so, artists and curators are able to assist viewers to build up their appreciation and understanding of a subject in a compound way, each image adding to those that have gone before and those that follow after. The best series or sequences enable a kind of accelerating involvement with the subject, which unfolds over time.

Although series can be used to present any set of images, however vaguely linked, the extension of the single photographic frame into a multitude of them suits the working style of many straight photographers as it allows them to mirror their own experience of a growing involvement with their subject.

Photographers who have innovated the sequence or series include: David Hockney, Duane Michals and Sophie Calle.

The Uncertainty Principle, # 12 (triptych): Warren Padula

Many of Warren Padula's prints are produced using a 50" wide Roland Printer. 'Uncertainty Principle is about the impossibility of measuring experience with photographs. It's a doomed attempt to make a forensic report.'

Kick. 2003 (Connor, the Long Meadow, Prospect Park, Brooklyn, NY 2001): Sean Justice

'An interest in story-telling and the presentation of authentic experience. These two ideas result in a desire to make pictures that feel either like a slice of life, an ordinary moment, or like an experience of the viewer's own.'

Girl with spotted ball: Sean Justice

Found objects and documentary projects

The 'butterfly collecting' approach I refer to relates to a rather cynical description of the act of taking photographs familiar to us all. At times, our relentless pursuit for images approximates this predatory, selfish grasping of moments so that we are compelled to trap them, then destroy their life, then preserve them for our eternal gaze convinced that these single moments have become ours forever. In doing so, we repress any realisation that their life and their place in this world have been snuffed-out.

Rather than grasping at single moments of life presented as one-off stunners, or trophy pictures, we have opportunities to try different approaches to convey our subjects in alternative ways. Using real artefacts or objects within a photographic presentation is one of these methods.

Photographers are on the whole, reluctant to consider the use of found materials and objects in their work, either because of notions of 'cheating' or because they prefer to maintain their 100% involvement with the medium that they trained in, and using found materials represents a small betrayal of this relationship. Something used by other 2D artists, or illustrators, in some other field.

In truth, found objects can be used in many ways – as the basis for a series of images, incorporated into a montage or collage, or even presented alongside the photographic image as a means of assisting the release of that trapped image by linking it more directly with the outer world. Rail tickets, luggage tags, all manner of paper materials can be used within a montage, and perhaps more familiar to many are the projects developed from ordinary family photographs that form the basis of more historical or biographical presentations.

Digital scanners can instantly record a variety of flat or even 3D objects, which can be incorporated into montage work far more readily than with traditional photographic methods. The files produced can be positioned, or 'thinned' using opacity control to merge with other layers, and sized to fit with ease.

Documentary projects allow photographers the chance to examine closely and reflect a subject in depth, over the course of many images. Using 'straight' photography in this way without recourse to post-production special effects or techniques forces the photographer to act instinctively, be self-reliant, and confident in their ability to record events dispassionately if necessary.

Here, images are created at the time of image capture, rather than re-assembled, reconstructed, processed or fabricated over a longer period of time. The notions of truth and objectivity are so enmeshed in the whole notion of documentary, that credibility is destroyed if digital manipulation or contrived events take place to satisfy the biased agenda or ego of the photographer. Even re-cropping, as every media student knows, effectively alters the whole meaning of an image by the inclusion or exclusion of seemingly trivial subject matter.

Documentary photography does not demand an unemotional, detached, or disinterested approach to the subject. Subjects that are close to the heart of many photographers can germinate into very strong projects and exhibitions in their own right, driven by the dual power of an interior passion and an outer ability to detach oneself and allow the life of the subject to project rather than the photographer's projection into the image.

Beyond documentary photography, there exists a wide variety of more 'applied' forms of photography – medical/scientific, forensic, architectural and so on. All concerned with truth, objectivity, proof, in other words the outer world.

Photojournalism might seem to have much in common with documentary, but the issues that face photographers in some of the more extreme events they have to cover can create huge conflicts between the interior life of that individual, and the more down-to-earth exterior demands for truth, objectivity, and the requirements of editors to sell newspapers. How can any human being return from the aftermath of a war zone unaffected? How can anyone take a neutral stand towards events or subjects that are truly dehumanising and tragic? Fortunately for most of us, we don't have to point our cameras at the world's death and destruction witnessed by thousands of news photographers across the globe. How many of us could really cope with having to create a 'good' or 'artistic' image of a dead body?

Whether your subject is the local boxing gymnasium, the everyday life of an ordinary family living in Brighton, or the slow pollution of the Norfolk Broads, your photography should still show passion and creativity without an over-reliance on technique or process. Your imagery is driven by your confidence to select moments and discard others, to allow the subject to speak for itself and to know when to step forward and when to retreat.

Light painting

Rhubarber: Emil Schildt

Light painting often works best with simple forms and subjects such as this. 'The technique allows me to enhance subtle details, which I cannot obtain in "classic" lighting.'

Some years ago I grew frustrated with the precision and predictability of photography. Technological and material advances meant that the once-imprecise nature of photography had given way to a more calculated era where everything was designed to leave as little room as possible for error. Exposure meters, Polaroids, etc. were all conceived to give the photographer maximum control over exposure and produce a technically perfect outcome.

Trouble is, I felt that I was being controlled by materials and technology. I wanted more risk, more spontaneity, and a less-predictable outcome, but I also wanted personal control over where the light hit my subject and to know that I could leave parts of the subject completely unlit if I chose to. I also wanted the thrill of not quite knowing whether my images would succeed or fail. I planned a series of still lifes in the studio where I could use a small pen-sized torch to literally 'paint' the light around a subject during a long exposure of perhaps 20–30 seconds or more.

Years later, I'm still light painting and grateful for those first few stumbling experiments in the dark for showing me an alternative lighting method that casts still lifes in a beguilingly revealing and unpredictable light. I am quite honestly hooked by it, and still working my way through a huge personal project based on light painting.

The mechanics of it are very simple. As its name implies, light painting is quite literally 'painting with light'. Almost a direct translation from Latin of the word Photo Graph(y). A blacked-out room is the first requirement, along with enough space to walk around a still life table, coffee table, or an upturned crate. Any camera with a decent lens and a 'B' setting (allowing open-ended exposures of a second or more), can be used on a sturdy tripod along with a cable release attached to the shutter. Tungsten-balanced film seems to work best as it returns the orange-coloured light, which would normally appear on daylight balanced film, to a more neutral white or warm-white.

You may need to experiment to begin with – opening the shutter with the lens aperture set to f16 or f22, to find the right degree of 'painting' required and the correct amount of time for the light to hit the film. Make notes if necessary to tally with your first developed film. Every camera and lens is different, so your light painting may require 20 seconds, 30, even 50 seconds to achieve a good overall exposure throughout. Remember also that white subjects will only need to be flicked over by the torch light, whereas black subject matter will need minutes with the light in motion before it will render itself visible on film.

The physical task of light painting is hard to describe, but it requires the practitioner to keep the torch in a kind of loosely-waving motion while highlighting the areas around your subject which you wish to highlight. This may mean planning a complete circuit around the table within 30 seconds' exposure time, or may mean spending more time on one particularly dark or difficult area. A low, raking light from the side works best. A moving light from above will render subjects flat and not bring out the best use of this style of lighting. Don't allow the torch light to remain motionless on any area for more than a second or two – highlight detail can be almost burnt away in a second or more.

Every light painted image is totally unique. It is simply impossible to replicate the same choreography of movement for a second time. It is also a gratifyingly physical process that doesn't happen in an instant. It reminds me of a return through time to the days when stiff Victorian gentlemen remained motionless with their necks in clamps to prevent subject blur on early photographic plates.

Chilies on Blue: Jeremy Webb

Light painting studio shots like these create numerous reminders of the importance of keeping things simple. The heat of the red chilies is offset by a cool blue background – actually a child's paint palette on loan from a local school art department and appropriated as a useful background.

My own light painting experiments have been attempts to subvert the whole nature of still life as a rather staid and clichéd genre. My own particular take on the whole idea of still life is hardly revolutionary, but it is important to me just the same as a personal means of 'redressing the balance'. I use my light painting to reflect the things that I find interesting, or the things that seem to turn up around the house, or under my children's beds – simply the stuff of modern life.

The effect of light painting on a first-timer is unnerving. There's a marble-like quality of light, something is odd or different, but you're not sure what. The major difference between this kind of light painting and any other form of photographic lighting you care to mention is that this slow technique completely disrupts our expectations of where light 'should' fall, and where shadows 'should' be. It's as if a low, raking sunlight has lit the hills and valleys of a landscape from the west, and other peaks and troughs of the same landscape have been equally well lit by a low light from the east. And all this appears to happen within the same instant. Within the same frame.

I also use light painting to create miniature tabletop landscapes of mysterious substances including liquids, modern packaging materials, and broken and discarded items of waste. It's a personal thing, but I actually find waste a fascinating subject. I'm far more interested in the remains of a product, or its packaging than any number of slick, shiny consumer products. I've also used light painting with the nude and for portraiture. The knack here is to have your subjects totally relaxed with head and shoulders supported. Blinks don't register on the film but roving eyes, deep breathing and even small movements of nostrils will show up unintentionally. The best way round this is to use a shorter exposure time but a correspondingly wider lens aperture.

It's my greatest hope that you'll find applications for this that are far more intriguing than the small patch of turf which I work on. I have a set of self-imposed parameters which define for me an area or space that I like to examine in depth, a personal theme that is all mine I suppose. I've no doubt that other, more ambitious projects could arise from this intriguing branch of photography. All it takes is a little experimentation and the imagination to acknowledge a need or realise a truth.

Extending light painting further

Consider every aspect of the process of light painting and see if any small changes or additions to the process provide any additional benefits to express your ideas, for example:

Try using daylight film (= blue cast).

Try using coloured gels on the torch.

Try firing a burst of coloured flash to light backgrounds.

Try using movement more deliberately, exploit the techniques perceived as weaknesses or drawbacks.

Try landscapes at night.

Developing themes

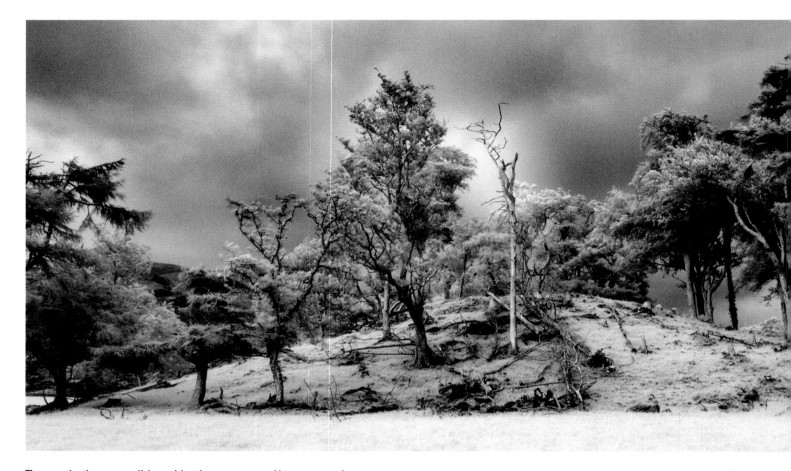

The use of a theme or unifying subject between a set of images can often create a body of work with far greater strength and substance than a random selection of arbitrary images, however good those single shots may be.

Such themes are ordinarily borne from something very close to the photographer. It makes little sense to embark upon a project without any passion or interest in it (unless you're being paid to of course). Sometimes one can be attracted to the idea of creating an image and not know why. It is only afterwards, or during post-production that it becomes obvious that the image 'fits' within a concept or theme of personal interest or involvement, however tenuous.

The instinctive photographer learns never to analyse too deeply, taking pictures as and when 'because it feels right', and trusting their own ability to act intuitively. Just because no immediate motivation or rationalisation is available to them, it doesn't mean that they should walk on unaffected, or snap away without thought or consideration. This post-event rationalisation is not always shorthand for working backwards to fit odd images neatly within a ready framework, neither is it justification by hindsight. Time can uncover reasoning and insight that couldn't find the vocabulary at the moment of recognition.

Trees, Isle of Mull, Scotland:
Michael Trevillion
Pentax 6x7 camera, Kodak
infrared film from Silverprint.

Shadow #20:
Kimberly Gremillion
Nikon N90S, high speed 3200
T-Max film, 80–300mm zoom.
'My creative vision allows me to
photograph what people suspect
is present but rarely see, to peek
into that place between darkness
and light; sleeping and waking;
the unconscious and the
conscious. My work is very
personal and is not a document of
the circus. I use the circus images
as a springboard into humanity.'

Subjects can throw themselves at you demanding that you embrace them, or they can be uncovered over time, revealing themselves to you slowly until you realise that your love of ambiguous empty spaces or your ambivalence towards barriers have motivated you to create a body of work which was, in its entirety, invisible to you as you gathered the materials together. Along the way, you may have photographed puddle reflections, clouds roaming through skyscraper windows, and so on, before allowing the process of time and the perception of your inner eye to make connections where none previously existed.

One of the best pieces of advice ever given to me by a publisher encouraged me to look thoroughly through the whole of my photographic output, and spend a week breaking it down into as many different categories as possible. Luckily for me, I had a spare week at the time and took him literally at his word. It was time well spent.

The process began with the obvious; portraits, landscapes, nudes, and so on, before moving on to categorising in as many different ways as possible; colour, or black and white, distant or near, and then on to specific locations, specific people, and so on. Later still, my quest for associations between my images evolved into ever-more abstract concepts which I had never previously acknowledged – intrusions, emptiness, red, pairs, surfaces, playtime, habits and rituals, traces, covering cracks, and so on.

By continually grouping and regrouping my work in this way, I discovered things about myself which were previously hidden. Images that were isolated and ignored – but which I never quite managed to summon the courage to throw out – became iconic, gateway images to unlock further associations, other images found strength inside newly-acquired family groupings, or created valuable starting points of their own for further ideas, which then grew into significant projects stemming from one single germ of an idea. This intensive inventory and analysis process allowed me the confidence and insight to concentrate on what was really important to me.

Most themes develop in this way. Something triggers a reaction which alerts the artistic eye and demands from the photographer a more considered response. These triggers can arise from both the inner world of concept and emotion, and from the outer world of actuality, society, culture, geography, and so on. If you face a creative block, or feel the need for fresh inspiration, the development of a creative theme can really refresh your motivation. Some of these starting points are given in the table below:

Themes by subject – people, profession, location, lifestyle
Themes by style – magnification, abstraction, a way of seeing that uncovers new worlds perhaps
Themes by 'emotional landscape' – dark corners, empty park, football pitches
Themes by concept – division, humanity, isolation.

Don't think, just shoot

Organ Pipe Cactus,
International Botanical Area:
Jeffrey D. Mathias

The book title 'Don't think, just shoot!' literally leapt off the shelf at me as I wandered through a local bookshop casually studying the books on view. It seems to capture with just four words the kind of reckless abandon that many of us have lost from the practice of photography, but one which nevertheless allows us the opportunity to photograph spontaneously; perhaps even without conscious thought. This kind of approach can be breathtakingly liberating, but impossibly hard to achieve.

Like any practice or profession, students are asked to work hard for their studies, and rightly so. We all know that you can't get anywhere without a certain amount of input, effort and involvement. Unfortunately, we repress those little voices in our heads that urge us to forget sophistication and artistic intent. Just do it, go on, act like a kid, whatever, but just do it.

It's really a plea to be less cerebral and more spontaneous. And thank God for that. Sometimes photographers get a bit precious about their work and need to be taken down a peg or three, to be shown a more unplanned, carefree approach to image-making that relies on instinct, a sense of fun, and freedom from the tyranny of choice.

The kind of choice I refer to is the multitude of shooting modes, shutter speeds, or file types that today's cameras (film and digital) supply us with. Freed from such issues as 'Do I use f.8, or can I get f.16 with a slower shutter speed?', spontaneous photography expects us to use a disposable with auto flash if needed, no focusing, and one shutter speed. It might just allow the 'P' program for automatic exposures on a 35mm camera, but no more than that.

It's hard to imagine most consumer digital cameras coping with this kind of approach. All those little buttons to scroll through, LCD screens to activate – not to mention the shutter delay. Many Holga camera enthusiasts express a certain childlike and spontaneous vision through the limited functionality of their toy cameras. Its operational simplicity, as already discussed, allows users the freedom to concentrate on the picture above everything else, and not be distracted or influenced by technical issues in the process.

The real value of spontaneous photography is found in those images that speak a kind of simple truth without artifice, or even art – a kind of 'anti-photography' which usually delivers stark shots of the everyday in a refreshingly honest way. If you've never tried it, or been frustrated at the lack of 'flow' in your work, get a couple of disposables, go out to the beach with friends, and just do it.

A sense of place

Untitled: Mark Holthusen
Empty spaces, keenly observed, elicit a sense of eerie involvement within the frame by the simple realisation that no one else is present at that scene. You are free to look unselfconsciously for as long as you want.

Bedsit Window: Jeremy Webb
Taken with a 5"x4" camera, the camera was mounted on a sturdy tripod. Both curtains were flapping in the wind let in by the open sash window, but because the exposure time of one minute recorded the movement throughout this period, the curtains appear as a ghostly and transparent image of their stillness.

The ability to extract a real and recognisable sense of actually being there is another form of the single image 'extended' into a documentary series of images that convey a vision more powerfully than the single shot. One image might present a 'condensation' or an abstraction, two or three additional images would give a further impression of greater strength, and half a dozen or so would represent another far more substantial and involving set still.

This kind of project usually appeals to the photographer sensitive to the atmosphere and nuance of a found interior space who seeks to capture and convey the essence of that particular environment, to give greater significance to an activity or subject that takes place within that space, or simply for its own sake.

The real challenge faced by embarking on this kind of project is that it throws up a similar issue affecting landscape photographers too – that of the reductive flat box to contain it all in. Many would argue that this weak distillation of the real world and real experience into the flat, four-sided box is always going to be photography's biggest problem anyway – no matter which genre or style you work in.

But leaving the bigger argument to one side for a moment, it's one thing to be strolling down the deserted hospital corridors of some abandoned institution, or through the crumbling rooms of an old cottage in a state of heightened awareness, but stick a viewfinder round it all and it becomes hard to convey that same assault on the senses that was present at the time, but now has very little evocative power.

It's the same kind of deal with landscape. Standing with your loved one on top of a cliff, breathing in the air, hearing the seagulls, and smelling the sea air, with the wind in your hair. Putting a box round that little lot can be so dispiriting. The way photography can distil that vast ocean full of reality into a frustratingly dilute interpretation inside four sides of that box still staggers me, but also motivates me to work harder to reach beyond that barrier.

Those who convey this kind of appreciation of space and our interaction with it often do so by careful attention to minute details that give 'clues', either overtly or covertly, to its history, purpose, potentiality, atmosphere, and soul. In recent years, there has also been a growing and recognisable movement promoting photography that avoids any representation of humankind, however small in the frame, its concern being simply with the empty space, and the traces that humans leave behind – the presence of their absence, if you like, and the environments these absences occupy.

Technical issues concerned with accurately and faithfully recording these environments must be considered carefully – black and white would suggest a subjective, interpretive response to the location rather than the accurate and more objective use of colour. Additional lighting could destroy the atmosphere as it was, obscuring a more accurate scene simply and directly revealed in the light available at the time.

Above all, personal success in this field requires a kind of clarity of vision that is untainted by the expectations of others, and is confident and self-assured, responding judiciously to the outer evidence available to you, by sensitive inner perceptual skills that recognise the emotive power of shape, texture, irony, space, suggestion, and so on. It also represents one of the best possible opportunities for self-expressive photographers to attempt a different style or approach by adapting to a more open style of photography, even if only for a very brief foray into this absorbing and hugely challenging world.

Summary

I'm often amazed at how polarised the photographic community has become – as if taking an interior/closed approach to photography automatically precludes you from taking other projects on which suggest a more exterior/open approach, or vice versa. It is possible to work with both, although I understand an artist's requirement for developing a coherent style that is immediately recognisable and necessarily single-minded.

There is more scope perhaps in mixing these two approaches recreationally, rather than professionally, so that a more rounded view of the medium is acquired, as well as a more rounded view of the artist themselves.

Some would argue that the exterior world offers the photographer easier pickings – far less hassle to scrutinse the stuff of life than look inside and give voice to humanity with all its rough edges and dark secrets.

The photographer or artist with creative vision will simply be driven by what feels intuitively 'right' as the means of transportation of that vision. Having been exposed to high quality works from both ends of the spectrum (and all shades in between) he or she will recognise in an instant the 'oneness of everything', the idea that the interior and exterior are interdependent, that neither could exist without the other, and that having the confidence and self-assurance to follow one's own path with positivity and an open-minded approach is the best way forward.

Janus CD booklet illustration:
Alessandro Bavari
'I started drawing when I was
three years old and became
interested in painting and
photography when I was 15.
I studied traditional techniques for
the use of colour in painting and
experimented with various
techniques in photography using
darkrooms...events and
impressions of the world make my
work what it is.'

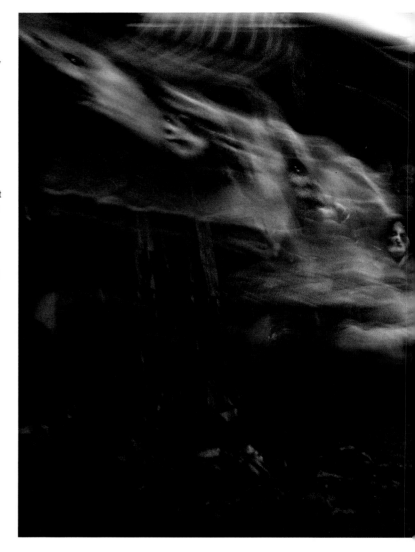

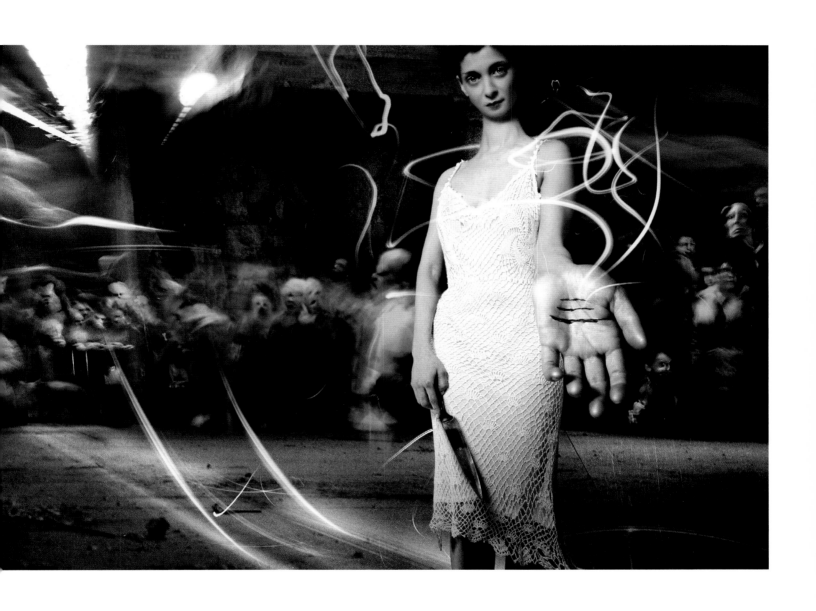

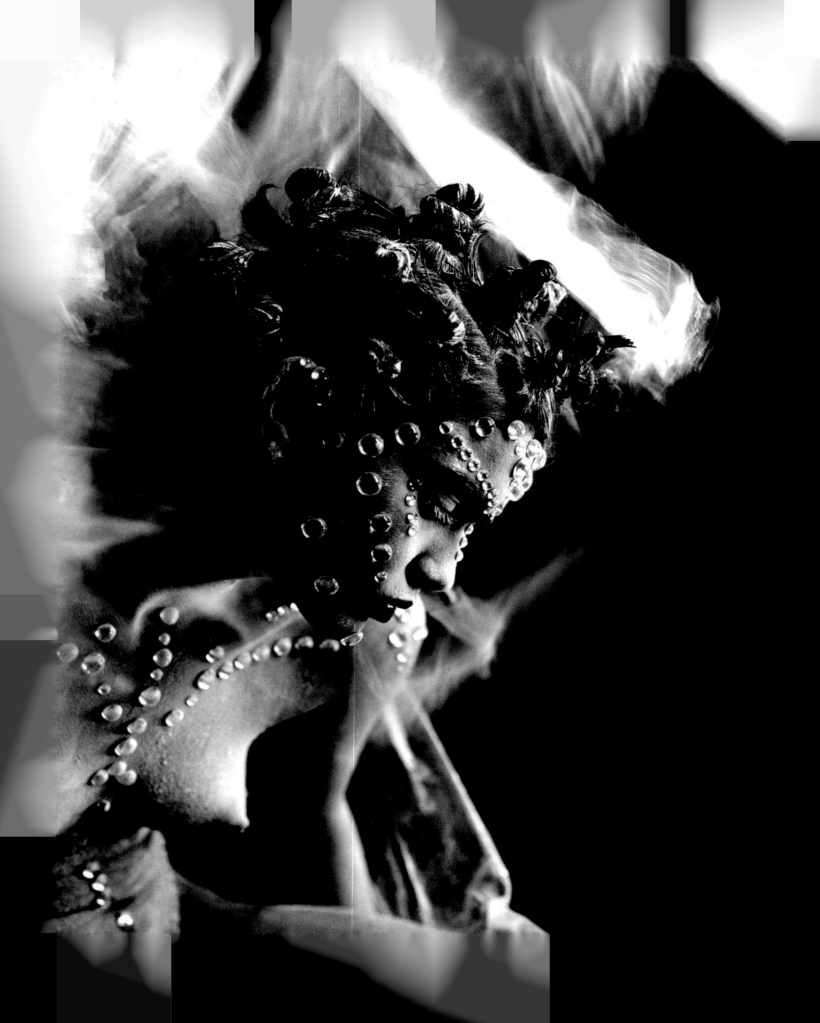

Chapter 9
Extending Traditional Genres and Styles

**Image from Fragment
series: Andrew Law**

Law has successfully woven many
influences together into a series
of beautifully mysterious images.
Andrew uses Tri-X film, which is
well-known to be a reasonably
forgiving film, and allows him to
'not worry too much about the
technical details. This results in
more freedom to create'.

**The issue is the same for all of us – how to go beyond what already exists,
or how to improve on what is already out there. Creative vision requires a
passionate determination to innovate and extend traditional approaches to
photography by feeding and nurturing a continual hunger to understand
and evaluate every area of this wonderful medium.**

It seems to me that in recent years, some artists have fallen back on the safety
of a digital world that still has a huge facilitating power to delight and thrill, but
which can't yet escape from the charge that it hops like a cuckoo into the nests
of other birds whose nests are already built.

In photography, it has simply seeped into the medium and really got its
claws stuck in with a frightening speed, but despite the still fresh excitement in
the opportunities it presents, much digitally-enhanced photography still does
just that – it enhances the speed of process, enhances the choice of materials
and techniques available to artists, but its users often forget that great vision still
comes from within the artist.

Many of the greatest photographers of the last century identified their own
clear path to follow, and did so with a fiercely independent appetite that
communicated its singularity and strength to a wider public. Where will the next
great photographic communicators come from and what will the new terms of
reference be?

Traditional yardsticks and touch-points currently used to measure today's
great innovators by, will shift and reappear in a different form, just as the social
and artistic culture surrounding us shifts and bends and creaks around us. Our
ability to pinpoint these slow and subtle movements is weakened by our
inescapable immersion in them.

Appropriated images

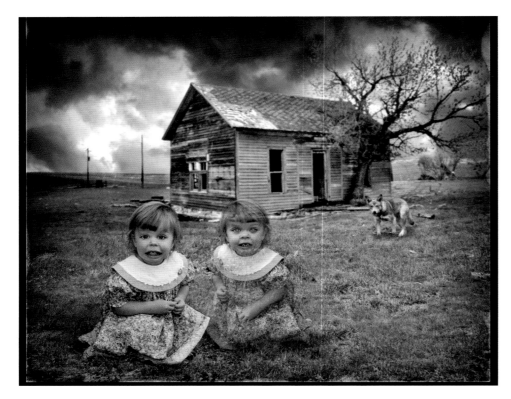

**Pretty Frieda and Her Imaginary
Friend Hunt for Bugs in the Yard
(Western Gothic series):
Patrick Loehr**

Loehr's digital montages are
humorously grotesque in their own
right, but the titles themselves
provide a vital extra dimension to
their impact and also give a
narrative context within which they
form part of an imaginary
historical series.

**The use of imagery that already exists came to peak prominence in the
1960s' Pop Art movement when post-modern artists reacted and responded
creatively to a kind of cultural saturation point. Their own works, which
incorporated appropriated imagery of their day, reflected many of the
current themes of the time – the rise of mass-media, the emergence of
celebrity culture, mass consumerism, and the art of the ordinary and
everyday. Uncanny how so many of these issues are still with us today.**

Foregoing traditionalist concerns of 'originality', the use of appropriated images
was in many ways a forerunner to the digital era. Artists found ways to more
directly incorporate the real world into their frames and canvases. Why
photograph a piece of wallpaper when you can glue the damn thing straight on
to the canvas? Across the whole spectrum of art, artists were finding and using
found materials from chocolate bar wrappers to real world urinals to blur the
boundaries between life and art.

Using photographic images within an appropriated image framework
allows the artist to re-contextualise that imagery, to apply contemporary
meaning to past images, which in turn reflects an artist's perspective. In the UK,
photographers like Jo Spence found powerful means of self-expression by
referencing popular culture and by using her own body and her own personal
history to combat what she felt were highly negative forces of modern culture
and politics around her. By doing so, she powerfully reclaimed her own sense of
self in the world and brought into being a very thought-provoking body of work.

Appropriated imagery has featured heavily in the formative years of many
well-known American photographers – Robert Mapplethorpe began
experimenting with it before taking a more active interest in creating his own

photography, and many of Cindy Sherman's film still series of self portraits were
based on found monochrome motion picture stills from the time.

Today, many photographers are plundering a whole range of new media to
create work that often pushes hard at the boundaries of acceptability outside the
artistic community. Thomas Ruff has appropriated images from internet porn
sites to create a series of nudes that have been enlarged and manipulated to
powerfully re-contextualise the original images. Nick Waplington has also
created a fascinating series of fake websites using real and constructed visual
material pulled from the world wide web.

Visual artists must take care if they use others' imagery within their own.
There are serious copyright issues at stake here, and a whole army of lawyers at
the ready to march in and sue for misappropriation. Greatest care should be
taken with images of recognisable people or famous artworks, and especially
global brands. We've seen artists in serious trouble over 'offensive' abuses of the
Barbie Doll, McDonald's, and that icon of American popular entertainment,
Mickey Mouse. These ubiquitous symbols of modern consumer culture are such
tempting targets for artists because of their bland omnipotence.

Aside from the legal and ethical issues involved, image appropriation is
another form of photographic practice that is best left to the transmission of truly
strong ideas or visions which demand a multimedia approach rather than
merely falling back on a process which is unsuited to its subject. That said, if it's a
new area for you, there's plenty of great work out there. If you can't say what you
really want to say with single-shot straight photography, try letting loose with the
family album, or a stack of magazines, but try to use it imaginatively. Try saying
something pertinent about the life that you lead, or the cultural 'water' within
which you are immersed.

The nude

Michael: Emil Schildt

'I am influenced by a lot of
different people...sculptors,
painters, musicians/composers
and other photographers: A
whole palette of people and art.'

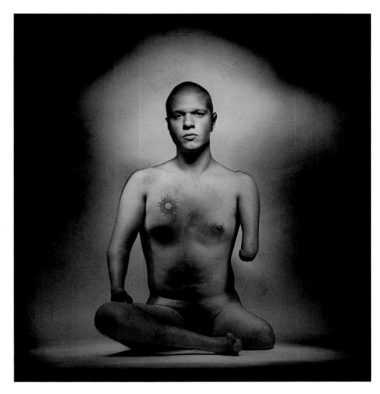

**Like no other subject in photography, the human body represents one of
the most discussed, most widely interpreted, most censored, most keenly
viewed, most polarising subjects to stand, sit, or lie in front of the camera
lens. How can any artist truly do anything new with a body that hasn't been
done before?**

Let's get a few things out of the way to begin with. The naked human body is,
for whatever reason, much discussed and viewed at present. There are a
thousand different interpretations one can apply to images of naked women
and/or men. Academics, theorists, historians, and artists all have them and
there are a thousand million different theories on why we do it, what it all means
today, why it corrupts, why it objectifies women, why it's done by men, why
freedom and democracy demand it, and so on.

We've had decades of the male gaze, of men objectifying women, of pre-
millennium pendulum swings where women objectify men, the strangely
appendage-less male nude for mainstream consumption, and a whole flurry of
recent additions to the range of advertising's physical stereotypes – Ad Fantasy
Man with his six-pack stomach, naked supermodels flogging perfume on
billboards, and so on.

The confrontation of taboos is one of the most important steps required to
nudge and prod the creation of new developments in the use of the human
body in modern photography. The naked body and the medium of photography
are too closely associated with pornography, while the rest of the art world has
acquired higher status with the unclothed figure via the classically figurative and
sculptural nude. Photographers and artists are continually challenging these
associations and pushing the line between the acceptable and the indecent.

Nudes in photographic art have traditionally fallen into abstract, classical or erotic. This may seem a touch simplistic, but I still believe this to be generally true. Abstract will continue to provide a rich source of experimentation for photographers. In the past, photographers such as Bill Brandt and Andre Kertesz worked on the distorted nude inspired in part by German Expressionism. Classical represents possibly the least potential for innovation, and erotic perhaps the most. These simplistic categories will expand and contract along with society's changes towards taste and freedom. But simple categories aside, in order to really take the whole genre forward into new areas, artists themselves have to consider many of the following issues, and face some honest self analysis head-on, before stumbling unprepared into this field. The questions below were summarised from a session with a group of students and have been grouped roughly according to general areas of doubt or concern:

Do we continually question the ideals (and the language spawned by these ideals) and our own attitudes of what constitutes nude 'beauty'? Whose definition are we referring to? Who sets the parameters? Who judges the outcomes?

Do we speak as we find, operate spontaneously, or do we trip ourselves up and gag ourselves on someone else's political correctness? How do we escape cultural conditioning, and how safe is it to do so?

Do we operate within a moral framework? Do we ask our models to do anything we would not do ourselves? Where is the division between observation and exploitation?

Do we knowingly or otherwise, bring our own sexuality into the process? Do I contribute something worthwhile to nude photography, or am I just following a conditioned path? Does my heterosexuality make me insecure or prevent me from photographing naked men? Does being female condition me against photographing nudes of either sex?

Do we further our understanding and appreciation of the human form in photographing our subjects in this way, or are we repackaging the past in a different form?

'Taking a picture of someone is a way of touching them. It's a caress. My pictures often come from erotic desire. It's like having safe sex.' Nan Goldin

Terry's Torso: Emil Schildt

Untitled: Jeremy Webb

I often seem to exclude the face from a nude, or at least cut across it. Faces request our attention, and I personally find that including the whole face makes it a portrait, rather than a nude, which says something perhaps more general, rather than specifically relating to the subject.

Some of the most interesting work with the human body has come from photographers who use themselves as their own models – John Coplans for example – exerting power and control of their images over no-one but themselves, and sometimes working to redress an imbalance or develop a political theme (In John Coplans' case, the invisibility of age).

Other photographic artists who have highly individual approaches to the nude include Spencer Tunnick, who seeks out the involvement of thousands of ordinary naked men and women in his human 'landscapes'. Robert Mapplethorpe, Vanessa Beecroft and British photographer Rankin have also contributed their own highly personal use of the nude in their work to great effect in recent years.

The human body, as opposed to the nude, is still the source of much conflict and negotiation between art and documentary photographers and their audiences. In recent years, Andres Serrano's images from a morgue offered the dual discomfort of respectful and beautiful pictures, which convey a previously unseen reality of death. Another taboo, particularly in Western culture where our everyday experiences of death go unseen. Alexa Wright took an unsentimental view of disability and normality with her series on amputees and skin abnormalities, and still the work of Joel-Peter Witkin continues to provoke revulsion and fascination in equal measure, while still being widely published, exhibited and discussed around the world.

Ultimately, the human body represents so many things to so many people – the challenge remains for photographers to find new and genuinely innovative ways to communicate their own visions divorced entirely from the crushing weight of current received wisdom.

Still life

Untitled: Jeremy Webb

So often, still life becomes a process of stripping away. We've almost become programmed to adding, compounding, cramming the set with all manner of unnecessary things, when all we really need to do is reduce, remove, pare down to the essential.

Yellow Boot: Jeremy Webb

Experimenting with different film formats enables you to consider and compose subjects that don't always present themselves if you stick rigidly to one type of camera, or one film format.

We all know (or we think we all know) what still life is. It's an item or a collection of items that are photographed on a tabletop. Unfortunately the still life genre for many people conjures up a very limited vision of what the term actually represents in terms of its creative potential.

I think we need to look back a little way through history to understand just how this limited vision of still life came about. John Berger, in his book 'Ways of Seeing', discussed the way in which oil paintings began to depict things as a way of possessing those things. Rich merchants might display their wealth in abundance with a commissioned painting in an attempt to preserve that wealth and prosperity. Fruits and pheasants would be consumed, or would perish and decay. Their presence was temporal, but a painting would last for many lifetimes, and carry forward the proof that one could buy whatever one desired.

The still life in photography has become a way of validating the media's own shaky self-confidence under the glare of painting's far more substantial artistic legacy. When photography was born, early pioneers were forced to use long exposures to record scenes on to surfaces. By referencing imagery available to them at the time, they naturally looked to painting for ideas and found simple tabletop scenes of fruit bowls, flowers, and so on, which reflected a necessarily romantic and rural pleasantness, and remained motionless for the camera.

These very early photographic still lifes came to represent the means by which photography claimed a kind of artistic parity with painting, and although other subjects were attempted with equal enthusiasm (portraits, rustic outdoor scenes, grand landscapes and so on), these early still lifes burnt their way into the consciousness of photographers and have preserved a stereotypical image of the still life ever since.

Modern photographers are capable of exploring so much more than falling back on these tired old templates. Contemporary life is so full of 'stuff' to photograph we're practically drowning in it. The still life appeals to a wide variety of photographers with various motivations and styles. Documentary and 'straight' photographers who record the world as they find it use still life as a kind of microcosm, which is truthful and accurate and signifies a bigger picture or wider scene by closing in on specific details. Expressionist photographers use abstract by selection, or manufactured scenes to express highly artistic inner visions.

Like many styles and genres, the modern still life is interpreted in new and exciting ways in an attempt to avoid being pinned down under more precise and limiting definitions. Although contemporary photographers can look to old masters like Irving Penn who is to many, the true master of the still life, there are photographers like Wolfgang Tilmans, and the late Helen Chadwick who have both in their own unique ways used the still life genre to great effect during creative explorations throughout their careers.

Still life is most commonly split between two main approaches:

Found still life – where scenes are recorded as they were found, with no intervention by the photographer.

Constructed still life – where the photographer has complete control over the inclusion and arrangement of elements within the scene.

With the advent of digital image capture, the simple desktop scanner becomes a very useful way to gather images that can be positioned in montage work or transformed within Photoshop.

If this is a genre new to you, or you don't quite know where to start, begin by developing a strong theme. This allows you to make comparisons between images made from one site and those at another. From past experience, some of those subjects given below have inspired some insightful work. These are only suggestions, from which I have seen more interesting work generated from. A thorough brainstorming with friends might throw up some more challenging choices:

Found under the bed
Garden sheds
After the party
Desktop and top drawer
Mantelpieces
Handbag contents

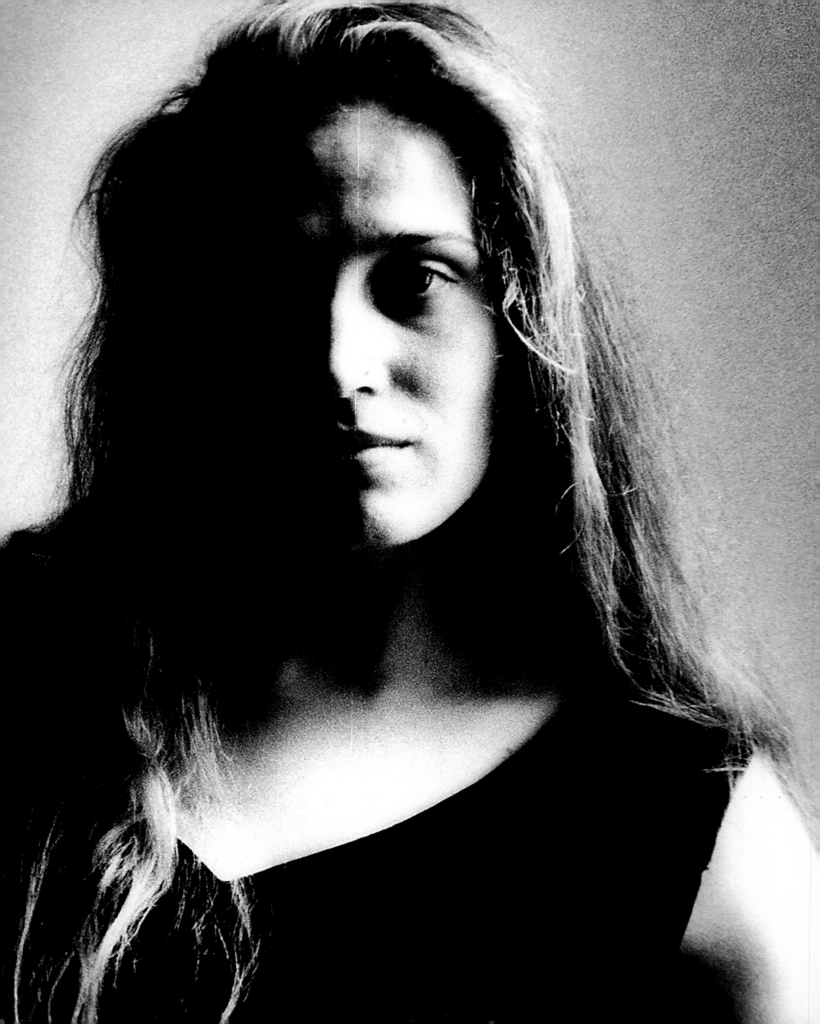

Portraiture

'A successful portrait is about the maker, the viewer, and the subject. It's about all three in nearly equal proportions. That's when a picture really works...when it's about all of us.' Keith Carter, from 'Photographs: 25 years'

Which of the above do you agree with? Any, or all, or none? The human face and figure has always been a favourite subject for photographers, and there have been as many creative approaches to portraiture as there have been sitters in front of the lens. Each photographer it seems carries with them their own unique take on the field of portraiture.

Untitled: Jeremy Webb.

I've always been a fan of strong, contrasty lighting, and saw no reason here to 'correct' the deep shadow or to soften the lighting in any way.

For many, it's a given that 'good' portraiture must impart something about the individual – their personality, profession, reputation, etc. But perhaps more than any other branch of photography, portraits are open to a huge range of interpretations by their audience, who bring so much of themselves to portraits and perceive meanings and associations which are uniquely personal to them, and completely outside the photographer's own control or motivation.

For this reason, many photographers have created deeply personal portraits of both famous figures of the day, and ordinary people, only to have the viewer completely ignore the intent of the photographer, and instead focus on the subject's perceived expression, or find greater significance in a minor detail. Is this a failure on the part of the photographer?

This range of responses is for me, what makes the portrait such a fascinating area to explore. One can take a portrait using a whole range of stylistic intentions one day, another quite different angle the next. An open and spontaneous approach seems to work best, and a certain loose willingness to allow things to happen. Although of course, many of the world's best-known portraits were created under tightly-controlled, technically precise conditions where one single intended outcome was planned for and skillfully executed.

Like many photographers, I've arranged shoots with subjects where several hours were spent in elaborate lighting sets, coaxing certain moods, or exchanging dialogue to draw something more from the sitter, only to find that

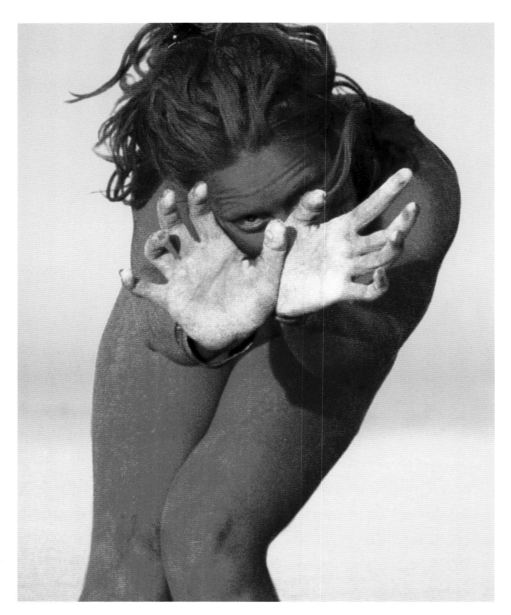

'Photography is like shooting people.' Susan Sontag

Red Girl, Black Rock City,
Nevada: Todd Kurtzman

This stunning image succeeds with
simplicity and directness from an
artist who is principally a sculptor
and who photographs dancers as
reference. Poses that he thinks will
translate well into three
dimensions are arrived at from the
photo and a live model to create

the sculpture. 'Within my work lies
a call to resurrect the ancient or
displaced values of nature
worship, the sacred feminine,
sexual expression as natural and
healthy, the symbiotic
relationships of yin and yang,
regenerative consumption, human
rights as the hallmark of freedom,
and individual spiritual truth.'

the 2nd of two frames fired off accidentally right at the beginning of the film
before the 'official' session began, providing me with an image of
breathtaking simplicity that goes way beyond the success of any of the later
official shots.

There are no ten commandments of studio portrait photography. It all
depends on the what, why, when, where and how factors. It's a fluid exchange,
primarily between yourself and your subject, but always with the viewer in the
mind's eye of both sitter and photographer. Being relaxed always helps, and
so does going into a session with planned ideas in tandem with the flexibility
to change course at a moment's notice.

For environmental portraiture, the experience is often less intense. Here,
your subject might find themselves in a secure environment of their own
choosing where they feel more relaxed and where you are the outsider. Your
subject might respond to you with complacency, annoyance, reticence, or
delight. The task here is to judge your degree of involvement and your level of
acceptance with your subject. Get too close and your involvement will directly
influence events and affect your subject. Too distant, and there's no
involvement, no sense of engagement with what's going on around you.

Other contemporary photographers have managed to create beautifully
crafted portraits by allowing their subjects to simply be themselves in front of
the camera in very controlled situations. Their subjects often project a raw

Hoi Polloi: Jeremy Webb

The original photograph was
taken upside down with the actors
and actresses draped over a
single chair, their heads toward
the floor. Working with physical
theatre actors and actresses often
creates a creative partnership
which can be highly productive.

humanity, letting their emotions be instantly recognisable and are simply drawn out by the presence of the camera.

Rineke Dijkstra's full-body portraits of young teenagers at the beach come to mind, where there are no walls to lean against, no pockets to hide hands in; the children simply stand there, quite actively doing nothing, slightly startled yet curious also, with only the background and lighting under the photographer's control. The rest of it – the body language, posture and pose – are all adopted spontaneously and without influence from the photographer.

Other contemporary photographers enjoy working in partnership with their subjects – both with equal creative control over the outcome. Working with creative people from other fields like this can be a very rewarding process. The greatest inspiration for portraiture comes from the creative vision of the photographer, but it always helps to view the work of other photographers, if only to realise the huge variety of talent on show. Consider such greats as: Richard Avedon, Angus McBean, Albert Watson, Annie Liebowitz and Nick Knight.

And if you really want to compare the styles of two great portrait photographers from two very different camps, try finding Arnold Newman's famous portrait of Igor Stravinsky, then find the same subject photographed by Henri Cartier-Bresson in 1967. The differences and stylistic comparisons between these two single images deserve a book all of their own.

Landscape

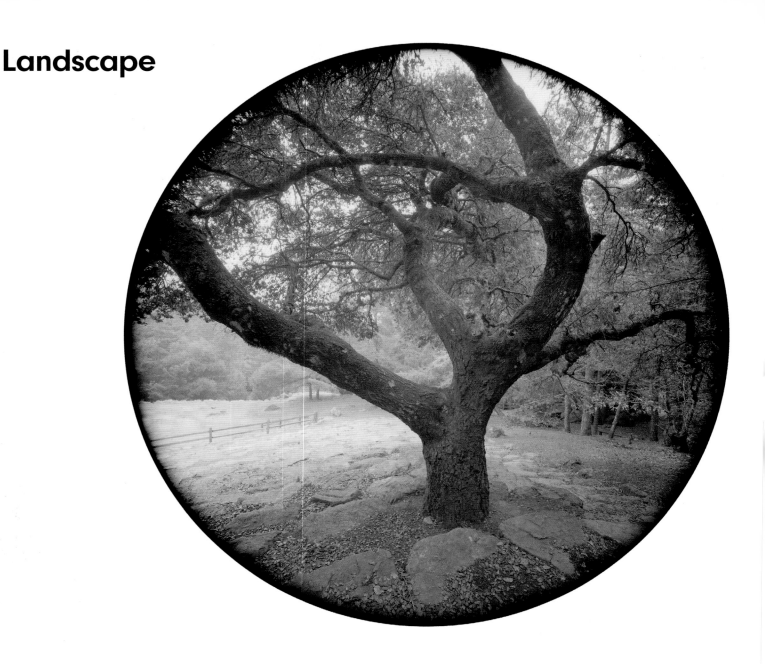

Finding creative solutions to the landscape genre requires us to examine closely our motives and personal involvement with our environment. It's a genre that can imprison us in its past and yet we so often adopt the rituals and traditions of its history without thinking.

Currently there is a range of approaches that photographers use to apply their responses, but the age-old divide between realism and romanticism still holds back a flood of more intuitive and personal visions from being seen by a wider public.

On the one hand, people feel passionate about the landscape; it's a source of primeval connection to our pasts, it stirs up deep feelings in us – spirituality, isolation, connectivity, humility, and so on. These big themes can't be communicated through simple naturalistic images. They have to be carefully moulded and fashioned into artful images to convey the mood or majesty that we felt when we were there. Our inescapable sense of the romantic compels us to exaggerate its actuality.

On the other hand, social documentary photographers and those of an open/exterior disposition scoff at the efforts made by photographers who become so involved in the process of exaggerating the landscape through process and technique, that exaggeration actually gives way to transformation of the landscape into something dishonest, something so unnatural and humanised that its reality is distorted by our continual interference and dishonesty with it.

What do we find on offer from these social realists? Bland, passionless, artless banality? It's not all that bad, but how does their arm's-length, forensic approach to the landscape really do justice to the experience of it. Used as an adjunct to political or social theory, photography often sublimates its real power and becomes a weak and watery descriptive tool in the service of a thesis.

Between these wild swings of the pendulum lies a more balanced approach: When photographers feel the confidence to express something of themselves in their landscape photography and are articulate enough to place their landscapes within a tighter framework or context than simply 'Beauty' or 'Calm Waters', for example – this is where I feel the most promising work arises from. Not a compromise between opposing camps but a more rounded and mature departure point from which to dive in and swim.

Oak Tree, Mt. Tamalpais, Marin County, California: Kerik Kouklis

'I photograph things and places in which I find beauty or curiosity. I especially try to find it in places where one wouldn't normally look. In other words, I avoid the easy targets and recognisable places that are all-too-often the subjects of photographs. If I can find something beautiful or curious in something most people would pass without a second look, then I've been successful.'

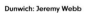

Dunwich: Jeremy Webb

Foregoing a horizontal, traditional 'landscape' format, this shot was intended to convey the simplicity of the experience itself, and to convey the energising sense of space.

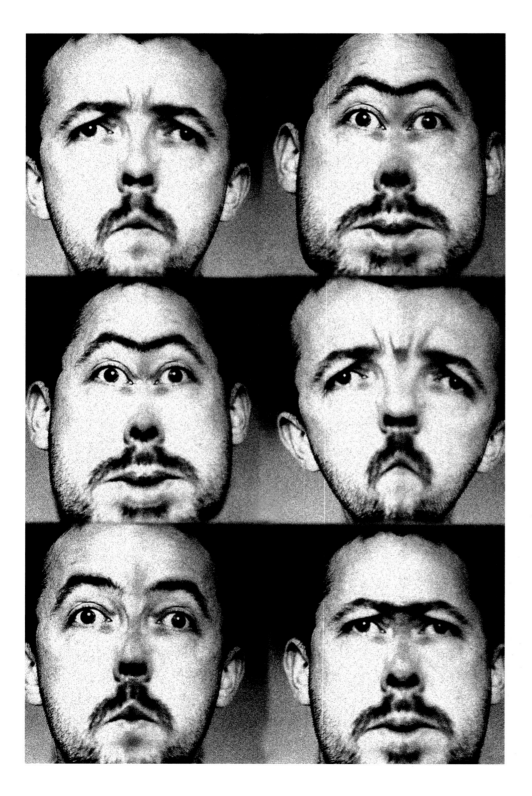

Self-portraiture

Untitled: Jeremy Webb

**720 degree portrait:
Justin Quinnell**
'In 10,000 years' time when the
language of the "Megapixel"
and "Cathode ray" has gone the
way of the dinosaur, people will
still be finding wonder in the
image forming properties of a
small hole.'

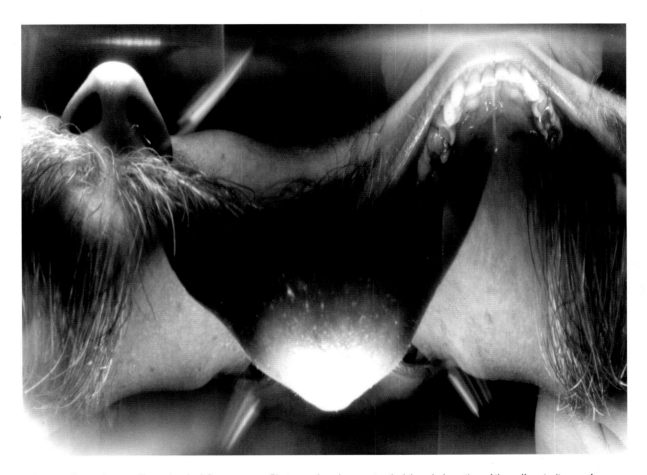

What drives us to capture an image of ourselves on film or in pixels? Exhibitionism, narcissism, both? Curiosity perhaps, in the same way that we can hear our voices recorded on tape or played back to us from old videos and question whether that was really our voice we heard. Images of ourselves can be uniquely disquieting and somehow alien to our own sense of self. A photograph of our face is not the same as the reflection we see in the mirror. A mirror throughout our life reflects back at us a horizontally-inverted image of our face. No wonder we sometimes gasp when we see pictures of our faces which are the right way round.

Most self-portraits are a highly creative vehicle for the communication of an artist's self-expression. By its very nature it is an indulgent practice. He or she may have something they want to offload, reflect back to the world, or simply have a burning desire to make sense of themselves by putting themselves in the picture.

Most photographic self-portraits fall into the following categories:

Artist in character

Artist as victim of someone/something

Artist as conqueror over someone/something

Artist as political agitator

Artist as commentator

Photographers have extended the whole notion of the self-portrait away from photographic realism and into expressionism, where internal concerns and moments from an artist's personal history are displayed whether the audience 'gets it' or not. It can be a form of personal catharsis or therapy, which may be immensely powerful to the artist yet somehow lost on the viewing public. Either way, it remains a very powerful and creative means of self-expression.

The artist/photographer doesn't even need to appear in the image anymore. His shoes, her bedroom, his wristwatch, her diary, whatever is deemed to be, so shall it be. The self-portrait doesn't have to please anybody. It doesn't have to be displayed or gawped at by anyone other than its originator. Some of the best self-portraits are extremely ambiguous, their layers of meaning so varied and open to question that they unsettle the viewer who brings their own personal history and experience to draw from, or they are deliciously simple and direct, their intent beyond question.

Every time you pull a face in the mirror, or catch a sidelong glance at yourself in a shop window, you're capturing your image. You might not always like what you see, but why not be honest about it, and use the medium of photography to create something permanent.

It could be your face, your body, something constructed, something spontaneous. I've always liked the idea of starting out on January the 1st by taking a self-portrait every day, for a whole year. I suspect I'd only get to about

mid-March before giving up due to lack of self-discipline. I have no doubt it's been done already many times over.

Finding a unique take on the self-portrait is a hugely personal thing. Because of this, a fine line develops between what is valuable and important to you, and what is elusive, vague or just downright dull to anyone else. Try to avoid the temptation to take safe refuge in visual metaphors. Symbolism is a rather lazy short-hand approach to an artistic challenge. A bit more 'lateral thinking' should provide a more articulate response.

Digital practitioners seem to come off particularly badly, dressing themselves up in Photoshop's limitless possibilities to become pixel warrior-type characters. Either that, or their senses abandon them completely and they depict themselves with their heads opening up like lids and all manner of crazy stuff pouring in or pouring out.

Photographers get scared. Scared to be honest, or scared that their meanings will be misunderstood or misinterpreted. Unfortunately, this is another occasion where self-portraits presented in the gallery often come attached to large text boards explaining in over-elaborate terms the thinking behind the image, so that only the photographer's intended meaning will over-ride all others. The power of photography as a communication vehicle of immense ability has been diluted by the practitioner's anxiety that other people might not understand what the artist is/was attempting to say. Photography has a power which hits the imagination with much more immediacy than mere language or written descriptions.

It's rather limiting to address the question of 'What will my self-portrait be about?'. Try expanding the whole thing sideways by starting with 'How do I see myself?'. Then 'How do others see me?'. And then 'How would I like to be seen?'.

The self portrait can become a uniquely creative exercise if approached with honesty and a sense of discovery. It would be a shame to write the whole thing off as vain narcissism or navel-gazing. This misses the point completely. The self-portrait is not self-flattery, nor self-flagellation, but an opportunity to scratch the surface and bring something out that previously remained hidden. An opportunity to be honest with yourself, for no one else's benefit than your own.

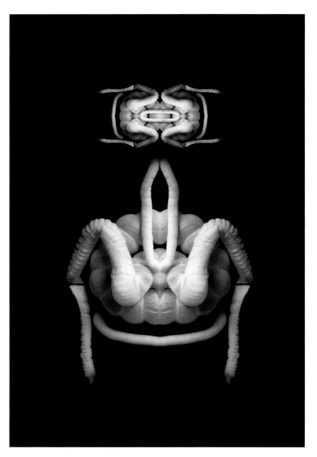

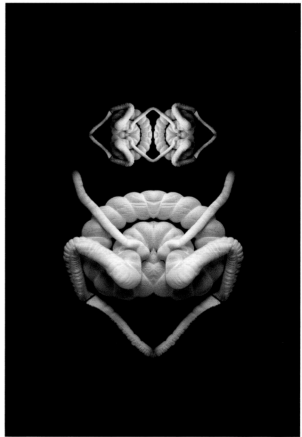

Untitled: Jeremy Webb

These diagrammatic variations on a theme resulted from different digital configurations of the same biological specimen, and are all derived from one single source image.

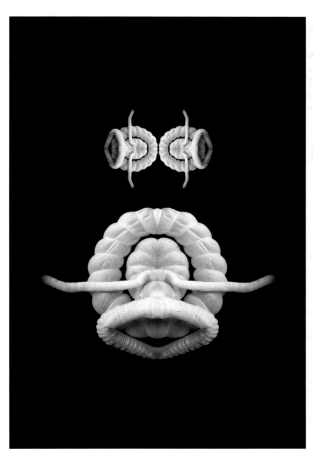

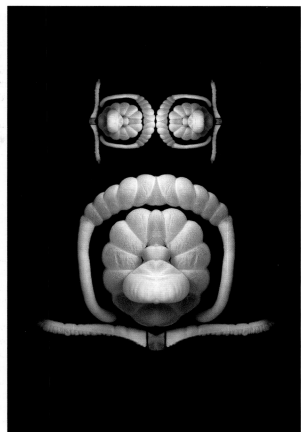

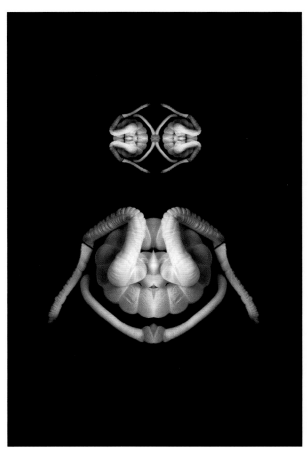

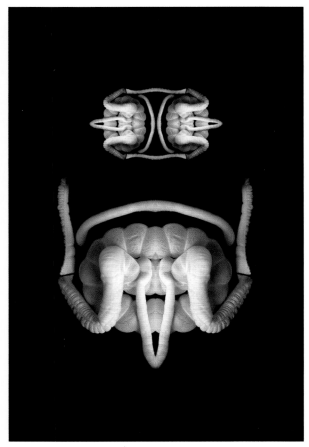

Summary

Subject alone is not enough, neither is style. Put the two together and you can at least reach the starting line. But what can photography give us that truly astonishes and delights above and beyond those simple concepts? Is there one common factor that somehow unites all these various schools, styles, genres, or subjects under one roof? What, if anything, can link all these different threads under the broad umbrella 'Photography'?

Aside from a necessary love of the nuts and bolts of the physical stuff of photography, dedication to the pursuit of your vision is essential if you are to truly innovate rather than emulate. Originality is borne from (amongst other things) a willingness to question everything, and some of the most interesting contemporary work in the medium today comes from photographers trained or specialised in one particular area and switching to another, or developing commissions and residencies that allow them to explore other uncharted subjects while being pigeon-holed as the master of only one.

Exploring one's own creativity is an enlightening and cathartic process, and so too is thriving on opportunities that allow us to explore styles or subjects outside our experience or knowledge. Whether your preference is for fine art, documentary, abstract, portrait, nude, architecture, fashion, or a thousand other subjects, the key ingredients are light, and creativity.

YesYesYes: Jeremy Webb

More graphic than photographic: I've always been interested in typography and pictorial lettering. This image was created digitally from a tiny handwritten word which, when magnified, picks up the inky streaks of an ordinary felt-tip pen as its nib rolls across a piece of acetate film. The desktop scanner allowed instant capture and feedback, which would not have been possible using film.

'Light makes photography. Embrace light. Admire it. Love it. But above all, know light. Know it for all you are worth, and you will know the key to photography.'
George Eastman

Chapter 10
Innovative Presentation
of Work

What does the word 'exhibition' conjure up in your mind? A big empty white room with framed prints tastefully lining its minimal walls? Maybe more cosy or intimate surroundings where your footsteps don't echo around the room. Today, artists and photographers have to think 'outside the box' or around the edges of what constitutes a traditional 'exhibition' in order to remain distinctive, and find fresher ideas on presentation altogether, if they are to be seen apart from the crowd.

The traditional exhibition space is one of many routes to explore. It's still pretty much the standard bread and butter option for many exhibiting artists and quality will always present itself no matter what, where, or how traditionally rigid the venue may be, but there are other less conventional methods of bringing your work to the attention of the public, some of which have proved to be more cost-effective and more lucrative in terms of the people who come to view an exhibition.

Recent developments to the exhibition space have seen artists working together to hold exhibitions in vacant shops and business units. Often located in busy, central areas, these temporary art shows can be negotiated with the premises' owners who may be more than happy to have the premises used in between lets, or simply because they are natural philanthropists.

Poster sites, bus shelter advertising sites, beer mats, black cabs – any space which hosts an advertising image is up for grabs. It takes a single-minded determination to negotiate these kind of deals, but an artist's experience of funding, the business world, and a little knowledge of how the media buying industry works can go a long way.

Presentation is not all about exhibition, locations, or channels of distribution. We're all savvy with the internet now, and no doubt we've all been impressed for a while to see how computers can loop sequences of images in a variety of flashy ways. But presentation is also about the more immediate concerns to image-makers of 'finishing the process', of following the image through to the finished artefact – framed, block-mounted, formal, informal, wall-mounted, or ceiling-suspended, and so on. Here are a few ideas to tempt those who find the traditional framed print a little stale, and need a few ideas to extend their creativity into considerations of print display and finishing for presentation purposes.

Raised prints and block-mounting

Untitled: Jeremy Webb
Part of a lightbox presentation, the original was created as a large-scale transparency that added far more depth and dimension than was possible by simply presenting it as a print.

The Arrival: Lance Keimig
'Photographing at night helps me to make sense of the world, and to put it all in perspective. It gives me time to observe the world around me in a way that I do not have time for during the daytime. I hope that my photographs reflect that sensibility.'

In deciding how best to present your images, don't be too hasty to dismiss the simple frame. It may appeal to more traditional tastes, and most of the gallery world in its entirety, but that is no reason to rip up the status quo just because your work is blazingly innovative. For many, the aesthetic effect of a frame is a means to 'contain' an image and signify its artistic 'value' or significance. Doing away with it could send a message out that your work is uncared for or somehow less significant, unless your alternative is strongly suited to your work.

Although Wolfgang Tilmans was able to challenge and poke fun at the gallery world by pinning or taping his works to gallery walls, his was a timely gesture, which instead of raising smiles or knowing nods today, would simply raise yawns instead. Doing away with the frame can be liberating – simply the image on its own, allowing in some cases, easier comparison and reference to other prints, or simply a confident statement that your work is strong enough to hold its own, without airs and graces.

Block-mounting is the simplest form of presenting frameless images on a wall and having them stand proud of the wall surface. Simple foam board of 5mm or 10mm thickness can also allow your images to separate from the exhibition wall, as will mounting materials like Foamex or Medite. Many professional photographic labs will provide samples for testing with small prints, or they'll discuss your requirements in person or over the phone.

Extending the idea further, a few photographers have really pushed their prints away from the wall by having them stiffened on foamboard then extended from the wall by some 10cm or 12cm with the use of a small, strong block which anchors the wall to the centre of the print.

The choice of presenting in this style is a highly personal choice, and should be considered as part of the process of print production as a whole. In other words, don't look at your prints, then decide how to present them – try to keep presentation in mind at the outset of their creation, and as an integral aspect of their production, not as an annex tacked on at the end.

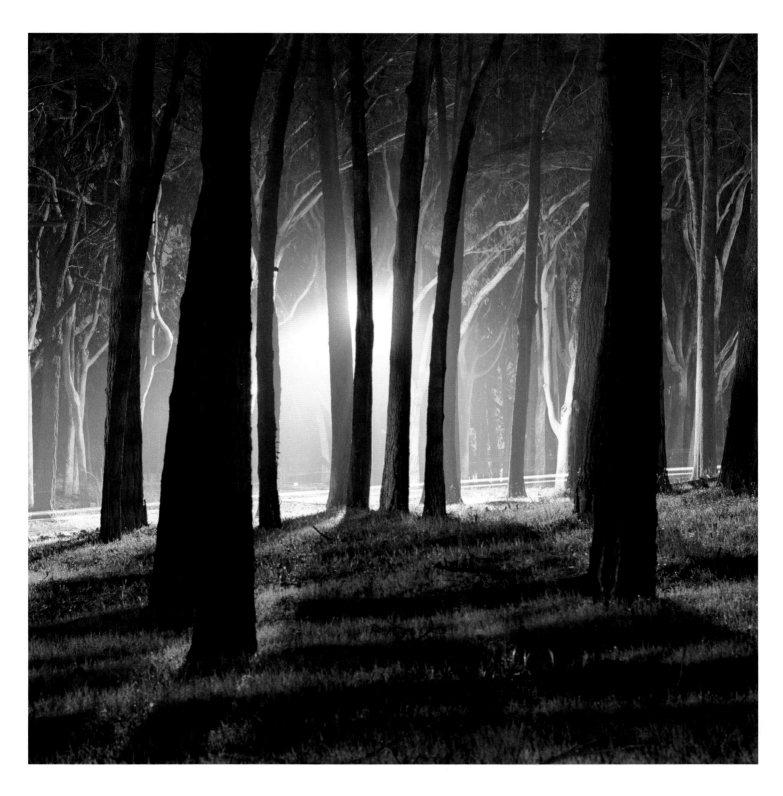

Backlit prints

By allowing light to pass through the print from behind, it's possible to display prints of a certain size and subtlety, in a similar fashion to the display of transparencies or slides. We're so conditioned to view the photographic print bathed in the light which falls on it, that it never occurs to us that backlighting the print can bring detail and a uniquely 'glowing' beauty to an image.

Care must be taken to achieve the right balance between backlighting and front lighting, and in the choice of photographic paper used. I've seen the effect worked most successfully with black-and-white images. By using ordinary resin-coated papers, a beautifully creamy glow can be given to the prints as light passes through them from a lightbox (less so when displayed in front of daylight and its varying blue-tinged colour temperatures). Colour prints also can benefit from an additional glow given to them.

Details not normally noticeable from shadow areas become hugely significant and highlights take on a luminosity which can create a very special atmosphere. On the down side, blacks can become greys too easily if the backlighting is overly strong, and any print spotting or retouching with Spotone dyes will become immediately visible. Some masking with the use of mattes or card windows will be needed to block off light spilling in over the edges and from outside the image area of the print. Older papers seem to present well in backlit displays like this. Out-of-date and discontinued stocks such as the OrWo Universal 10″ x 8″ made in Germany, plus a wide range of fibre-based papers will also give remarkable results. Don't try presenting colour enlargements from the high street labs though, as these prints come from huge rolls with the paper manufacturer emblazoned all over the back of the print and appears as 'watermarks' when backlit.

Backlighting is a display technique that appeals to photographers who like to observe the world's urban and rural environments, interior spaces, and those who explore the nature of light. One photographer in particular stands out – Elisa Sighicelli, whose calm and beautifully-observed interior domestic views are made all the more impressive by the use of partial backlighting.

Nine Months: Tamara Lischka
On the conflict between technique and art, Tamara Lischka says: 'At which point does one stop trying to find just one more technique (film, chemical process, paper formulation) that will permit you to squeeze out just one more shade of brilliant white, and start noticing the world you initially started photographing? On the other hand, when do you stop and realise that an image may contain what you want to say, but simply fails to render itself brilliantly (and perhaps fails to catch the viewer's interest as well)? For myself, with perfectionist tendencies, it is easy to get sidetracked on either path. My hope is to utilise the technical craft in order to further my vision...and become neither mired in the search for technical (and perhaps, esoteric) excellence, nor in becoming mired, in my own mind, and producing work that does not engage the viewer to the fullest extent that I am capable.'

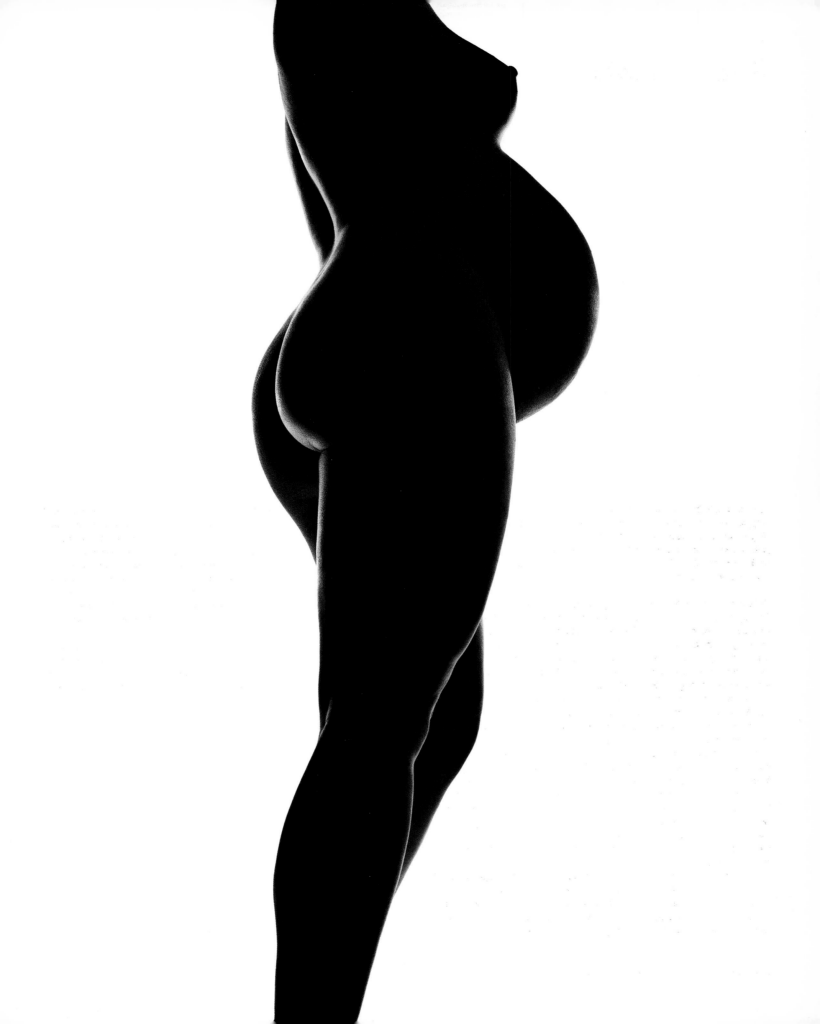

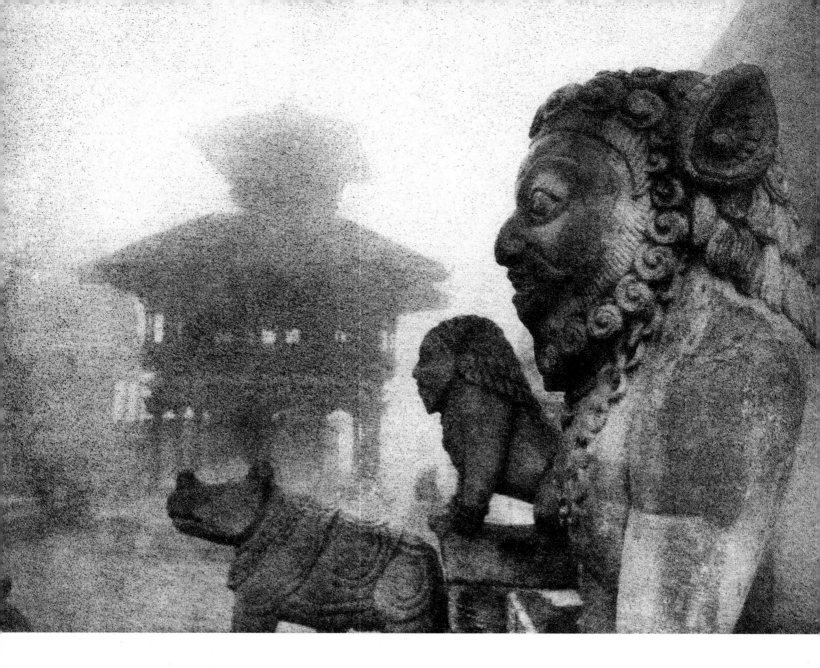

The Guardians, Bahktapur, Nepal: Eliza Massey

'I have chosen Bromoil as a means of expressing my photographic art work. Because every Bromoil is hand-made, no two are ever the same, so the creative freedom is endless. The choice of subtle colours, depth of layers and artistic hand with a brush, all contribute to the beautiful and timeless qualities that make a Bromoil stand out.'

Untitled: Jeremy Webb

This image features two flattened-out foil wrappers found during a beachcombing trip to the Norfolk Coast. From a series of images that feature the minute detail of the discarded and abandoned, it was shot on a simple lightbox and presented as a poster-sized transparency at exhibition to reveal its minute texture and surface detail to the full.

Liquid light

Happy Land, 2001:
Rob & Nick Carter
'Photograms have a history that
goes way back to the early
pioneering days of the medium.
Even before the camera was
"invented", Fox Talbot made
photograms by placing pieces of
lace on photo-sensitive paper
material, and exposing it to the
sun for perhaps 15–20 minutes.'

Bridge Tower: Justin Quinnell
An image captured with the use
of a wheelie bin pinhole camera.
'After eight minutes' exposure this
is then dragged back to my
bathroom where I tape it to the
wall above the bath and let fly
with photographic chemicals.'

Liquid light or liquid emulsion has been around for a while now, and is not exactly new, nor for that matter could it still be considered innovative. However, to the uninitiated it may offer creative possibilities that have gone unrealised in the past, and in the spirit of a book which still even at this late stage encourages experimentation and the willingness to approach ideas with an open mind, it merits its inclusion on that basis alone.

Quite simply it is as its name implies, it's a photographic emulsion in liquid form (or more like a rather sloppy gel actually) that is warmed, then brushed or painted on to a suitably prepared surface to create hand-made papers or other whackier surfaces, which receive the latent image from your enlarger and are then processed in much the same way as more conventional black-and-white materials.

Like some Polaroid transfers and emulsion lifts, it has suffered from a peculiar kind of photographic 'showing off' in the past, where the real substance of the image – its communicative power – seems to take second place to the craft and skill of the mastery over the process. Many image-makers also regress to rather

clichéd Victorian subjects. It's almost as if the rough and unpredictable nature of the emulsion lures photographers back through time to revisit and recreate the portraits of Julia Margaret Cameron. But this is by no means a brush to tar the lot with, there have been some very imaginative uses of the process.

It can be coated on to many different surfaces – wood, fabric, tiles, metal, and a wide range of artist's rag papers and fibrous materials, but often requires a subbing layer which is coated on to the surface prior to the emulsion so that it will 'take' evenly and not sit in pools or sink into the surface below. Naturally, once warmed, the emulsion is applied under safelight conditions and allowed to cool and harden before being used.

I've seen it used with a series of portraits on old long playing records and in one installation I came across, it had been coated on to sections of wallpaper that were then hung directly on to a fabricated wall placed within a fake domestic interior. Used with foresight and consideration of the media limitations, it has the power to transform the ordinary into the extraordinary. Melanie Manchot has produced some quite breathtaking images using liquid emulsion and for those who remain continually harassed by the presumed need for speed in the digital era, it returns once again a slower pace and craft to the process of image-making using this versatile and deliciously imprecise medium.

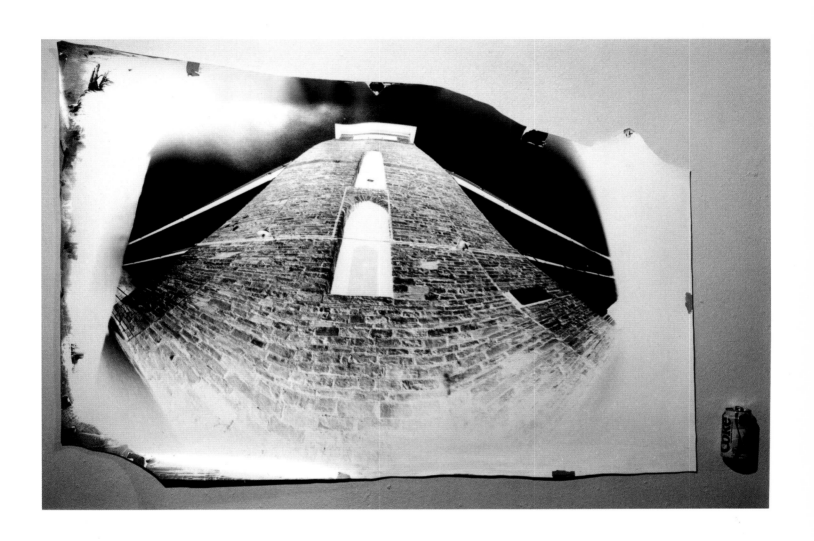

Captions

Within an exhibition context, captions can strengthen the implied meaning or motivation behind an image, but can also undermine the power and the nature of an image to offer ambiguous meanings within a variety of viewer's 'interpretive embraces'. Used wisely they can enhance our experience of the images we're viewing and can help us absorb the meaning and motive behind the work. Unfortunately, too much of the written word can ruin a good exhibition. Any image can be hugely communicative and emotive before it is even 'understood' rationally. Words require a different kind of brain workout, which sometimes interferes with our ability to allow images to 'unfold' before us and seep into our contemplation. Like artist's statements, extended captions or explanations used in exhibitions are best kept short, precise, and free from any waffle.

The Essence of Style: Rajiv Seth

'The one thing my teacher Takeji Iwamiya, one time head of the photography dept, Osaka University of Art, taught me was to "find my own eye". Seeing that all traditional and several untraditional methods were a crowded field, I arrived at extreme close-ups of weathered machinery that offered me that nexus of colour, texture and design that when blown up looked more like abstract paintings than photography...Doing more with less.'

Large scale prints

Size matters. If your vision drives you to produce your images as contact printed 5" x 4" prints, because they are 'fragile moments caught in the blinking of an eye which don't need to scream', traditional gallery settings may not be your ideal forum – publication may offer better opportunities.

On the other hand, interior locations and environments provide plenty of opportunity to present large scale works and much of this is simply the requirement to impress, to fill the space and increase the spectacle as much as anything else. We are all somehow impressed by size, and large scale works demand our

Teenage Ballroom Dancer: Morten Nilsson

These breathtakingly beautiful portraits demonstrate the sheer power of photography to astonish and reveal perhaps more intimately than any other medium – the boy's slightly parted mouth, stiff jaw, and tiny hairs loose from his combed-back brow, the raised vein in his temple, the glistening sweat above that stiffly starched collar. The girl's tiny mole stands out as being uniquely individual against a self-presentation

involvement in them rather than a nice, polite suggestion that there might, just possibly, be something here to interest you.

By going big, you invite your audience to closely examine every detail of your picture magnified massively and viewed up close. It invites participation on two levels – the initial 'hit' of an image from a distance, and the closer examination of enlarged detail while being too close to absorb and respond with the bigger picture.

If your work is clean and free from specks and stray pixels, going big makes sense if your images will be enhanced by an upward change in scale. Not everything works big. Like a springboard in front of a vaulting horse, size can glorify

your skill or it can magnify your weaknesses. Wall-sized prints take everything up an extra notch still. They used to be considered a bit unfashionable, but since the emergence of countless interiors makeover TV programmes, they've since become popular again, if only for a season or two.

Companies such as Photo Furnishings and Digitile will turn your images into wallpaper, ceramic tiles, and create any number of fabric designs for a wide range of purposes. Snappy Snaps and other high street stores can now produce massive enlargements (perhaps not wall-sized) and so it goes on, all over the land, thanks in large part to digital technology and its ability to appropriate, channel and distribute with efficiency.

projected with such perfection in mind – eye mascara thick and intended to be seen at distance, her real features almost buried behind a screen. 'It's a world where the right size and measures, the right positions, grown-up demands and conservatism rules. It's about basic training in being a perfect adult – a perfect gentleman or a real lady princess. But as with most teenagers – the teenage imperfection and diversity breaks through even the most perfect surface here and there.'

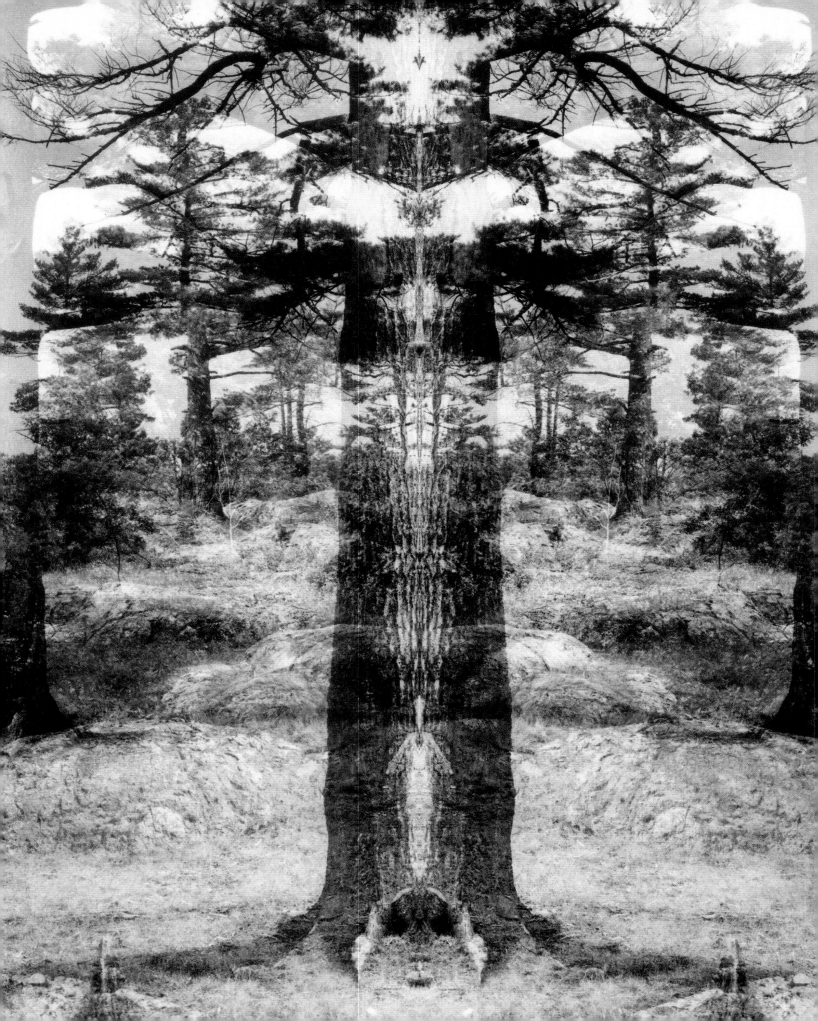

Cubes, postcards and vending machines

Untitled – part of Folded Axis
Study: Jeffrey D. Mathias
Folding screen: Jeffrey D. Mathias
Hand-coated Platinum
Palladium print.

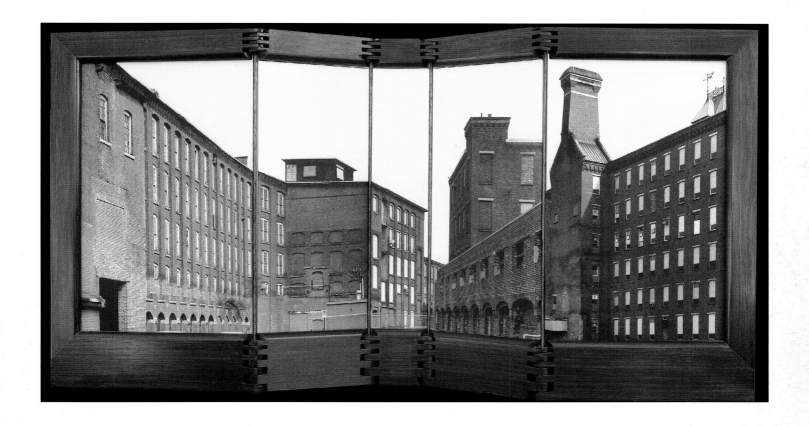

In an age when it becomes harder and harder to negotiate the shifting boundaries between what were once separate and easily-defined artforms, the photographic artist has the potential to mix and match from whatever he or she feels is appropriate in order to present their work in a way that is innovative and strategic to its content and purpose. This may involve looking for inspiration from some of these other artforms in mixed media, and new media especially.

Mixed media includes installation art and other three-dimensional work, and has provided photographers with tempting opportunities to display work in a variety of weird and wonderful rotating, spinning displays – even scratch 'n' sniff has put in an appearance somewhere down the line. I've seen cubes, pyramids, fabricated corners of imaginary rooms, and recently came across one exhibition featuring a cardboard box full of quite beautiful prints mounted in junk shop frames left in the corner of a gallery, tucked away from the rest of the exhibition. This was intended to recreate the feel of a chance find in the street and was ignored by the great majority (thinking it was simply something left behind by the cleaners), but delighted the few who took the trouble to peer into this strange box. As an idea, you'd have to admit that it succeeded so well

simply because it achieved the result that it was supposed to – a chance find for some, ignored by others.

Other display and presentation ideas have seen photographers print and display their works like seaside postcards, or mounted behind disused window frames rescued from a skip. These presentation ideas are all very well, but should be thought through rigorously before abandoning more conventional methods. So often the motivation is simply to impress, which can backfire if the work itself goes unnoticed and style wipes the floor with the content.

New media opportunities for innovative presentation are many and boundless – digital sound and video presentations, websites, networks, screen projections, interactive VR, and so on – and all are very exciting, but add an element of risk too, in the way that any perceived digital 'attachment' to artwork can also slap on it a kind of badge to impress with. Many strong and creative ideas find their natural home within the digital domain.

And since 'interactive' is one of the big buzz words of the moment, the Hayvend project is an interesting development to the creation and distribution of artworks. A series of vending machines distribute artists' work inside small boxes. Like a lucky dip, you could end up with a mini masterpiece from a well-established artist or simply receive an artist's unique print in miniature form, small but somehow made all the more appealing by the medium and concept through which it's been presented.

Summary

Strange, in a way, that we should end the book here, discussing the pros and cons of a simple cube one minute, modern digital technology the next. But this ability of the photographic medium to integrate the very simple with the very new and very technical is one of its greatest strengths, and something that will allow future changes within the medium to go through a continuing cycle of adapt – transform – reform, well into this new millennium.

More importantly, the artist's vision must adapt too, and artists should continually question their motivations and test their beliefs at every opportunity. I've tried as far as possible to provide some inspiration within these pages, inspiration and ideas that start from the inside and extend outwards into the world. I hope also that the excellent work of the contributors to this book will have inspired you just as much as they have inspired me.

In the end, creative vision rests purely with the individual – the ability to pursue your artistic goals with determination and insight, and not to work under the mirage of whatever happens to be in vogue this weekend. It's an ongoing journey without an end, and I sincerely hope that it brings you fulfilment and success in whatever form it may reach you.

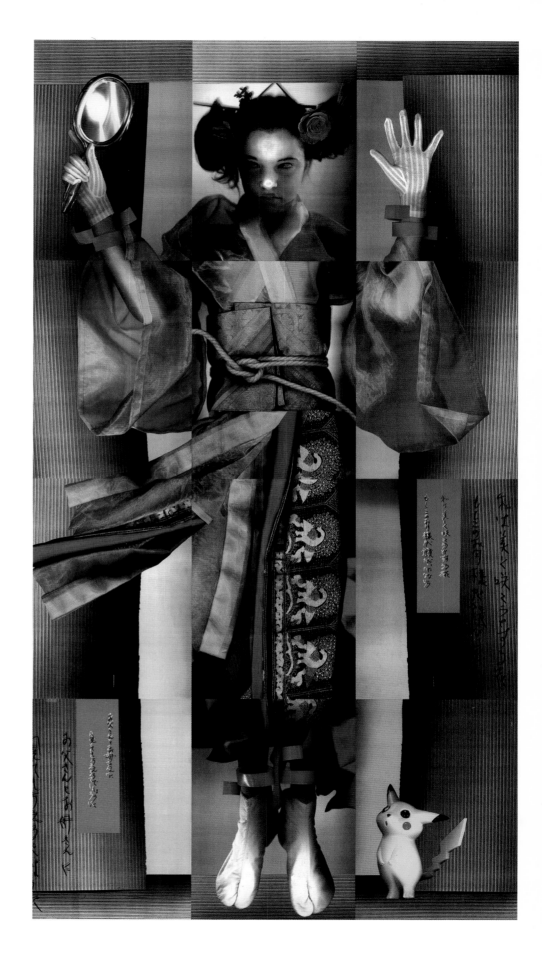

Sister Midori: Lieve Prins

A photocopy collage from a true pioneer in the art of copier art, having began experimenting with photocopies some 12 years ago.

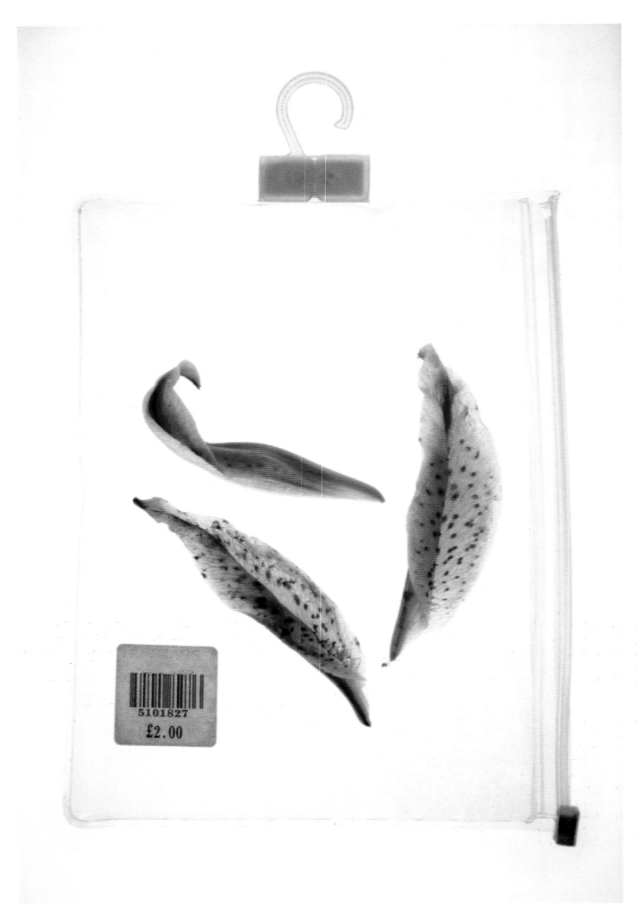

Untitled: Jeremy Webb

A desktop lightbox provided
the necessary backlighting for this
simple image that juxtaposes the
concepts of nature and
purity with artificiality and
mass-production.

Conclusion

Artistic movements come and go like cultural waves – Pop Art and Punk, to name two of the most recent seismic tremors to shake up the art world. Who knows whether the still-evolving Baroque Povera movement will create any truly distinctive art? Or will it simply trickle into the mainstream to be swallowed-up and spat out again as a weak pastiche of itself?

Technology has also transformed the medium of image 'capture' to such a degree that, with the mass adoption of mobile phone cameras, we truly are all photographers – every one of us. But time has 'shrunk' in effect, and digital image capture (unlike the earlier mass adoption of box brownies) can be seen and studied instantly without lengthy processes or technically difficult procedures involved. There has always been a certain fondness for the lucky amateur who turns out to be the man on the spot, and gets the front page picture before any of the pros turn up. Today, front-line soldiers can capture footage of horrors or happenings around the globe on their cameras or phones, in places that are simply impossible for professional photojournalists to reach.

Everywhere you look, the race for speed and convenience seems to bypass or obliterate quiet reflection, consideration, and composure – surely essential requirements for a meaningful and honest self-examination in general, as well as prerequisites for an examination of one's own more specific artistic practice. Technology aside, the artist's vision must also adapt to continually question motivations and test beliefs at every opportunity and to remain open to technological change but ready to treat all techniques and processes with the same equilibrium whether simple crayon, or the latest new-fangled digital peripheral.

Appendix

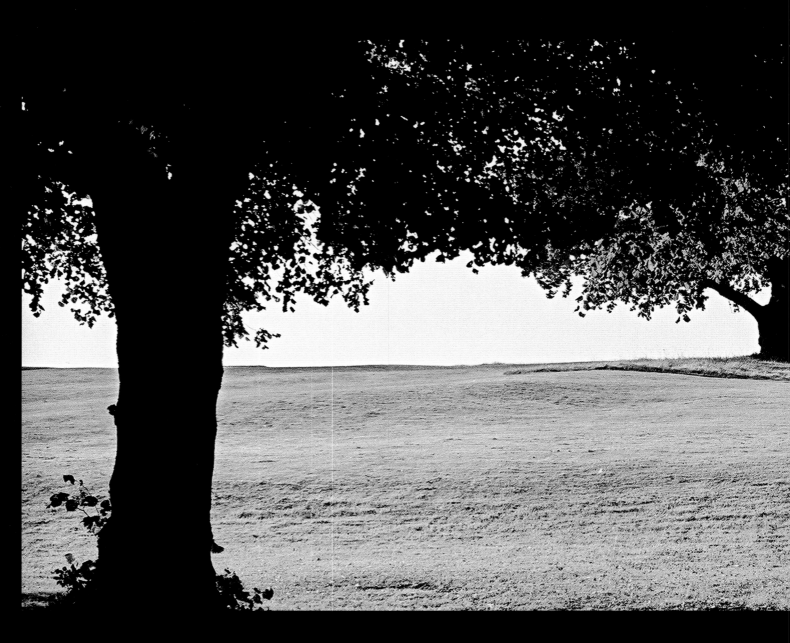

Glossary

Adjustment layer – This allows Photoshop users to create a layer above an image beneath it to change the effect of the pixels directly below it.

Analogue – This refers to traditional film capture and process of photographic images.

Aperture – The opening in the lens that controls the amount of light reaching the film (in conjunction with the shutter speed).

Bounced flash – This achieves softer light from a flash gun or flash head by bouncing the flash off a nearby wall, ceiling, or white reflector.

Bracketing – A method of ensuring correct exposure by taking several additional pictures, usually +1 stop above the given exposure, and -1 stop below the given exposure.

Cable release – A flexible extension to the shutter release of a camera which is most commonly used to prevent camera shake on slow exposures.

Contact sheet – A print made on photographic paper by exposing the paper to light with the negatives in direct contact with the print. These same size 'thumbnail' images are used as a basis to establish which images to print, what cropping needs to take place and so on, although some larger format negatives, due to their size, can create their own contact prints without the necessity of an enlarger.

Cyanotypes – Prints produced using a specialised process which look blue in appearance.

Daylight-balanced film – Colour film intended for use with a light source with a colour temperature of 5500K. This is considered to be an average daylight colour temperature.

Depth of field – The amount of a picture which will appear sharp in front of and behind the point at which you focus the lens. Large depth of field refers to a large area of the picture being in sharp focus from near foreground to far distance, usually achieved with wide angle lenses or small apertures of f.16, f.22 etc. Small depth of field indicates a very narrow band of focus often by the use of wide apertures such as f 1.2, or f.2.

Dodging and burning – Dodging is a method, when printing, of holding back exposure to localised areas that would otherwise appear too dark on print. Burning is the method whereby localised areas are given extra exposure where they would otherwise appear too light.

Duotone – A popular Photoshop effect which gives the appearance of hand-toned photographs by using black and another colour ink when working in greyscale mode.

Emulsion – This is the light-sensitive, image-forming material on a film or paper.

Exposure – The combination of lens aperture and shutter speed, which is used to control the intensity of light reaching the film.

Fixer – Chemical solution that removes undeveloped silver halides from processed film or paper and makes the image permanent.

Flattening – In Photoshop, the process of merging together all layers within the file to return the image again to one, single background image.

F stop – This indicates the size of the lens aperture. The smaller the number, the wider the aperture, the higher the number, the smaller the aperture.

Gaussian blur – Used within Photoshop, this creates a softer, defocused effect.

Grain – Composed of minute metallic silver particles in film which form the visible image when exposed and developed.

Greyscale – Print or transparency consisting of a series of grey tones of regular increasing depth from white to black.

History palette – Within Photoshop, every time you modify or edit your image, it is recorded as a history state within the history palette. This chronological recording of events can be used if you want to return to an earlier state within the current work session.

ISO – Initials of the International Standards Organisation – used to indicate the speed or light sensitivity of photographic materials.

JPEG – A type of digital image file that compresses files by up to 75%, although some image data can be lost. Usually produces much smaller file sizes than PSDs or TIFFs, hence the ease with which JPEGs can be sent via email or as screen previews of much higher resolution images.

Layers palette – An information palette within the Photoshop interface that provides information on the number and type of layers within a digital image. New layers are automatically created when using the type tool, and when any copy and paste work is undertaken.

Levels – A Photoshop function that adjusts the tonal balance of the image. Highlight areas, mid-tones, or shadows can be edited in selected areas or throughout the entire image as a whole.

Masking frame – Adjustable, flat holder for printing paper, necessary to keep the printing paper in position on the enlarger easel.

Multigrade paper – Paper used for black-and-white printing that has a variable contrast range controlled by the use of coloured filters, instead of the more traditional single grades of paper contrast.

Negative carrier – A Metal or plastic holding frame used to keep the negative flat in the enlarger head between the light source and the lens.

Pixelation – The blocky effect that occurs when an image is enlarged to a size where the pixels become obvious.

Pixels – Individual picture elements usually (though not exclusively) seen as square blocks that form the basis of all digital images. Most visible at high

magnification if the image is said to be of high resolution. More easily visible in low resolution digital images such as those using the JPEG file type.

PSD – Stands for Photoshop Document and is the native file format for Photoshop images. Most often used for works in progress, or layered images that require many work sessions, or multiple opening and closing of the file.

Push processing – 'Pushing' is the deliberate extension of the development time of a film to increase its speed and contrast. Pushing is often a useful technique in dim flat lighting conditions. 'Pulling' is the deliberate underdevelopment of a film.

Resolution – the picture detail and sharpness, or quality of a digital image measured in pixels per inch. The higher the resolution, the higher the quality and detail (& file size). The lower the resolution, the lower the quality and detail (& file size).

Reticulation – Formation of minute cracks on the surface of an emulsion, usually caused by extremes of temperature during processing. Modern films are normally very resistant to reticulation.

Safelight – Darkroom light of a particular wavelength to which the photographic paper is not sensitive. This allows you to see and handle materials in the darkroom. In the case of black and white printing the appropriate safelight is usually an orange, red or deep green.

Shutter speed – The amount of time (usually measured in fractions of a second) for which a camera shutter remains open, permitting light channeled through the lens, to fall on the film.

Solarisation – is the term used to describe the Sabattier effect, which is a partial image reversal caused by the exposure of an image to light during development, and then allowed to continue to develop in the normal way.

Stop bath – Chemical bath used in processing to arrest the action of the developer, and to prevent developer being carried-over into the fixer.

SWOT – Strengths, Weaknesses, Opportunities & Threats.

TIFF – a type of high quality digital image file, stands for Tagged Image File Format and supports up to 24-bit colour per pixel.

TTL – Through-the-lens metering, a method which uses light-sensitive exposure metering cells within the camera body to take readings of the reflected light falling on the subject, exactly as seen by the lens. In automatic cameras these readings are translated directly into apertures and/or shutter speeds.

Tungsten-balanced film – Colour film designed to give natural colour when exposed under tungsten lighting.

Unsharp mask – A Photoshop filter that enables you to sharpen blurred or soft detail either selectively, or to the entire image.

Vignetting – This is the visual effect of the darkening of edges and corners. It can be deliberate or accidental.

Photographer's contact details

Donna Fay Allen
California, USA
dfallen@surewest.net
http://lightpainter.tripod.com/donnafayallenphotography

Floris Andrea
Amsterdam, the Netherlands
info@florisandrea.com
www.florisandrea.com

Michelle Bates
Seattle, USA
meesh@drizzle.com
www.michellebates.net

Alessandro Bavari
Latina, Italy
info@alessandrobavari.com
www.alessandrobavari.com

Herbert Boettcher
Bielefeld, Germany
office@herbertboettcher.com
www.herbertboettcher.com

Siegfried Burgstaller
Vancouver, Canada
siegfried@epiclight.com
www.BlackandWhiteLight.com

Ray Carofano
California, USA
ray@carofano.com
www.carofano.com

Rob & Nick Carter
London, UK
rob@robandnick.com
www.robandnick.com

Victoria Dean
Belfast, Northern Ireland
victoriajdean@yahoo.co.uk
www.victoriajdean.com

Christopher Evans
Vancouver, Canada
czarf1972@yahoo.com
www.czarf.com

Lisa Folino
Newport Beach, USA
lisa@lisafolino.com
www.lisafolino.com

Alain Gauvin
Quebec, Canada
info@alaingauvin.com
www.alaingauvin.com

Misha Gordin
Minnesota, USA
mail@bsimple.com
www.bsimple.com

Kimberly Gremillion
Houston, Texas, USA
kimberly@kimberlygremillion.com
www.kimberlygremillion.com

David Hlynsky
Toronto, Canada
davidhlynsky@mac.com
http://home.ican.net/~davidhy

Mark Holthusen
San Francisco, USA
mark@markholthusen.com
www.markholthusen.com

Sean Justice
New York, NY USA
sean@seanjustice.com
www.seanjustice.com

Bob Karhof
Utrecht, the Netherlands
info@bobkarhof.com
www.bobkarhof.com

Lance Keimig
Pembroke, MA USA
lance@thenightskye.com
www.thenightskye.com

Kerik Kouklis
California, USA
kerik@kerik.com
www.kerik.com

Todd Kurtzman
Oregon, USA
toddk@toddkurtzman.com
www.toddkurtzman.com

Andrew Law
Montreal, Canada
andrewlaw@videotron.ca
www.andrewlaw.ws

Fritz Liedtke
Portland, Oregon, USA
fritz@fritzphoto.com
www.fritzphoto.com/art

Tamara Lischka
Oregon, USA
tamara@tamaralischka.com
www.tamaralischka.com

Stephen Livick
Ontario, Canada
slivick@livick.com
www.livick.com

Patrick Loehr
Arvada, Colorado, USA
patloehr@hotmail.com
www.loehrgallery.com

Louviere + Vanessa
New Orleans, USA
vanessa@louviereandvanessa.com
www.louviereandvanessa.com

Rebecca Martinez
California, USA
RebeccaSMartinez@aol.com
www.roberttat.com

Eliza Massey
Maine, USA
eliza@elizamassey.com
www.elizamassey.com

Jeffrey D. Mathias
Vermont, USA
jeffrey.d.mathias@att.net
http://home.att.net/~jeffrey.d.mathias/

Morten Nilsson
Copenhagen, Denmark
info@mortennilsson.com
www.mortennilsson.com

Warren Padula
New York, USA
wp@wpadula.com
www.wpadula.com

Troy Paiva
San Francisco, CA USA
paiva@lostamerica.com
www.troypaiva.com

Lieve Prins
Amsterdam, the Netherlands
lievep@euronet.nl
www.cmp.ucr.edu/photography/prins/

Justin Quinnell
Bristol, UK
justinquinnell@hotmail.com
www.pinholephotography.org

Rajiv Seth
California, USA
rajiv@rajivart.com
www.rajivart.com

Emil Schildt
Vraa, Denmark
emilschildt@hotmail.com
www.vraahojskole.dk/emil

Gordon Stettinius
Virginia, USA
elgordo@eyecaramba.com
www.eyecaramba.com/self.html

Donna Hamil Talman
Massachusetts, USA
dhtalman@aol.com
www.donnahamiltalman.com

Michael Trevillion
London, UK
michael@trevillion.com
www.michaeltrevillion.com

Jeremy Webb
Norwich, UK
jeremywebb.photo@virgin.net
www.pixelsoup.biz

Bill Westheimer
New Jersey, USA
bill@billwest.com
www.billwest.com

Recommended reading

General

Photography As Fine Art – Introduction by Douglas Davis
pub. Thames & Hudson

The Impossible Image: Fashion Photography in the Digital Age –
Mark Sanders (Editor) pub. Phaidon

The Photography Handbook – Terence Wright
pub. Routledge

Right Brain, Left Brain Photography – Kathryn Marx
pub. Amphoto

Tao of Photography – Tom Ang
pub. Mitchell Beazley

Home Photography – Andrew Sanderson
pub. Argentum

Looking at Photographs – John Szarkowski
pub. Museum of Modern Art, New York

What's Missing? Realising Our Photographic Potential –
compiled Eddie Ephraums pub. Argentum

Innovation/Imagination: 50 Years of Polaroid photography –
Deborah Martin Kao, Barbara Hitchcock & Deborah Klochko
pub. Harry N Abrams

Fine Art Photography – Terry Hope
pub. RotoVision

Susan Sontag On Photography – Susan Sontag
pub. Penguin

Public Relations – New British Photography
pub. Cantz

Photographic Possibilities (2nd edition) – Robert Hirsch & John Valentino
pub. Focal Press

Blink
pub. the editors at Phaidon

Individual Photographers

Karl Blossfeldt: Photography – Christoph Schreier & Jurgen Wilde
pub. Hatje Cantz

Brandt: The Photographs of Bill Brandt – David Hockney (Foreword) et al
pub. Thames & Hudson

Josef Koudelka: Reconnaissance Wales
pub. Fotogallery in association with the Cardiff Bay Arts Trust, The National
Museum & Galleries of Wales & Magnum Photos

The Americans – Robert Frank
pub. Scalo

Robert Doisneau: A Photographer's Life – Peter Hamilton
pub. Abbeville Press

Altered Landscapes – John Pfahl
pub. The Friends of Photography in association with the Robert Freidus Gallery

Couples & Loneliness – Nan Goldin
pub. Korinsha Press

Philip-Lorca diCorcia: Contemporaries – Peter Galassi
pub. The Museum Of Modern Art, New York

Other Edens – Nick Waplington
pub. Aperture

The Democratic Forrest – William Eggleston
pub. Doubleday

Montage

John Heartfield – Peter Pachnick (Editor) & Klaus Honnef (Editor)
pub. Harry N. Abrams, Inc.

Cut With the Kitchen Knife: The Weimar Photomontage of Hannah Hoch
– Maud Lavin
pub. Yale University Press

Instructional

Photography's Antiquarian Avant Garde – The New wave in old processes –
Lyle Rexer
pub. Harry N. Abrams, Inc.

Creative Photo Printmaking – Theresa Airey
pub. Amphoto Books

Spirits of Salts: A Working Guide to Old Photographic Processes – Randall
Webb & Martin Reed
pub. Argentum

Silver Gelatin: A User's Guide to Liquid Photographic Emulsions – Martin
Reed & Sarah Jones
pub. Working Books Ltd.

**Cyanotype: The History, Science & Art of Photographic Printing in Prussion
Blue** – Mike Ware
pub. The Science Museum & The National Museum of Photography, Film &
Television

Sun Prints – Linda McCartney
pub. Ebury Press

The Darkroom Cookbook (2nd edition) – Stephen G. Anchell
pub. Focal Press

Websites and other resources

Networks/organisations/information

www.photodebut.org	Forum, advice, support, debate, opportunities
www.axisartists.org	Online Axis artists' database
www.unblinkingeye.com	Discussion, galleries, alternative processes
www.ilford.com	Discussion forum, technical know-how
http://peeledeyeshop.com	Fine art photography gallery (UK)
www.photocollect.com	Online US gallery, book & print shop
www.photography-now.com	Info on international exhibitions
www.sfcamerawork.org	US-based non-profit, contemporary photography
www.vam.ac.uk	Victoria & Albert Museum, interviews, galleries
www.a-n.co.uk	Artists' newsletter website resources
www.bjphoto.co.uk	British Journal of Photography online
www.the-aop.org	The Association of Photographers
www.art-online.com	Search & information site
www.artdeadline.com	US-based resource and info site
www.artnetdirectory.co.uk	Info on courses, exhibitions, networks etc.
www.artquest.org.uk	Information site, mainly London, e-newsletter
www.themothhouse.com	Career advice, portfolio feedback
www.artscouncil.org.uk	Useful info on funding for exhibitions etc.
www.photoprojects.org	A multitude of useful leads and links
http://art-support.com	Thorough in-depth articles and advice
www.focalfix.com	Online photographic community and support
www.artmarketing.com	Info on arts funding and marketing
www.photographysites.com	Extensive links to online galleries etc.
www.photonotes.org	Encyclopedia, dictionary, terms explained
www.photonet.org.uk	The Photographers' Gallery website
www.zoom-in.org	Darkroom, studios and facilities in London
www.photo.net	Huge portal

Online portfolios/gallery sites

www.paparazziphotoart.com	Virtual gallery & magazine
www.nufoto.com	
www.malojo.com	
www.pontosdevista.com	
www.projekt30.com	
www.photoarts.com	
www.zonezero.com	

Art & photography e-magazines

Still	www.stillmag.com
This Is A Magazine	www.thisisamagazine.com
Tiger	www.tigermagazine.org
Richardsons	www.richardsonmag.com

Miscellaneous links/resources

www.onenakedegg.com	Online photography
www.completelynaked.co.uk	Always something of interest here
www.ephotozine.com	Info, articles, much good simple technical info
www.photolucida.org	Organises the excellent Critical Mass project
www.showstudio.com	Fashion meets photography meets cinema meets performance
http://www.artmarketing.com/Homepg/hotlinks.html	Large US-based info
www.hayvend.com	Info on their art vending machines' project
www.acmi.net.au/CCP	Centre for Contemporary Photography, Australia
www.photomediacenter.org	Traditional and digital photography site
www.london-photographic-awards.com	Photographic directory and competitions

Book fairs & festivals

Frankfurt Book Fair www.frankfurt-bookfair.com
London Book Fair www.lbf-virtual.com
Rhubarb-Rhubarb www.rhubarb-rhubarb.net
Camera show in Germany www.photokina-show.com
Information on photography festivals worldwide www.festivaloflight.net

Digital resources

Bitforms exhibiting best in digital artforms www.bitforms.com
Digital Arts Network www.digitalartsnetwork.org
Digital Research Unit www.druh.co.uk
EFX Art & Design Magazine www.macartdesign.matchbox.se
www.good-tutorials.com Photoshop tutorials
www.photopheed.com Info, news, blogs etc. all digital
www.phong.com Photoshop tutorials
www.javamuseum.org Internet technology and art

Digital art sites:

Dive in/explore/marvel/take your pick:

www.insertsilence.com
www.noodlebox.com
www.praystation.com
www.soundtoys.net
www.stanza.co.uk
www.gloriousninth.com
www.patriciapiccinini.net

Magazines & journals:

Artists Newsletter (see www.a-n.co.uk, left)
Ag
Next Level
British Journal of Photography www.bjphoto.co.uk
Aperture www.aperture.org
European Photography http://equivalence.com
Big www.bigmagazine.com
Catalogue www.000.cataloguemagazine.nl/about.html
Cheese www.cheesemagazine.com
Doing Bird www.doingbird.com
Exit www.exitmagazine.co.uk
Eye Caramba www.eyecaramba.com
Kilimanjaro www.kilimag.com
Portfolio www.portfoliocatalogue.com
Quest www.qvest.de
Spoon www.spoonlive.com
Zoom www.zoom-net.com
ArtPhoto Magazine www.artphoto.ro
Prefix www.prefix.ca
Lenswork www.lenswork.com
Handheld www.handheldmagazine.com
Hotshoe Magazine www.photoshot.com
Shots Magazine www.shotsmag.com
Source www.source.ie

Acknowledgements

A huge thank you to Natalia Price-Cabrera and Brian Morris at AVA Publishing for making this book possible, to Dan Moscrop of Them Design for the book's beautiful design, to Sarah Jameson for her endless positivity, patience and hard work while researching the images for this book, to George Glenny and Gordon Carter whose inspiration is still there and whose wisdom I can still call on, to Andrea, Trudi, RCJ, Dick and Paul, to my gorgeous wife Kat, and my children Jack and Dixie for putting up with my tantrums and keeping me sane, to my endlessly supportive father Julian, and my brothers Simon and Andrew. Thanks to all the photographers who contributed their images. Unearthing their gems has been an awe-inspiring pleasure and a true privilege.